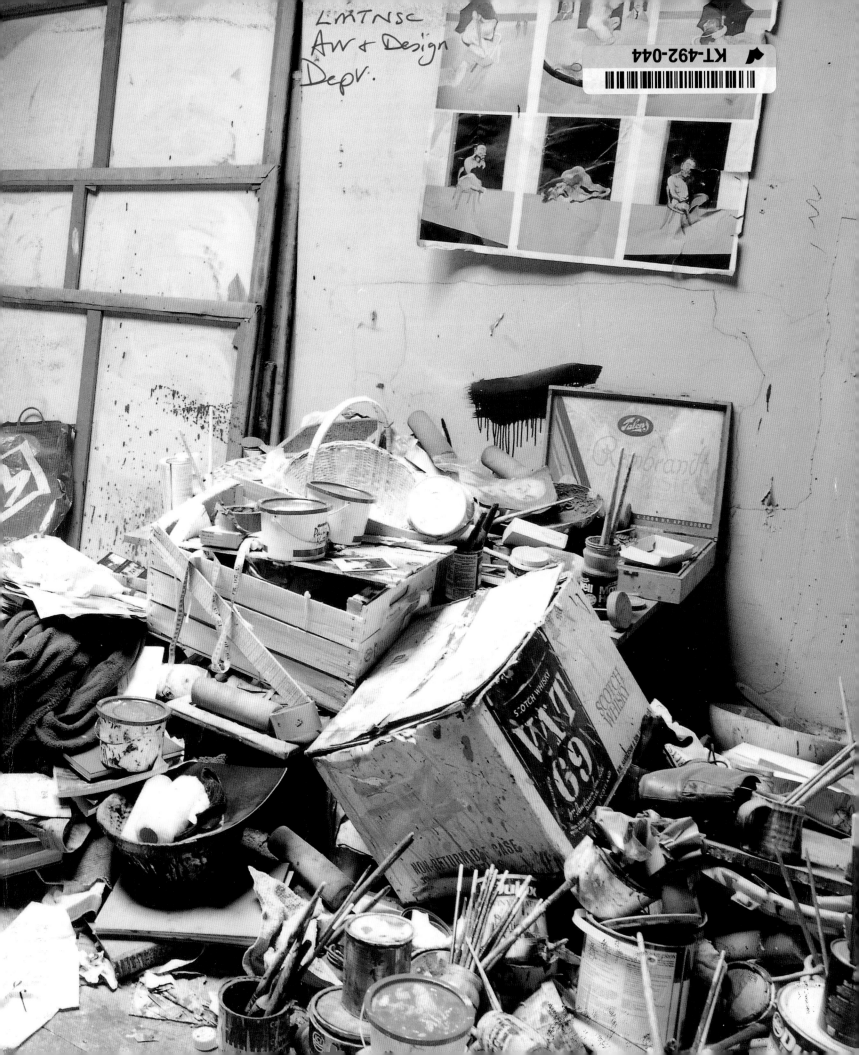

Francis Bacon

A Retrospective

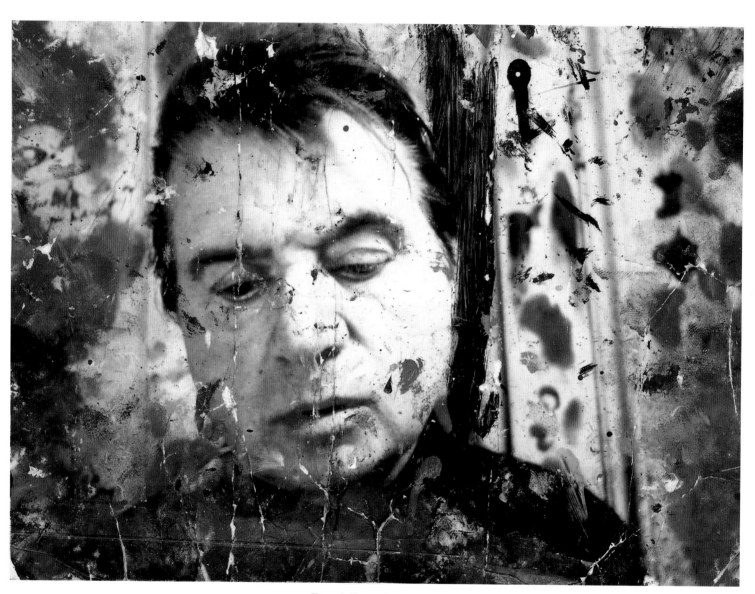

Francis Bacon in 1970

Francis Bacon

A Retrospective

GUEST CURATOR
DENNIS FARR
CO-CURATOR
MASSIMO MARTINO

WITH ESSAYS BY
DENNIS FARR
MICHAEL PEPPIATT
SALLY YARD

HARRY N. ABRAMS, INC., PUBLISHERS

IN ASSOCIATION WITH

THE TRUST FOR MUSEUM EXHIBITIONS

Francis Bacon

A Retrospective Exhibition

ITINERARY

January 25–March 21, 1999

THE YALE CENTER FOR BRITISH ART
New Haven, Connecticut

April 8–May 27, 1999

THE MINNEAPOLIS INSTITUTE OF ARTS
Minneapolis, Minnesota

June 13–August 2, 1999

THE FINE ARTS MUSEUMS OF SAN FRANCISCO
California Palace of the Legion of Honor
San Francisco, California

August 20–October 15, 1999

MODERN ART MUSEUM OF FORT WORTH
Fort Worth, Texas

CONTENTS

Acknowledgments

We have legions to thank for a beautiful and fascinating volume that accompanies an important exhibition about one of the eminent artists of the twentieth century — Francis Bacon. We are infinitely grateful to the many people who assisted the Trust for Museum Exhibitions (TME) and Dr. Dennis Farr with this exhibition. The lines below are our tribute to a distinguished group of dedicated, creative, and talented people.

We wish to thank most warmly Valerie Beston and Kate Austin of Marlborough Fine Art for their unfailing help and support during the planning of this exhibition. We gratefully acknowledge the help of Alex Robertson of Leeds, and of Janet Balmforth and Dr. Anthea Brook of the Courtauld Institute.

Dr. Farr's two collaborators in this volume were Michael Peppiatt, Bacon friend, scholar, and biographer, and art historian Dr. Sally Yard. Mr. Peppiatt presented us not only with a marvelous essay on the artist's working methods, but also with the record of three interviews that he conducted with Bacon from 1963 to 1989. Dr. Yard has presented an excellent assessment of Bacon's life.

We also want to thank those diligent colleagues who helped us secure so many of our loans: Valerie Beston, for many years the executrix of the Bacon Estate, and Kate Austin of Marlborough Fine Art, Ltd. of London, as well as the art dealers Ivor Braka, Gérard Faggionato, and Richard Nagy, all also of London. Massimo Martino, Bacon friend and expert from Mendrisio, Switzerland, deserves special mention for the many roles he played on behalf of the exhibition: for securing the inclusion of many wonderful paintings; for advising TME, the guest curator, and the other essayists on a number of issues; and for his advice in the design and installation of the exhibition at each venue. We thank our museum and gallery colleagues for their willing help, especially Nicholas Serota and his staff at the Tate Gallery.

Four fine museums in the United States deserve TME's thanks and appreciation for helping to make this exhibition possible: the Yale Center for British Art, The Minneapolis Institute of Arts, the California Palace of the Legion of Honor, and the Modern Art Museum of Fort Worth. In addition, we owe great thanks to the generosity of our lenders, both institutions and private collections, whose willingness to part with wonderful paintings for a time enabled TME and its colleagues to create this superb project.

For the preparation of the catalogue, we were aided by the enthusiasm and expertise of the professional staff of Harry N. Abrams, Inc. — especially Paul Gottlieb, President and Editor-in-Chief; Elaine M. Stainton, editor par excellence; and Raymond P. Hooper, designer — who have all once again worked their magic.

Finally, we cannot thank enough our colleagues at the Trust for Museum Exhibitions, whose hard work behind the scenes over a period of many months made it all come together: Diane C. Salisbury, Director of Exhibitions, and her predecessor, Mary A. Sipper; Maria Gabriela Mizes Hickey, Registrar; Kia Dorman, Development Officer; Keith Bamberger, Volunteer Coordinator; Jerry Saltzman, volunteer; and Katalin Banlaki, TME's President's Scholar for the summer of 1998.

ANN VAN DEVANTER TOWNSEND
President, Trust for Museum Exhibitions

DENNIS FARR
Former Director, The Courtauld Institute Galleries

Lenders to the Exhibition

Collection Juan Abelló

Aberdeen City Art Gallery and Museums, Aberdeen, Scotland

Albright-Knox Art Gallery, Buffalo, New York

Arts Council Collection, Hayward Gallery, London

Astrup Fearnley Collection, Museet for Moderne Kunst, Oslo

Ivor Braka Ltd., London

Dallas Museum of Art, Dallas, Foundation for the Arts Collection

The Detroit Institute of Arts, Detroit

European Institution Collection

Faggionato Fine Arts, London

Fine Arts & Projects, Mendrisio

Francis Bacon Estate

Samuel and Ronnie Heyman

Mr. and Mrs. J. Tomilson Hill

Hirshhorn Museum and Sculpture Garden, Smithsonian Institution, Washington, DC

Kirklees Metropolitan Council, Huddersfield Art Gallery, Huddersfield, England

Marlborough International Fine Art

The Minneapolis Institute of Arts, Minneapolis, The Miscellaneous Works of Art Fund

Museum Moderner Kunst, Stiftung Ludwig, Vienna

Collection Museum of Contemporary Art, Chicago

Museum of Modern Art, New York

Richard Nagy, Dover Street Gallery, London

Private Collection Vittorio Olcese

Private Collections England, Belgium, Melbourne, Milan, and Paris

Paul Jacques Schupf

Tate Gallery, London

Toyota Municipal Museum of Art, Toyota, Japan

Yale University Art Gallery, New Haven

Yale University, New Haven

Richard S. Zeisler Collection, New York

Francis Bacon

BY SALLY YARD

For over a decade beginning in 1949, Francis Bacon worked to reinvent Velázquez's *Portrait of Pope Innocent X*. "Haunted and obsessed by the image, . . . by its perfection,"[1] he painted more than twenty-five variations which trace a sort of stop-action collapse of their enthroned protagonist. The public grandeur of the Baroque pontiff becomes a foil for the private disintegration of the twentieth-century imposter. "I think that man now realizes that he is an accident, that he is a completely futile being, that he has to play out the game without reason,"[2] Bacon mused in 1962.

Mindful of the senseless drift of life proposed by the frame of Existentialism, and alert to the brutality exposed in the Second World War, Bacon was unflinching in his confrontation with the shrill evidence at hand. If contemporaries in England sought to restore wholeness to the human figure, Bacon instead enlisted distortion so as to "transform what is called appearance into image. . . . If you want to convey fact, this can only ever be done through a form of distortion."[3] "People always seem to think that in my paintings I'm trying to put across a feeling of suffering and the ferocity of life, but I don't think of it at all in that way myself. You see, just the very fact of being born is a very ferocious thing, just existence itself as one goes between birth and death. It's not that I want to emphasize that side of things — but I suppose that if you're trying to work as near to your nervous system as you can, that's what automatically comes out. . . . Life . . . is just filled, really, with suffering and despair."[4]

Francis Bacon's parents,
Edward Anthony Bacon and
Winifred Firth Bacon
OPPOSITE:
Francis Bacon in 1955

There was ample indication in Bacon's own experience of this "ferocity of life." Born in Dublin in 1909 to English parents who restlessly moved between war-torn Ireland and England, his early years were inflected by the steady peril of violence. The graceful and airy bay windows of Farmleigh, the country house in County Queens where Francis often stayed with his beloved maternal grandmother, had to be sandbagged against the possibility of attack. And the traveler along rural Irish lanes might be ensnared in camouflaged ditches or fired on by snipers. Yet normalcy persisted in the domestic routine and the generosity of social life, and the parties at Farmleigh were festive in defiance of the constant danger. Within the Bacon household itself, decorum barely prevailed, the reputedly vehement temper of Francis's fractious father Edward, a retired army officer who bred and trained racehorses, threatening to erupt at any moment.[5]

Francis, whose education had been informal as a result of asthma and the frequent changes in the family's address, evidently discovered his homosexuality at the age of fourteen in the embrace of the stableboys who were enlisted by the elder Bacon to adminis-

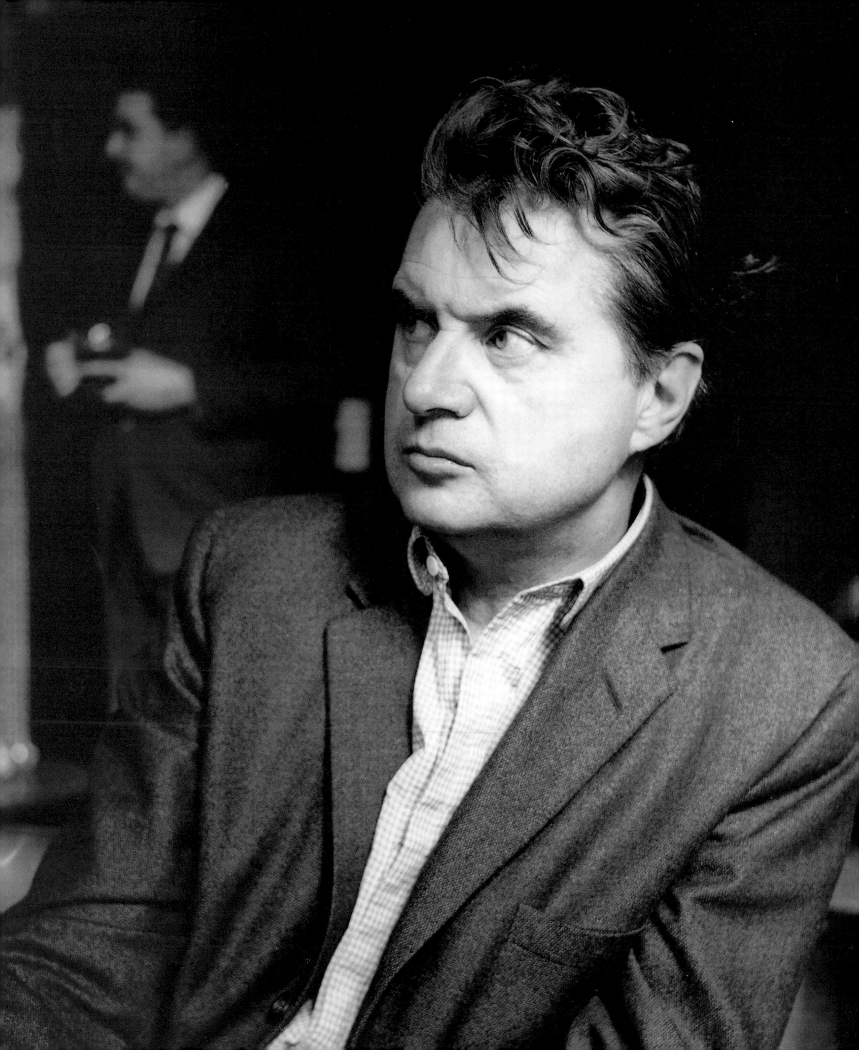

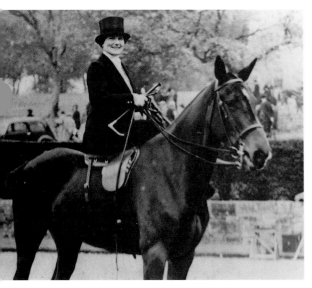

Winifred Bacon on horseback

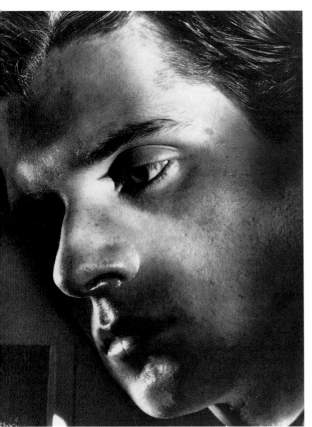

Francis Bacon in Berlin

ter disciplinary whippings to his errant sons. Banished from the family home for the transgression of trying on his mother's lingerie, sixteen-year-old Francis took up a new life in London.[6] Perhaps alarmed by the apparent verve with which his son — who was "what you call pretty, . . . and had no trouble getting around and getting money" — was settling in, Edward Bacon enlisted an ex-army friend and family relation, notable for his sturdy masculinity, to take Francis abroad in hopes of straightening him out.[7] Their stay in Berlin during the spring of 1927 seems instead to have refined the young man's emerging lifestyle. Based in an opulent hotel, the seventeen-year-old roamed a city that appeared at once glamorous and decadent, its streets a bazaar of erotic come-ons. In the end, the chaperone seduced Francis, who eventually made his way to Paris, where he took up work as a designer of interiors and furniture.[8] An exhibition of Picasso's drawings at the Paul Rosenberg Gallery during the summer of 1927 was to have a lasting impact: Bacon for the first time considered becoming an artist.

Back in London by 1929, Bacon transformed a garage space at 17 Queensberry Mews into a studio, where he shortly presented an exhibition of the sleek modernist furniture and rugs he had designed. The purchase of a rug around this time by a wealthy businessman called Eric Hall marks the beginning of a friendship that would be decisive for Bacon.[9] Although he had begun to receive serious attention as a designer — his furniture the subject of "The 1930 Look in British Decoration" published in *The Studio* magazine — Bacon's focus was shifting toward art.[10] He made his first oil paintings in 1929, and a few years later abandoned design work entirely. The dual directions of the moment were signaled in a second exhibition at Queensberry Mews, in 1930, including both furniture and paintings by Bacon, together with images made by his new-found friend from Australia, Roy de Maistre, and by the painter Jean Shepeard. De Maistre introduced the younger artist to a circle of friends who would be significant to his emergence as a painter. Central among these was Graham Sutherland, whose paintings of the Crucifixion ran parallel to the Christian subjects of de Maistre's work. Bacon soon set in place a pattern of frequent moves, settling on Fulham Road in 1931 and then Royal Hospital Road in 1933. But from 1931 through 1951, he would be accompanied in all of his domestic arrangements by Jessie Lightfoot, the woman 39 years his elder who had served as his childhood nanny and with whom he had remained enduringly close.[11]

Bacon's career as an artist slowly took shape, with periodic exhibitions and occasional sales. Herbert Read included the first of Bacon's *Crucifixion* paintings in 1933, the year it was painted, in his book *Art Now,* as well as in the exhibition at the Mayor Gallery that coincided with the book's publication. This impressive debut was followed by an even more unexpected demonstration of interest in the young artist's work, when Sir Michael Sadler, a major collector of modern and contemporary art and Master of University College, Oxford, saw the *Art Now* reproduction and acquired the painting, sight unseen. Convinced of the importance of Bacon's work, he undertook an unusual and suggestive approach to commissioning a

portrait to be hung in University College, sending Bacon an X-ray of his skull on which to base a likeness.[12]

Bacon himself organized his first one-man show away from the premises of the studio. Taking over the basement of a mansion in Mayfair, in 1934 he presented in this space — newly christened the Transition Gallery — seven of his paintings, together with a number of works on paper. The exhibition produced scant sales and a discouraging review in *The Times*.[13] Bacon's sense of rebuff was compounded in 1936 when his submissions to the International Surrealist Exhibition at New Burlington Galleries were excluded as "insufficiently Surreal."[14] That he was disheartened seems clear; he ceased to paint for most of the next seven years. In the first of a succession of crucial efforts on Bacon's behalf, Eric Hall took immediate action to reverse the discouraging momentum, prevailing upon Thomas Agnew & Sons on Old Bond Street to host an exhibition in 1937 of *Young British Painters,* among them Bacon, de Maistre and Sutherland.[15] Hall was fierce in his advocacy and defense of Bacon's work over the next seventeen years, and steadfast in his financial support.

Bacon's father died in 1940, and during the next four years Bacon's involvement in art seems to have consisted primarily of destroying almost all of his early work.[16] He vol-

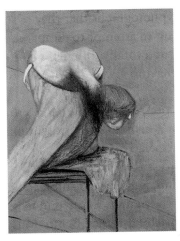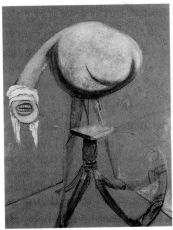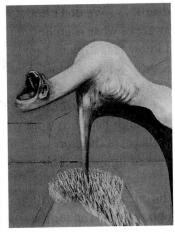

Francis Bacon,
Three Studies for Figures at the
Base of a Crucifixion, *1944*
Tate Gallery, London

unteered briefly, in 1941, for the Civil Defense Corps rescue service. His work with the Service aggravated his asthma, and he and Hall rented a cottage in Petersfield, Hampshire where Bacon could recuperate. By late 1942 he was back in London, with a studio at 7 Cromwell Place. Bacon gradually gathered energy, resuming painting in 1944. Faced with the horror of the Second World War, the distortions of Picasso's work of the late 1920s and 30s took on fresh significance. Certain, now, of the despairing violence of life, Bacon arrived at a subject that would be immediate in resonance and mythic in implication. The chthonic forces of the Furies were fused with the tormenting flagellations of Christianity in his *Three Studies for Figures at the Base of a Crucifixion* (1944).[17] This, and a second work, were included in a 1945 exhibition of contemporary English painting at the Lefevre Gallery in London. Both paintings were sold, *Three Studies* to Eric Hall.

It was probably during this period that Bacon solidified an outlook noted by David

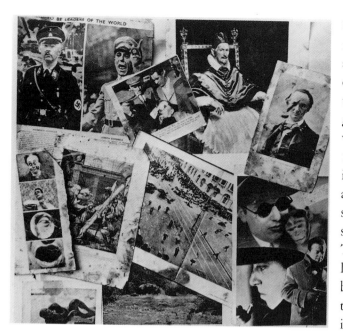

Clippings in Francis Bacon's Studio

Sylvester: "One thing that's always struck me about you [Francis] is that, when you're talking about people you know, you tend to analyze how they've behaved or would be likely to behave in an extreme situation, and to judge them in that light."[18] The sense of terror during the Blitz, as civilians fled for cover in the Underground, must have been reiterated for Bacon in a photograph, which Sam Hunter discovered amidst the artist's studio clutter in 1950, of civilians running from a battle in the streets of Petrograd in 1917. "Not one of these hundreds of figures looks remotely like a conventional figure," Bacon would later explain to John Rothenstein. "Each one, caught in violent motion, is stranger and at first sight less intelligible than one could possibly have imagined it."[19] The panic captured in the Petrograd photograph was probably linked for Bacon with the instinctuality of animal fear. "I've always been very moved by pictures about slaughterhouses and meat, and to me they belong very much to the whole thing of the Crucifixion. There've been extraordinary photographs which have been done of animals just being taken up before they were slaughtered; and the smell of death. . . . We don't know, of course, but it appears by these photographs that they're so aware of what is going to happen to them, they do everything to attempt to escape. . . . I know for religious people, for Christians, the Crucifixion has a totally different significance. But as a non-believer, it was just an act of man's behavior, a way of behavior to another."[20]

Bacon's disconsolate assessment is anguishingly expressed in *Painting 1946.* Although he set to work on an image of a bird alighting in a field[21] — an intimation, perhaps, of the story of Prometheus — he arrived by some associative process at a thick-necked figure with blood-stained lips enthroned before a carcass that presides as though in some perverse conflation of Crucifixion, patriarchal blessing, and beatific embrace. In the unconscious proddings of "appearance" toward "image," the figures captured in news photos strewn about the studio — of Joseph Goebbels, Heinrich Himmler, Benito Mussolini — were absorbed into the "compost"[22] of the artist's imagination and blur into the magisterial thug who ironically usurps a space customarily reserved for the subject of a papal or state portrait.

Prodded by Graham Sutherland, the dealer Erica Brausen visited the studio, purchasing *Painting 1946* on the spot. His finances bolstered by this unexpected windfall of £200, Bacon set off for Monte Carlo, where he lived, with intermittent stays in London, until 1950. Drawn to the Mediterranean resort's atmosphere thick with risk — "It has a kind of grandeur even if you might call it a grandeur of futility" — Bacon was energized by the constant imminence of disaster. "I had a really marvelous win at one point. I was playing on three different tables and I kept thinking I could hear the numbers called out before they came up—as if the croupiers were actually calling them out. I had very little money and I was playing for small stakes. But by the time I'd finished I'd got sixteen hundred pounds, which was a very great deal for me then. And I went out and took a villa and stocked it with food and drink and invited a lot of people to come and live

there. . . ."[23] In Bacon's absence, Brausen sold *Painting 1946* to the Museum of Modern Art in New York in 1948, which must have boosted Bacon's morale considerably. Monte Carlo was presumably not conducive to the concentration required for painting, and Bacon painted the six *Heads,* which made up his first one-person exhibition at Brausen's newly opened Hanover Gallery, in London just in time for the opening in November 1949.[24]

If the scarcely human mouth of *Head I* wails from within a space that announces Bacon's overlay of papal throne and claustrophobic cage, then *Head VI* initiated Bacon's protracted process of recasting Velázquez's *Pope Innocent X* as a fidgeting and flailing man in disarray. Here the worldly power that the seventeenth-century spiritual leader so easily wears is melded in Bacon's promiscuous imagination with the unspeakable loss of control captured in a scene in Sergei Eisenstein's 1925 film, *The Battleship Potemkin.* Among the photographs that littered Bacon's studio during these years was a close-up still photograph of the nurse in the Eisenstein film, showing the moment when she has just been shot in the eye, while the perambulator cradling the infant in her care hurtles down the Odessa Steps beyond reclaim.[25] The critical response to the Hanover exhibition indicated that Bacon, whose only other solo exhibition had taken place fifteen years before, would not go unnoticed. Lawrence Gowing recalled the reception of *Head VI*: "It was an outrage, a disloyalty to the existential principle, a mimic capitulation to tradition, a profane pietism, like invented intellectual snobbery, a surrender also to tonal painting, which earnestly progressive painters have never forgiven. It was everything unpardonable. The paradoxical appearance at once of pastiche and iconoclasm was indeed one of Bacon's most original strokes."[26] In a willfully blunt public pronouncement of his conviction that there can be no distinction between mind and body, Bacon took the opportunity to explain to *Time* magazine that "painting is the pattern of one's own nervous system being projected on a canvas." "Horrible or not," the article on the exhibition summed up, "his pictures were not supposed to mean a thing."[27] In the wake of the war, and in the light of Nietzsche's conclusion that God is dead, Bacon inhabited a world bereft of divine design or redemption: "We are born and we die, but in between we give this purposeless existence a meaning by our drives."[28]

In 1948, during one of Bacon's periodic returns to London from Monte Carlo, he happened upon a new club in Soho opened by Muriel Belcher. As regal in bearing as she was profane in banter,[29] Belcher liked Bacon immediately. Over the decades, the Colony Room would remain one of the constants in Bacon's life, a site of daily sociability and occasional liaisons. After a short stint teaching at the Royal College of Art in the fall of 1950, Bacon traveled to South Africa, where his mother had settled and remarried. Bacon's entire immediate family had by this point emigrated: His two sisters lived in Rhodesia, where their eldest brother Harley had died of tetanus. The sense of expatriate elegance, and the vague intimation of doomed colonial-outpost decadence, perhaps appealed to the artist's interest in life on the margins. Fascinated by the animals in the landscape, Bacon visited Kruger Park. Back in London he amplified his memory of the veldt by consulting the photographic plates in Marius Maxwell's *Stalking Big Game with a Camera in Equatorial Africa* (1924).[30] But Bacon turned his immediate attention in 1951 not to the wild game of another continent, but to *Popes I, II,* and *III,* which con-

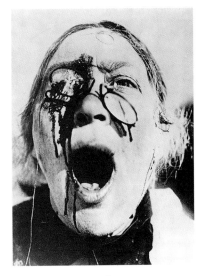

Close-up of Nurse from Sergei Eisenstein's film, The Battleship Potemkin, *1925*

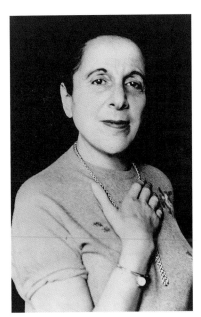

Muriel Belcher

stitute his first attempt to show sequential actions of a single figure in a series of paint-
ings. For the moment, the image of Innocent X remained so riveting, in fact, that a 1953
portrait of the art critic David Sylvester had by the fourth sitting metamorphosed into a
picture of the pope entitled *Study for Portrait I.* Working with little respite over the next
two weeks, Bacon completed seven variations: *Studies for Portrait II* through *VIII.*[31]

Eric Hall, whose unwavering commitment to Bacon had destroyed his marriage and
depleted his financial resources, had remained devoted. Positioning the artist for what
was to be substantial recognition in the years just ahead, in 1953 he gave the painting
Dog to the Tate Gallery, followed in 1954 by the gift of *Three Studies for Figures at the Base
of a Crucifixion.*[32] Bacon's increasing preeminence was evident in the widening geo-
graphic reach and established stature of the institutions presenting his work. Gallery
exhibitions in London, and a retrospective in 1955 at the Institute of Contemporary
Arts focused steady attention in England. Durlacher Brothers in New York organized
Bacon's first solo exhibition in the United States in 1953. The following year, works by
Bacon, Ben Nicholson and Lucian Freud represented Great Britain at the Venice *Bien-
nale.* Exhibitions followed in Paris in 1957, and in Milan and Rome in 1958. In 1959
Bacon's work was shown at *Documenta II* in Kassel, Germany, and at the São Paulo *Bienal.*
By the end of the decade Bacon had moved on from those who had launched and nur-
tured his early success. In 1958 he left Brausen's Hanover Gallery for Marlborough Fine
Art Ltd., which would represent his work internationally for the rest of his life. Eric Hall,
who had lived with Bacon through most of the 1940s, and had spent his final years alone,
died in 1959.

Bacon had met Peter Lacy at the Colony Room by 1952. The compelling physical-

ity of their affair perhaps suggested to Bacon the subject matter introduced in *Two Figures* in 1953, for at this moment Bacon's fascination with Eadweard Muybridge's photographic studies of *The Human Figure in Motion* (c. 1885) surfaced in the transmutation of wrestling men into embracing lovers. A year before, Muybridge's images of *Man Performing Standing Broad Jump* had informed Bacon's *Study for Crouching Nude* (1952). It is as if Bacon's assault on the composed demeanor and commanding dignity of the seated pope had now precipitated a sort of devolution of the postures of his figures toward the hunkering stances of less-than-human primates. During the mid-1950s Lacy left London for the sun-drenched hedonism of North Africa. In the sudden stillness that followed his lover's departure, Bacon turned to the work of van Gogh. In 1956–57 he painted eight variations on van Gogh's *The Painter on the Road to Tarascon* (1888). True to form, Bacon knew the work only in reproduction, the painting having been destroyed during World War II. The completion of the series was interrupted by Bacon's visits to Tangier, where he took a succession of rooms and apartments until his final split with Lacy. In this

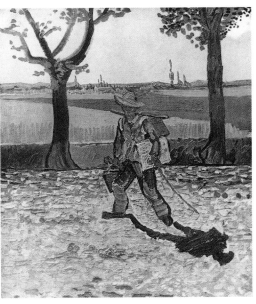

Vincent van Gogh,
The Painter on the Road to
Tarascon, *July 1888 (destroyed)*

humid place of transit and bohemian languor, Bacon befriended Allen Ginsburg, William Burroughs, Paul Bowles, and Jane Bowles. The relationship with Lacy ended, however, and Lacy carried on with the self-destruction by alcohol on which he had embarked some years before.[33] By 1961 Bacon, whose living and working spaces had changed with persistent regularity throughout the decade following the death in 1951 of Jessie Lightfoot, had taken a small apartment above a garage in a Kensington mews. He apparently at last felt at ease. Illuminated by bare lightbulbs, the windows draped with heavy dark green curtains, his rooms at 7 Reece Mews remained the central spaces of his life and work until his death thirty years later.

Early in 1959 the Tate Gallery presented an exhibition called *The New American Painting,* including works by the Abstract Expressionists Barnett Newman, Mark Rothko, Willem de Kooning, and Jackson Pollock. While Bacon remained unmoved by what he saw as the detached aestheticism of abstraction, it seems likely that he was impressed with the potency of Newman's use of color, for the seething surfaces of the van Gogh paintings gave way in 1959 to spare fields of saturated color describing interiors inhabited by Bacon's friends. At a moment when artists such as Richard Hamilton in England and James Rosenquist in New York were turning toward the commercial domain that made even the most private imagery a matter of public display, Bacon focused ever more closely on personal subjects played out in the seclusion of enclosed spaces.

Plans for a major retrospective of Bacon's work, scheduled to open in 1962, were under way at the Tate Gallery. The chronological and conceptual beginning of the exhibition was *Three Studies for Figures at the Base of a Crucifixion.* Bacon took up the triptych format and Crucifixion subject matter once again, completing *Three Studies for a Crucifixion* (1962) in time for inclusion in the show. The stories of the Passion and of the Furies had apparently lingered in Bacon's imagination as constructs which could be recast in twentieth-century guise. Reflecting, in 1966, on the imagery of the Crucifixion, Bacon observed: "I haven't found another subject so far that has been as satisfactory for cover-

ing certain areas of human feeling and behavior. . . . I think that this may be that we live in a period when we're rather lacking in a contemporary myth."[34] Amidst the congratulatory telegrams that arrived to celebrate the opening, there was one that reported Lacy's death in Tangier.

George Dyer

The effect of Bacon's first retrospective in the United States, which opened in New York at the Solomon R. Guggenheim Museum in October 1963, can hardly be overstated. Painted against the grain of the clean, hard-edged dispassion of Minimalism, the work likewise countered the slick, low-brow cool of Pop Art. Flush with the professional triumphs of the previous few years, Bacon was by 1963 romantically involved with George Dyer, whose life of petty crime till that time had perhaps not equipped him with the social prowess to move effortlessly, as Francis did, between East End bars and collectors' drawing rooms. Handsome and uneducated, Dyer was the subject of a succession of paintings throughout the latter half of the 1960s. In Paris for the opening in 1971 at the Grand Palais of an exhibition of Bacon's work of four decades, Dyer — alone in the hotel room — died from an overdose of alcohol and drugs.[35] Bacon confronted his desolate sense of loss in a series of triptychs, infused with grief and self-accusation, made between 1971 and 1973. Searching his role as artist-observer, Bacon looked to Proust. "I think the *Recherche* is the last great tragic book to have been written," Bacon later observed to Michael Peppiatt. "It may be the morbid side of my nature, but there's something so extraordinary about the way all these characters Proust has made change. When Charlus falls on the cobblestones, he's reduced to nothing — after being so pompous, he becomes completely pathetic, fallen there. And of course it goes on for pages. In the end, all the characters Proust has created turn out to be ciphers out of which the book itself has been made."[36]

By the 1970s the possibilities of the Crucifixion had been exhausted for Bacon: "I would never use it or could never use it again because it's become — it was always dried up for me — but it's become impractical even to use it."[37] Instead, the Furies move into the breach. Bacon had, no doubt, taken note of Harry's horror when the Eumenides track him to Wishwood in T. S. Eliot's play *The Family Reunion* (1939). Harry echoes the cry of Orestes: "You don't see them, you don't — but *I* see them: they are hunting me down, I must move on."[38] If for Aeschylus the Erinyes were harpies of Moira, of Fate, then for Bacon they are lurid emblems of disaster. Ghoulish, predatory and corrosive, they are our private demons. "We are always hounding ourselves. We've been made aware of this side of ourselves by Freud, whether or not his ideas worked therapeutically."[39] The Furies had early on been suggested in the slavering beast-in-pursuit who clamors atop the cross in *Fragment of a Crucifixion* of 1950. Two decades later this embodiment of ill-omen appears in the batlike void that snares the figure of George Dyer as he subsides into the supple curves of death in *Triptych, May–June* (1973).

In 1974 Bacon bought a small apartment in Paris, where he lived now and then during the remainder of the decade. During the spring of 1975 he traveled to New York (which he had first visited in 1968) for the opening of a substantial exhibition of *Recent Paintings 1968–1974* at the Metropolitan Museum of Art. Over the next few years there would be exhibitions in Paris, Mexico City, Caracas, Tokyo, Kyoto, Nagoya, and

Moscow. An exhibition presented at the start of 1977 at Galerie Claude Bernard in Paris was nearly stormed by admirers whom police fended off with cordons in the streets. The Tate Gallery in 1985 organized a second major retrospective which traveled to Stuttgart and Berlin. Four years later, in 1989–90, the Hirshhorn Museum and Sculpture Garden circulated Bacon's work to the Los Angeles County Museum of Art and the Museum of Modern Art in New York.

No longer concerned to guard the distance from works purposely known only in reproduction, Bacon traveled in 1990 to Colmar to see Grünewald's Isenheim altarpiece, and to Madrid to see the Prado's Velázquez exhibition. Stricken with respiratory trouble on a visit to Madrid in April 1992, he was rushed to hospital. As if in some final complicity with chance, it was there, attended by nuns of the order of the Servants of Mary,[40] that the remorseless atheist died. Four years later, viewers flooded an expansive exhibition at the Centre Georges Pompidou in the city where Bacon had first thought to be an artist. Surely Bacon had long since won a wager made early on. "The gamble," as John Russell had put it in 1971, "was for high stakes in the old European tradition, and the pictures were to deserve either the National Gallery or the dustbin, with nothing in between."[41]

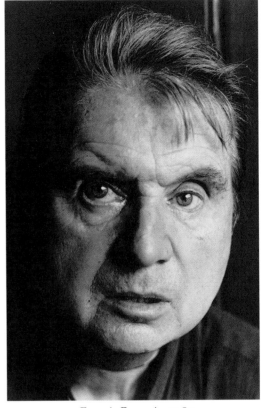

Francis Bacon in 1980

"Well, of course, we are meat, we are potential carcasses," Bacon declared with blithe nihilism. "If I go into a butcher's shop I always think it's surprising that I wasn't there instead of the animal."[42] But, even so, "we give this purposeless existence a meaning by our drives." By our drives, and by their aftermath. The Crucifixion and the vengeance of the Furies are paired scenarios of conscience and of guilt. "One can hardly imagine a symbol that expresses more drastically the subjugation of instinct," Jung observed of the Crucifixion. "Such a deed alone seems adequate to expiate Adam's sin of unbridled instinctuality."[43] Unrelenting, the Furies first appear in Aeschylus's *Eumenides* moaning, chanting "Get him, get him, get him, get him. Make sure."[44] If the Furies were in 1942 recast in the deflated guise of flies in Jean-Paul Sartre's play *Les Mouches,* then the crucified anatomies — festooned with butchers' garlands — of Bacon's paintings are ironic subversions of the tragic image of sacrifice at the core of Christianity. In the lingo of Sweeney in T. S. Eliot's *Sweeney Agonistes*: "Birth, and copulation, and death./ That's all the facts when you come to brass tacks:/ Birth, and copulation, and death."[45]

And yet for Bacon that's not all the facts. One by one, in the solitude of interior spaces, or framed as though for police photographs,[46] and once or twice poised on a London street corner, the pantheon of Lucian Freud, Isabel Rawsthorne, George Dyer, Muriel Belcher, Henrietta Moraes, and John Edwards takes shape. "Any movement you paint has all kinds of other implications. Why and how a person stands or sits conveys all sorts of other things."[47] Pushing "appearance" toward "image," Bacon no doubt often dreamed of literature — of Shakespeare, for example, "who just enlivens life, no matter how futile you think it is . . . both by his profound despair and pessimism and also by, you may say, his humor. And his absolutely, really, in a way, diabolical cynicism. I mean, what can be more cynical than Macbeth at the end, in 'Tomorrow, and tomorrow, and tomorrow'?"[48]

Francis Bacon in Context

Many great artists create myths around themselves, or are willing to encourage others to propagate them. Francis Bacon was no exception, and only now, more than five years after his death are we able to unravel some of the received truths as either fictions or less than the whole story. It is well known that during his lifetime he insisted that there should be no detailed commentary on individual pictures printed in any of the major retrospective exhibition catalogues, after the Tate Gallery's in 1962. Given his dislike of what he called "illustration," it is understandable that he should not want mini-exigeses for each of his exhibited works, preferring to let nothing stand between his paintings and the spectator.[1] Yet, paradoxically, and fortunately for us, Bacon was willing to talk about his work in an engaging and enlightening manner, so providing clues to some of the sources of his inspiration, and a partial explanation of his working methods.[2] He was adamant that he never made drawings or preparatory sketches for his pictures,[3] which we now know to be untrue; and with the exception of the 1962 Tate exhibition, where four early works were shown, during his lifetime he would never allow paintings made before 1944 to be publicly shown. Details of his private life were also hard to come by, and such as were published had first been filtered through his censorship net. Only in later years, as his reputation became established, were we allowed a closer glimpse of his origins and background.[4] Even his year of birth, 1909, had been wrongly recorded in the sparse early literature about him.[5]

It would not be an oversimplification to cast the young Francis Bacon as the archetypal "outsider." From early in childhood he was marked out as a loner by his chronic asthma, which prevented him from participating in either a normal school curriculum or the sporting pursuits of his class. Sent out hunting on his pony by his insensitive, bullying father, Francis would be laid up for days afterwards, gasping for breath. His brothers and sisters do not seem to have figured much in his life, and his feckless parents seem to have been indifferent to his welfare. Apart from some perfunctory private tutoring from a local clergyman and two years at Dean Close School, Cheltenham, between the ages of fourteen and sixteen, he was left largely to his own devices. He ran away from some of the schools to which he had been sent as a child; but he read widely and through his maternal great-aunt, Eliza Mitchell (née Watson), Francis saw the collection formed by her late husband, Charles Mitchell, at Jesmond Towers, just outside Newcastle upon Tyne, where he made several prolonged visits before and during the First World War. Mitchell had collected the fashionable academic artists of his day, from William Etty to Lord Leighton and their French Salon counterparts. In later life, Bacon used to tease critics and art historians by saying: "Remember, I look at everything," and he was endowed

with a particularly retentive visual memory. To his physical disability was added another, more subtle, barrier: the discovery in adolescence of his homosexuality, which he later described, in certain moods, as "It's like having a limp."[6]

Shy, yet somehow conscious of his latent gifts, Bacon learnt to fend for himself, even as he seemed to drift aimlessly through life. Discovered by his father trying on his mother's underwear, he was expelled from home, after a blazing row, and at the age of sixteen, made his way to London. He was given a weekly allowance of £3 by his mother from her private income, which enabled him to subsist.

The trauma of his expulsion from home scarred Bacon for life, especially as it came at a moment when he was only beginning to mature into adulthood. He drifted from one temporary job to another, learning the furtive ways of the homosexual underworld and no doubt supported by this informal network. Homosexuality was still severely punished in England, and not until 1967 would a more tolerant attitude be reflected in legislation which permitted homosexual activity between consenting adults in private. His father made one last effort to rescue Bacon from the seedy life of Soho; in the spring of 1927, he prevailed upon a respectable and successful uncle on his wife's side to take Francis with him on a trip to Berlin.[7] Booking into the Adlon Hotel, this virile uncle introduced his nephew to high living in Berlin, but soon abandoned him. After two months there, Bacon moved on to Paris. It is intriguing to speculate what he might have seen in Berlin, apart from the wild decadence of the Weimar era, with its extremes of luxury and poverty. Given his later essays in interior decoration and furniture design, one wonders if he saw the displays of well-designed, mass-produced furniture and pottery in Wertheim's department store. Could he have seen the products of the Deutscher Werkbund or of the more avant-garde Bauhaus designers and their pupils then established at Dessau? In Paris he could have heard of the recent Exposition Internationale des Arts Décoratifs et Industriels Modernes, held in 1925 (from which the term Art Déco was retrospectively coined). This might have been at the cultivated Bocquentin household, when Mme. Yvonne Bocquentin took the young man's cultural (and linguistic) education in hand for some months at their Chantilly house. He would have noted the suave elegance of French design, the luxury and fine craftsmanship, as well as its modish jazzmodern elements. But by 1927, Art Déco was already in decline, its place taken by the new modernism.[8] Less stark than German Bauhaus style, French modernism combines modern tubular steel frames, and glass and pale veneers, with an understated opulence. Carpets and textiles featured abstract designs derived from the late Synthetic, or decorative, Cubism of Picasso and, in particular, from Juan Gris and Jean Lurçat's simplified abstractions. When Bacon began to paint in 1929, his work owed much to these artists. Such of his interiors and textiles, including his own studio, as were recorded at the time or which have survived, have a Bauhaus-like austerity and an orderliness quite alien to his later lifestyle.[9]

We do know that in July 1927, Bacon saw an exhibition of recent work by Picasso at Paul Rosenberg's gallery in Paris, and over twenty years later he recalled how these post-classical nudes and metamorphic paintings of bathers executed by Picasso at Dinard the following year, made a great impression on him.[10] He was struck by the way Picasso distorted the human figure while still preserving its organic identity, a process he him-

Francis Bacon in Berlin, c. 1927

Francis Bacon, Gouache, *1929*

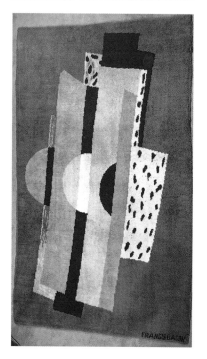

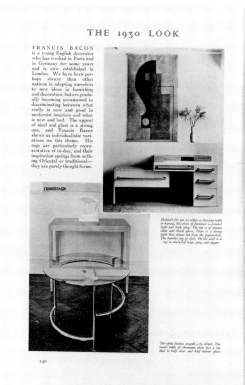

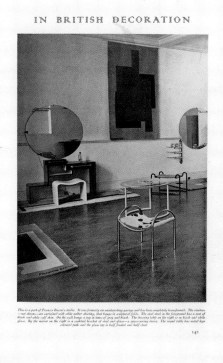

FRANCIS BACON is a young English decorator who has worked in Paris and in Germany for some years and is now established in London. We have been perhaps slower than other nations in adapting ourselves to new ideas in furnishing and decoration, but are gradually becoming accustomed to discriminating between what really is new and good in modernist interiors and what is new and bad. The appeal of steel and glass is a strong one, and Francis Bacon shows us individualistic variations on this theme. His rugs are particularly representative of to-day, and their inspiration springs from nothing Oriental or traditional—they are purely thought forms.

Designed for use as either a dressing-table or bureau, this piece of furniture is painted light and dark grey. The top is of opaque white and black glass. There is a strong light that shines out from the pigeon-holes. The handles are of steel. On the wall is a rug in shades of beige, grey, and nigger

The white faience maquili is by Adnet. The round table of chromium plate has a top that is half clear and half mirror glass

This is a part of Francis Bacon's studio. It was formerly an uninteresting garage and has been completely transformed. The windows—not shown—are curtained with white rubber sheeting, that hangs in sculptural folds. The steel stool in the foreground has a seat of black and white calf skin. On the wall hangs a rug in tones of grey and black. The dressing-table on the right is in black and white glass. By the mirror on the right is a cocktail bracket of steel and glass—a space-saving device. The round table has metal legs coloured pink and the glass top is half frosted and half clear

140 141

self was to adopt in his own figurative work. Whilst in Paris, Bacon is said to have obtained a few commissions for interior decoration, possibly through the homosexual network, but exactly how he began this career is unknown, and he was later to dismiss it contemptuously as totally unimportant. His few surviving early drawings and watercolors are very much in the Picasso-Surrealist mold. Both aspects of his early career — as interior decorator and painter — point up his ability to absorb the latest trends in art and design and to reproduce them with panache. He was only twenty when given the accolade of a write-up, as a designer, in *The Studio* in August 1930; but he was already beginning to paint and, with help from a new-found friend, the Australian painter Roy de Maistre, to master the technique of oil painting. He early developed a flair for self-promotion. Thus, in November 1930, he invited de Maistre and a portrait painter, Jean Shepeard, to join him in a studio exhibition, where he showed four of his own pictures and a print, as well as four rugs. But the harsh economic climate, coupled with a monumental public indifference to modern art, meant that few commissions came his way.[11] Even so, he scored some success when one of his *Crucifixions* (Cat. no. 1), shown at the Mayor Gallery's *Art Now* exhibition of October 1933, was reproduced in Herbert Read's *Art Now: An Introduction to the Theory of Modern Painting and Sculpture*, published to coincide with the exhibition, and which led to its purchase by Sir Michael Sadler, a noted collector of modern art. In this silvery-grey painting Bacon makes use of X-ray photographs. Freddy Mayor, incidentally, was one of the most adventurous dealers of his generation, and his gallery was renowned for its avant-garde policy.

Bacon's next foray was a one-man exhibition that he organized in February 1934, which took place in the basement of Sunderland House, Mayfair, by courtesy of the inte-

rior designer, Arundell Clarke, who admired his work. Called appropriately, the Transition Gallery, as if marking his rite of passage to a full-time professional painting career, the venture was a partial failure. Seven oils and six gouaches were shown, and apart from a sniffy review in *The Times*, the exhibition attracted little attention outside the artist's circle of friends, some of whom bought a few of his pictures.[12] Sensitive to faint praise mingled with snide criticism, Bacon was depressed, and he destroyed some of his work in a fit of acute self-criticism. He stopped painting. His morale was not improved when, on submitting work to the International Surrealist Exhibition in June 1936, he was rejected by Roland Penrose (one of the principal organizers of the show) and Herbert Read as being "insufficiently Surreal." Many years later, Bacon concurred in this judgment, but at the time, it must have increased his feeling of isolation. Broadly speaking, the three main strands in British art in the mid-1930s consisted of the abstract-constructivists, led by Ben Nicholson and Barbara Hepworth; the principal Surrealists, Paul Nash, Ceri Richards, and Graham Sutherland; and a third group, broadly neo-realist, centered around what was to be known as the Euston Road School (founded 1937), led by William Coldstream, Claude Rogers, and Victor Pasmore. This last group had as their mentor Walter Sickert (1860–1942), an artist whose use of photographs, engravings and press-cuttings as a basis for some of his compositions from about 1927 onwards was to find a willing disciple in Bacon from at least the early 1940s. Surrealism in Britain was perceived by influential critics like Herbert Read as a continuation of a much older, predominantly literary tradition; the work of artists like Sutherland, whom Bacon had met in 1930, was seen by these critics as shading into neo-Romanticism.

One of Bacon's early surviving oils, *Interior of a Room* c.1935, is a curious amalgam of Picasso's Analytical Cubism, with its sharp disjunctions of spatial organization, the use of decorative panels à la Matisse, and the mysterious element of a dog whose neck appears separated from its body as if in a blurred action-photograph. Another early work, *Figures in a Garden*, c. 1936, is suffused with a predominantly green-hued, lyrical, quasi-pastoral atmosphere, which is then abruptly shattered by the totem-like presence of a screaming figure, who is clawed at by a dog. We are in the early stages of the Baconian nightmare. Apart from participating in a group exhibition of "Young British Painters" held at a usually rather conservative dealer's gallery, Agnew's, in January 1937, Bacon drifted aimlessly and virtually abandoned painting. This exhibition, which was sponsored and organized by his friend, Eric Hall, also presented the work of such future stars as de Maistre, Sutherland, Pasmore, John Piper, Ceri Richards and Julian Trevelyan. Bacon's faculties of observation were not dormant, however, but were rather being nurtured *in pectore*. Although not sufficiently Surrealistic to please the organizers of the International Surrealist Exhibition, Bacon nevertheless used the Surrealist techniques of unexpected conjunctions of apparently disparate objects, and the dislocation of "normal" space in his work of the mid-1930s, and he was to refine these devices in his mature work in subtler ways than those employed by the official Surrealists, some of whose rather obvious shock tactics now look distinctly jejune.

Although in the years immediately before the outbreak of World War II, Bacon led a precarious existence, living on the verge of penury with his old nurse Jessie Lightfoot, he nevertheless indulged his taste for gambling and an extravagant lifestyle whenever

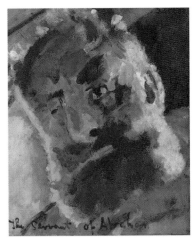

Walter Sickert, The Servant of Abraham, *1929*
Tate Gallery, London

Francis Bacon, Interior of a Room, *c. 1935*

OPPOSITE TOP:
Francis Bacon,
Watercolor, *1929*

OPPOSITE RIGHT:
Article from The Studio, *August 1930, showing furniture and rugs designed by Bacon in his Queensberry Mews studio*

OPPOSITE CENTER:
Roy de Maistre, Francis Bacon's Queensberry Mews Studio, *1930*

OPPOSITE BOTTOM:
Francis Bacon, Rug, c. 1929

Francis Bacon,
Figures in a Garden, *1936*

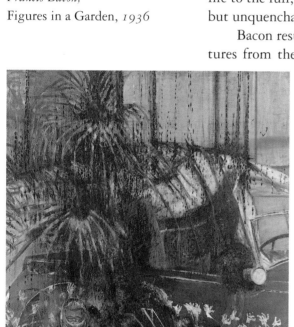

Francis Bacon,
Landscape with a Car,
c. 1939–40 and 1946

possible. Throughout his adult life he enjoyed mixing in all levels of society, from the salons of rich, cultivated women, to the squalor of Soho and the East End of London. When war came, Bacon was rejected as unfit for military service; he volunteered for the Civil Defence, but helping to clear corpses from the dust-laden rubble of bomb-devastated houses aggravated his chronic asthma, and he was eventually discharged from these duties. By early 1942, helped by Eric Hall, he was spending time in the country, but he retained his studio in Glebe Place, Chelsea, until, at the end of that year, he rented a magnificent studio at 7 Cromwell Place, South Kensington, that had once been owned by the famous Pre-Raphaelite artist, Sir John Millais, President of the Royal Academy. For Bacon, the horrors of war only confirmed his innate fatalistic nihilism, and his conviction that life was utterly futile; yet he believed in living life to the full, buoyed by an expectation that experience had taught him was misplaced but unquenchable.

Bacon resumed painting sporadically in 1939–40, and a number of abandoned pictures from the years 1939–46 had survived at the time of Ronald Alley's catalogue raisonné of his work published in 1964.[13] These prepare us, to some extent, for the *Three Studies for Figures at the Base of a Crucifixion* of 1944 (see p. 11), which caused such a sensation when it was first exhibited at the Lefevre Gallery in April 1945. Individual elements in these three panels had appeared in *Landscape with Car,* c. 1939–40 and c. 1946,[14] for example, the figure with an elongated neck that ends in a mouth with lips drawn back showing bared teeth. Other abandoned pictures also contain images which Bacon developed in *Three Studies*, a painting he had worked on for some time before its actual completion in 1944. As was to be so often his practice, photographic images of, for example, Hitler stepping out of a car, or of Goebbels in peaked cap and open-mouthed full rant, have been incorporated, in much transformed state, into this and other finished paintings of 1945–46.

John Russell eloquently caught the mood of shock created by *Three Studies:* "Their anatomy was half-human, half-animal, and they were confined in a low-ceilinged, windowless and oddly proportioned space. They could bite, probe, and suck, and they had very long eel-like necks, but their functioning in other respects was mysterious. . . . They caused a total consternation. We had no name for them, and no name for what we felt about them. They were regarded as freaks, monsters irrelevant to the concerns of the day, and the product of an imagination so eccentric as not to count in any possible permanent way. They were spectators at what we hoped was going to be a feast, and most people hoped that they would just quietly be put away."[15] He recalled that Bacon, an atheist, had titled his painting figures at "a Crucifixion" not "*the* Crucifixion"; and that not only had scenes of human degradation attracted ghouls since time immemorial, but from April to June 1945 there were plenty of ready-made examples, from the corpse of Mussolini suspended upside down from a meat hook in a suburb of Milan, to Hitler's

bunker; and, most gruesome and shaming of all, in June, the liberation of survivors in the Belsen and Dachau death-camps from the uniformed murderers of the Third Reich. Man's inhumanity to man was to be a recurrent theme in Bacon's work; his taste for the macabre, too, had been fed by an old medical textbook on diseases of the mouth, with hand-colored plates, which he had bought in the 1930s. The screaming open mouth, and the half-closed mouth with bared teeth, became dominant motifs in many of his paintings. He was also fascinated by the beautiful colors of sides of beef which hung in butcher's shops; these, too, featured in some of his *Crucifixions*. His study, in translation, of the ancient Greek tragedians, Æschylus and Sophocles, had confirmed his belief in man's helplessness before preordained disaster, a leitmotiv also of T. S. Eliot's sombre poetry and of his play *The Family Reunion*, which Bacon read many times. He felt his own life to be haunted by the Furies, with some reason, for what should have been joyous celebrations on two occasions were marred by the deaths of loved ones. In 1962, his friend Peter Lacy died in Tangier just as Bacon's first full-scale retrospective opened at the Tate Gallery; in autumn 1971, his companion George Dyer committed suicide on the eve of Bacon's Paris retrospective at the Grand Palais. A taste for sado-masochism may also have been nurtured by the beatings he received at the hands of his father's grooms as a youngster.

Francis Bacon, Crucifixion, *1933*

Bacon preferred to work from black and white dramatic documentary photographs such as those that appeared in *Picture Post* from 1938 onwards, as well as from colored reproductions of old master paintings. Photographs are, to a modern figurative artist like Bacon, what etchings and reproductive engravings were to his predecessors in earlier centuries. They conveyed an image, often seeming more objective (or neutral) than the actual object itself. Another powerful source of inspiration was Eadweard Muybridge's volumes of sequential photographs showing athletes (and animals) walking, running, jumping, wrestling, and so on. These, the forerunners of the motion picture, provided a rich treasury of poses for Bacon to mine throughout his career, a career that cannot be neatly divided into distinct phases (although there is a clearly discernible progression towards greater technical mastery), but can more conveniently be considered thematically.

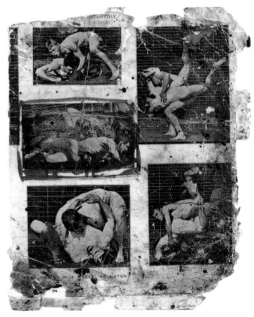

Page of photographs by Eadweard Muybridge, from Human and Animal Locomotion, *1887*

Apart from the *Crucifixion* series, which run through to the mid-1960s, Bacon became obsessed by Velázquez's *Portrait of Pope Innocent X* in the Doria Pamphili Gallery in Rome, and he created many variations on this theme, mingling it with modern photographic images of Pope Pius XII. Typically, he knew the Velázquez only from reproduction, and never attempted to see the original even when in Rome for a protracted stay in 1954. It was almost as if seeing this powerful icon in the flesh, so to speak, would impair Bacon's creative freedom in exploiting the authoritarian father-figure, a figure he often satirized and used interchangeably with images of sober-clad businessmen in varying stages of psychological collapse.

Bacon's range of subject matter was comparatively limited within the orthodox categories, yet surveying his work, it is remarkable just how much he attempted: figure

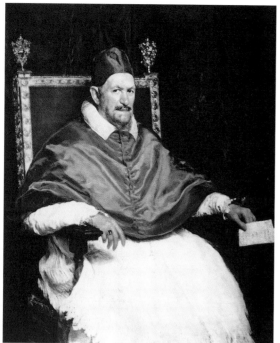

Diego Velázquez,
Portrait of Pope Innocent X

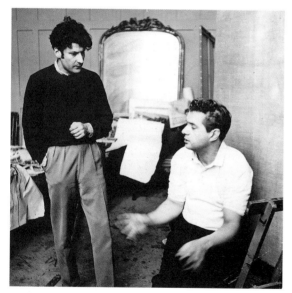

*Lucian Freud and Francis Bacon
in Bacon's studio, 1953*

painting, landscape, animals, and portraiture. Admittedly, his treatment of these themes was highly unorthodox, although his approach to them, in terms of conception and scale, was that of an old master. It is no accident that he wanted his paintings to be glazed and framed in heavy gold frames, so as to heighten their remote, iconic power. He admired the rich technique of artists as diverse as Titian, Velázquez, Rembrandt and Degas; their ability to handle paint (and pastel) sensuously was a challenge he accepted, and in much of his mature work he contrasted the treatment of the forceful central figures with their smooth, bland backgrounds. His adoption of the triptych format, traditionally associated with altarpieces, had a similar purpose, and although initially he rejected any attempt at sequential narrative, preferring each individual panel to be read (and hung) as an independent unit only loosely associated with its companions, a thematic unity does emerge in such work as the magnificent *Triptych, 1976* (Cat. no. 57).

When Bacon startled the London art world in 1945, he touched a collective raw nerve in the otherwise rather good-mannered ambience of English art at that time. While the prevailing mode of nostalgic neo-Romanticism practiced by artists such as Keith Vaughan, John Minton and John Craxton gave way during the 1950s either to the more rigorous abstraction of Nicholson, Pasmore, and the St. Ives School, or to the short-lived Kitchen Sink School of realist painters, Bacon pursued a different course. His disquieting imagery influenced the older artist, Graham Sutherland, with whom he became quite friendly, and when he taught briefly at the Royal College of Art in 1950, the students had already elevated him to the status of a cult-hero.[16] Bacon remained his own man, eschewing the expressionism of David Bomberg's Borough Group centerd around Frank Auerbach and Leon Kossoff, and the frivolity of the emerging Pop Art scene of the early 1960s. Like Lucian Freud, he remained essentially a figurative artist, but unlike his younger friend, his imagery was not drawn directly from the studio model or sitter, but at several removes, from a well-stocked visual memory filtered through the mysterious workings of a unique creative genius. In a very real sense, one must accept his contention that, at its most profound, his work is inexplicable, and that we see it through a glass darkly.

Francis Bacon at Work

BY MICHAEL PEPPIATT

"My whole life goes into my work."

— Francis Bacon (in conversation)

Francis Bacon in 1953

So many engaging stories now exist about Francis Bacon immersed in his pleasures, drinking, gambling, and generally carrying on until the small hours, that we forget how often he would close the studio door against any distraction and bring his prodigious powers of concentration to bear entirely on painting new pictures. Since he slept little and had boundless energy, Bacon found the time to amuse himself with great abandon as well as work hard. Even to close friends, he appeared to be always out on the town, holding court with Wildean wit and flamboyance in restaurant and bar; but while the habitués of the Soho drinking clubs he favored awoke and struggled to prepare themselves for another bout of excess, Bacon himself had already completed a full morning's stint in front of the canvas.

How Bacon did it — how he managed to drink immoderately for some fourteen hours a day, drifting from club to bar, leaving scores woozily incapacitated in his wake, and then focus on the hazardous process of bringing a new image into existence — remains a mystery. Bacon himself pretended he painted particularly well with a hangover. "My mind simply crackles with electricity after one of those evenings," he would announce with disarming simplicity to the dazed and pallid friends who had stayed the course with him. "I think the drink actually makes me freer," he sometimes added, rosy-cheeked and cheerful, as if he had consumed pure elixir in the last seedy outposts of the London night. Even his doctor, a close friend who had scrutinized the secrets of his constitution, could only point to Bacon's natural resilience and his ability to metabolize alcohol unusually fast. Whatever the alchemy that allowed him to transmute paralyzing amounts of drink into creative energy, this

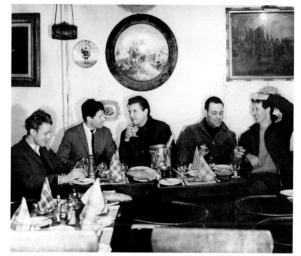

Francis Bacon and friends at Wheeler's Restaurant, Old Compton Street, London c. 1962. From left to right: Timothy Behrens, Lucian Freud, Francis Bacon, Frank Auerbach, Michael Andrews

regimen seemed to suit Bacon admirably. Invariably alert and mostly good-humored after the worst excesses, he would rise around six in the morning, paint until midday, then once more begin his round of the pubs and private drinking clubs of Soho. Since he was well-liked and open-handed, Bacon always fell in with various friends whom he treated to extravagant meals and the occasional session at one of his preferred gambling clubs; and it was rarely much before dawn that Bacon tumbled into a last taxi and went back to snatch two or three hours' sleep before facing up once more to his latest canvas.

This punishing routine was established early in Bacon's career, and he adhered to it

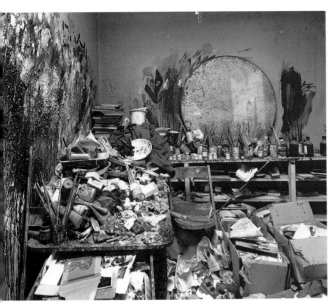

Francis Bacon's studio in 1992

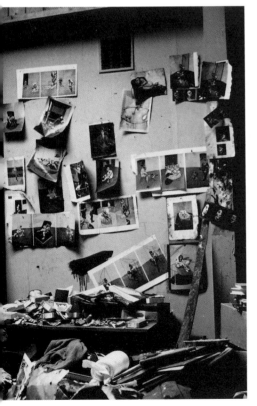

Francis Bacon's studio

even when elderly with a near-ascetic strictness. "You have to be disciplined in everything, even in frivolity," he once said in the course of a riotous dinner, raising his glass and adding pointedly, "above all in frivolity." Nevertheless there were periods, especially when a new exhibition loomed on the horizon, when Bacon barely stirred from the studio beyond keeping a few necessary appointments. Such periods were heralded by a gradual withdrawal from the usual round: an unwillingness to see the night out at the gambling tables and the almost apologetic repetition of phrases like "The thing is, for some reason, I do terribly want to work at the moment." Then the nonchalant drifting, the outrageous, champagne-fueled monologues and the hazardous promiscuity which Bacon relished were replaced by an iron determination to complete the number of pictures that had been building up in his mind and which he had promised to have ready by a certain date. For not the least paradox in this impulsive, loose-living bohemian, whose day-to-day existence seemed permanently to teeter on the edge of chaos, was that he strove to fulfil his commitments to the letter and would not spare himself until he had delivered his pictures on time.

To help him meet such deadlines, Bacon did follow a rudimentary plan. He would list, sometimes in sketchbooks, sometimes in one of the diaries London nightclubs used to send him assiduously, brief titles of the works he aimed to do — such as "Figure on bed" or "Man walking along street" — accompanied every now and then by the simplest possible outline of the overall image he had in mind. When the work was going well, Bacon reckoned to complete a large painting about every ten days, thus producing a full-scale triptych within a month. The process regularly included, of course, false starts and images that were partially executed, then abandoned and destroyed. After finishing a triptych, Bacon might relax for a while, resuming his forays into the bars, though this could have disastrous consequences. On several occasions Bacon returned at night, mightily drunk and convinced he could improve a panel he had recently finished, only to find, the morning after, that he had pushed the image too far and ruined it irretrievably. As a result, in later years, Bacon's dealers took the precaution of picking up a new picture the moment the artist told them it was ready.

During these bouts of intense concentration, Bacon usually made a point of not drinking at all. Cases of vintage champagne and claret, sent by admirers and collectors who knew his tastes well, would lie temptingly on the landing outside the studio, but they would not be opened unless the day's work was done and a friend had dropped in. "I almost never have a drink when I'm alone," Bacon once told me, as we cracked open a bottle, "even though there's always masses of stuff lying around here. I suppose in that sense I'm not what you might call a complete alcoholic." Similarly, Bacon ate relatively little while the painting mood was on him. Although a connoisseur of every delicacy and the most lavish meals that restaurants in London and Paris (his other favorite city) could provide, he would confine himself to the simplest foods, claiming that there was nothing in the world he really liked as much as a boiled egg. The rare friends invited to the studio during such work sessions might very occasionally be treated to the privilege of having Bacon cook for them. Then, in this strangest of domestic situations, with the

most violent imagery just offstage and the studio's chaos lapping at their feet, guests would be regaled by roast chicken, a bread sauce that had become a byword among Bacon's Parisian friends, and a sublime claret.

The Artist as Drifter

"I often wish I'd been more disciplined about work when I was young. But there it is, I've always been a late developer."

— Francis Bacon (in conversation)

Throughout the first half of his career, Francis Bacon was notoriously peripatetic, often changing his address after a few weeks and never settling anywhere for more than a year or two. The list of his known studios ranges right across Chelsea and South Kensington, reaching out to Battersea (as well as, later, to the East End), and stretching beyond London to such unlikely locations as Petersfield in Hampshire and Henley-on-Thames. On several occasions Bacon left England altogether, choosing the foreign cities, notably Monte Carlo and Tangier, he knew would cater best to his particular tastes and way of life.

Moving or at least fantasizing about the possibilities of moving occupied Bacon a great deal. When he was sixty-five, for instance, he realized a dream that had originated on his very first trip abroad as a youth in the 1920s: he took a studio in Paris, perfectly situated beside the Place des Vosges, and worked there in short bursts for over ten years. And at the very end of his life, with his young man's appetite for change miraculously intact, Bacon toyed with the idea of trying yet another location. By then he had tired of the Right Bank, but not of Paris, and he began to spend more time at old haunts in Saint-Germain-des-Prés, enthusiastically visiting whatever likely studios were on the market. But come winter, when his chronic asthma always worsened, he began to think fondly of warmer climates, even though he knew, from past experience on the Côte d'Azur and in North Africa, that strong sunlight had always hindered him from painting.

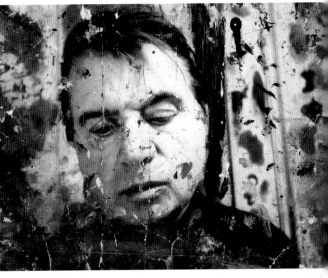

Francis Bacon in 1970

A degree of stability — a fixed place of work and some semblance of a working routine — is of course essential to any sustained creativity. For painters it is especially important, since their work depends so much on light, space, and having a specific range of materials to hand. How Bacon managed to work at all within this pattern of constant migration is as central and mysterious a question as how he produced a steady flow of paintings even when — one might say, especially when — his private life was at its most

chaotic and dissolute. One reason, quite clearly, was that for all his apparent wayward-ness, Bacon possessed an exceptionally strong sense of purpose. But although no amount of drifting and disorder could completely disrupt Bacon's driving need to paint, the lack of a permanent studio began to weigh very heavily on him when, after numerous failures and frustrations, he came resoundingly of age as a painter in 1944.

Three Studies for Figures at the Base of a Crucifixion, Bacon's first masterpiece, was painted, significantly enough, in the first stable environment that the artist had known since his father had ordered him to leave home some twenty years previously.[1] He had taken a lease on the studio once used by the Pre-Raphaelite painter, John Everett Mil-lais, at 7 Cromwell Place in South Kensington. There Bacon benefited from what was, for him, an unusually secure emotional situation, since he shared his new quarters at Cromwell Place with his old nanny, to whom had always felt closer than to his own mother, and an outwardly conventional, married man called Eric Hall, who had fallen disastrously in love with the young painter and abandoned his wife and children to move in with him. This bizarre ménage suited Bacon perfectly. His two older companions advantageously replaced his own parents, a frivolous, self-centered mother and a brutal disciplinarian of a father, and helped to some extent to heal his childhood traumas. By the same token this chosen "family" reinforced the extraordinary self-confidence Bacon required to come into his own and produce images of a violence never seen in English art before.

The painter Graham Sutherland, a close friend and mentor whom Bacon invited for what seemed, in the midst of postwar rationing, an exotic dinner of spaghetti with gar-

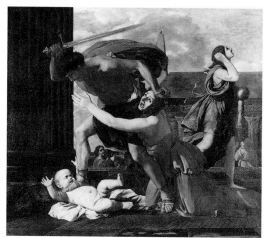

Nicolas Poussin,
The Massacre of the Innocents,
1630–31
Oil on canvas, 57⅞ × 67⅛9
Musée Condé, Chantilly

lic and walnuts, described the Cromwell Place studio as "a large chaotic place, where the salad bowl was likely to have paint on it and painting to have salad dress-ing." The main room, illuminated by a top light during the day and two huge Waterford crystal chandeliers at night, had that mixture of faded grandeur and will-ful mess which was to remain Bacon's preferred domestic style. Possibly in revolt against his recent experience as an interior decorator, Bacon had not hesitated as to how he should furnish the cavernous interior.[2] It was to be nothing but a studio: a couple of rather forlorn velvet sofas were put round the walls, but the central posi-tion, on a dais, was entirely taken up by his easel, his materials and his latest paint-ings. One of these, *Painting 1946,* with its grandiloquent, yet disturbingly familiar conflation of public authority and private carnage — a dictator garlanded with butcher's meat — was shortly to enter the collection of the Museum of Modern Art in New York. Its spell has not diminished over the years, and where once we thought we saw Mussolini haranguing an unseen crowd, we now discern memories of Major Bacon, the artist's overbearing military father, overlaid with ghost impressions of Velázquez's *Pope Innocent X,* the screaming mouths of the mother in Nicolas Poussin's *Massacre of the Innocents* (left) and the nurse in Eisenstein's *Battleship Potemkin* (see p. 13), as well as clinical photographs of diseases of the mouth, which Bacon had found, during his first stay in Paris in 1927, in a book of beautiful, hand-colored plates that he trea-sured for many years.

The comparative idyll of Cromwell Place was not to last. When Jessie Lightfoot, the adored nanny, died there in 1951, aged eighty, Bacon's world fell apart. Eric Hall had

already left, almost certainly because Bacon no longer wanted to continue a close liaison with him, and the whole raison d'être of that strange and cherished establishment had come to an end. Having let his lease go for next to nothing, Bacon proceeded for years thereafter to flit once more from studio to rented room to borrowed apartment, as if some inner conflict, grief or even guilt at his nanny's death, prevented him from coming to rest. The constant moves would have ruled out any extended bouts of work, and Bacon was as prompt as ever to destroy any picture with which he found the slightest fault. Yet some of his most haunting images — such as the naked figures coupled on the bed (1953) and as if melted into a single body in the grass (1954) — date from exactly this period.

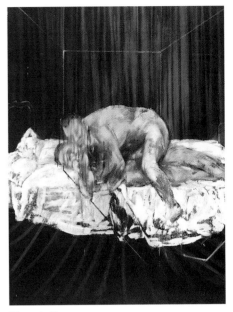

Francis Bacon,
Two Figures, *1953*
Oil on canvas, 60 × 45⁷/₈9
Private collection

Reece Mews,
Still Center of a Turning World

"I knew as soon as I walked in here that it was a place where I could really work."

— Francis Bacon (referring to his Reece Mews studio)

Bacon's wanderings grew even more disruptive for his work from 1956 onwards, when he began to visit his new lover, Peter Lacy, in Tangier. Although the visual impact of North Africa and the mores of the seedy city ("Interzone," as William Burroughs baptized it) could not fail to fascinate Bacon, his attempts to paint there were regularly frustrated. Neither the atmosphere nor the intensity of the light proved conducive to work, and most of the canvases that Bacon did complete during his long sojourns in Tangier were cut up by his lover during their frequent, drunken fights. Fortunately, Bacon had established a modicum of domestic stability in London by moving in with two friends who lived in a mansion block overlooking Battersea Park. There he had a room where he was allowed to strew the floor with the paint-spattered mess of books and photographs that served him so well as he moved to and from the easel, trying to encapsulate a bewildering range of ideas, influences, and impressions in a single image. Nondescript and ill-used, this room (brilliantly photographed at the time by Cecil Beaton) proved to be the prototype of the kind of space where Bacon worked best. Nevertheless, as he moved towards his fiftieth birthday and the pressures, both internal and external, to produce paintings grew steadily, Bacon became urgently aware that he needed a place of his own. After a brief search, he discovered a small mews house in South Kensington that seemed to provide both the space and the privacy he wanted. To many

Francis Bacon,
Two Figures in the Grass, *1954*
Oil on canvas, 59³/₄ × 469
Private collection

among its attractions for Bacon was the fact that it lay just behind the Cromwell Place studio to which he had been so attached. Inasmuch as the word was ever applicable in his case, Francis Bacon had come home.

For over ten years, Bacon had been exhibiting his work at the Hanover Gallery, run by Erica Brausen, who had become a close friend in spite of the habitual tensions between artist and dealer. In 1958, however, he signed an agreement with the Marlborough Fine Art, and his career suddenly accelerated. Bacon's successful first show with his new dealer prompted the idea of holding a retrospective of his work at the Tate Gallery in 1962. Vauntingly ambitious for his art and his reputation, Bacon knew that his entire professional future would depend on the exhibition's success, and he set about working for it with characteristic daring and determination. It was during these early months of concentrated creativity that the Reece Mews studio became the indispensable center of Bacon's existence. And for the rest of his life, even though he became rich enough to indulge in a succession of alternative studios, it was to this functional and seemingly charmless base that Bacon steadfastly returned.

If there was a certain magic to Reece Mews, it was because Bacon infused it with his eccentric individualism, while the power of the images that he had created there lingered perceptibly in the paint marks climbing in firework explosions of color up the studio walls and the visually riveting strew of images that lay ankle-deep on the floor. Whatever came Bacon's way, he transformed: the soulless apartment, the dyspeptic collector, the "rough trade," the gambling loss, the boring journey. All great artists are essentially transformers, of course, shaping everyday experience anew. The concept is certainly an essential key to understanding Bacon, who brought to everything he touched a metaphoric charge, drawn from a lifetime of turning accepted truths upside down, very much in the tradition of Oscar Wilde, and — devout modernist that he was — blending the most disparate sources to his purpose. Paradoxically enough, he achieved this with a minimum of means. What Bacon liked most about Reece Mews, which came to mirror the artist in all kinds of unforeseen ways, was its very ordinariness. He might have transformed it, as he had done as a young designer with his first studio, into a stylish showpiece, an arty space conducive to making and selling pictures. But he did nothing. The drab exterior remained untouched, indistinguishable from the other brick façades of the little converted carriage houses overlooking the cobblestone passage. Inside, a staircase as steep as a ship's ladder led to a bare landing with a basic kitchen and bathroom. On the right, it gave onto a large, low-ceilinged space that served as the studio; on the left, to a similar space that Bacon used as a bedroom-cum-living room. The latter was sparsely furnished with a bed, a large velvet-covered couch, and a big pine table, littered with books and letters. Apart from a rich Moroccan bedcover, a handsome French commode and a wall mirror with a spectacular starry smash in it, the room looked almost deliberately ordinary and comfortless.[3] There were no carpets on the plain wooden floors, no pictures on the whitewashed walls, and no shades on the lightbulbs that hung down like malevolently glowing fruit from the ceiling, heightening the sensation of defiance and threat that Bacon's own presence often radiated.

The relatively rare visitors whom Bacon welcomed to his lair were often taken into this room to savor a fine champagne. If they were very fortunate or if they had specific

business to transact with the artist, they might be taken across the landing into the studio to be shown a new painting. As time went on and Bacon grew more sought-after, the studio became increasingly a closed space. Bacon said he felt "inhibited" by having models or sitters present while he worked — adding that he did not wish to carry out in front of them the "injury" he felt his painting did to them. For a period in the 1950s he had in fact painted portraits directly from people sitting for him, and he himself may have been wounded by some of their reactions to the result (when Cecil Beaton showed dismay at the portrait that had been done of him, for instance, Bacon destroyed it without a word). Later Bacon claimed, simply and unanswerably, that he could capture the people he chose to portray better from memory, alone in the studio and referring time and again to photographs he had commissioned specially of them as a "dictionary" of their appearance.

As he grew older and more famous, Bacon deliberately fostered an aura of secrecy around his studio, exactly as he fostered an aura of mystery around his art. He had always regarded his working space as his one area of privacy, even when he was younger and less

protective of his image: it was, after all, a hallowed place where he practiced a form of magic, and he was categorical that no one should watch or film him as he made a picture. Paradoxically, although Bacon poured his most withering scorn on any form or semblance of religious belief, he had a near-religious approach to his own painting: at its most potent and effective, it was an activity that happened outside his control, so that he sought to lose control as he painted, to allow some greater force, rising perhaps from the well of the unconscious he believed to be the ultimate source of his imagery, to take over. In this, Bacon constantly invoked the power of chance, and he went through a distinct ritual (in painting as at the roulette table) to get this particular god on his side.

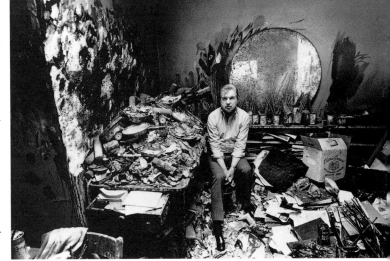

Francis Bacon in 1978

Bacon also manipulated the interpretation of his paintings to a similar, quasi-religious end. Although, with their population of screaming oppressors and flayed victims, with their swastikas and syringes, their mirrors and cages, they seemed to portend so much, Bacon decreed they meant nothing. He repeated it at every turn. "I'm not an Expressionist as some people say," he would declare archly. "After all, I have nothing to express." In the same vein, whenever an admirer pressed him for an explanation, he would retort: "I myself have no idea what they mean." Or again, once a friendly critic tried to get him to declare his debt to Surrealism, he cleverly sidestepped and confused the issue by asking, with nicely feigned wonder: "What in the end could be more Surreal than Aeschylus?" Their meaning, in a word, was that they suggested everything — from Greek myth to existentialist despair, medical deformity to Old Master grandeur — but meant nothing. Their very point was that they could not be defined, because once an image became defined, Bacon believed with an almost superstitious intensity, its power bled away. Thus he instinctively shrouded them, making them as suggestive but also as unknowable as possible, even though in many cases the paintings had specific links to his life and to certain visual impressions that Bacon preferred not to disclose. Indeed, another curious — if perfectly

understandable — contradiction in the artist was that he talked openly about some influences on his work, but remained secretive about others, as if some enlightenment, but only so much, would best serve the long-term potency of his troubling icons. The mystery had to be preserved, and the material correlative of Bacon's desire to seal it in hermetically was surely his insistence that all his paintings be kept in thick gilt frames under glass.

The Essence of Artifice

"I'm like a grinding machine. I've looked at everything and everything I've seen has gone in and been ground up very fine."

"Images breed images in me."

— Francis Bacon (in conversation)

Bacon had an unusual capacity for knowing what might be useful to him as an artist and absorbing that information very swiftly, even though he had had little schooling and no formal training of any kind. As a very young man, for instance, he made himself into a furniture designer and interior decorator within a few months; he also became sufficiently fascinated by Aeschylus's *Oresteia* to tackle such brilliant, but highly specialist and recondite commentaries on the Greek poet as W. B. Stanford's "Aeschylus in his Style." Both these experiences were to have a lasting effect on his whole conception and practice of art, but they were among an incalculable number of other influences. Although Bacon developed the most personal, instantly recognizable style imaginable, his painting drew its substance from the most diverse sources. Many of these, such as the influence of certain works of literature, are all but impossible to detect, but Bacon was undoubtedly a great reader, and he made much of the lasting impact certain authors had on him. In writing as in painting, what Bacon sought was the most concentrated form of expression: "the sensation without the boredom of its conveyance" or, as he put it even more succinctly, "a shorthand of sensation." Thus his favorite reading tended almost exclusively to the more concise literary forms, drama and poetry. Bacon's tastes, here as in painting, were for the great classics, but he was highly discriminating within each author's oeuvre, prizing *Macbeth* above all Shakespeare's plays, preferring early Eliot and late Yeats, but choosing *Ulysses* and even *Dubliners* over *Finnegans Wake*, since he thought Joyce had given his brilliant inventiveness too free a rein, making his last book almost "abstract" (the most damning adjective in Bacon's vocabulary).

New books, often sent by friends or by admiring authors, flowed into Bacon's studio, but usually he would take a glance and discard them, or offer them to someone else and return to the short list of books that he reread regularly. By his bedside there always seemed to be a copy of the *Oresteia*, along with Eliot's *Waste Land* (preferably the original version showing Pound's annotations), Van Gogh's *Letters*, and Proust in English or French. He read Freud with great fascination, admiring both his perceptiveness and his prose style while remaining skeptical about the benefits of psychoanalysis. Bacon occasionally suggested that some of his literary admirations had had more effect on his paintings than anything else. The sense of impending doom that comes through the *Oresteia* so powerfully certainly corresponded to something very specific in Bacon's own makeup. "Often in my painting," he once said to me, "I have this sensation of following a long call from Antiquity." As examples he referred to the hold certain phrases in Stanford's translation of Aeschylus had always had over his imagination: "It has these images in it that are so beautiful they've been with me ever since," Bacon continued. "'The reek of human blood smiles out at me' was one. Then there was another that described Clytemnestra sitting over her sorrow like a hen." Similarly, Bacon was deeply moved by what he called "the whole atmosphere of despair" in Eliot's poetry. And just as he paid direct homage to Aeschylus in the title of the great triptych he painted in 1981, so he had earlier commemorated Eliot's influence in *Triptych Inspired by T. S. Eliot's "Sweeney Agonistes"* of 1967.[4]

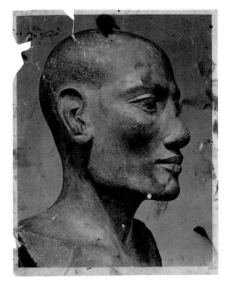

Photograph of an Egyptian bust of Pthames in the Leiden Museum, from Francis Bacon's studio

Bacon had as clearly defined a pantheon of artists as of writers, and again his admiration went out only to the greatest accomplishment from antiquity to modernism. He thought of Egyptian art not only as the source of Western tradition but as the grandest and most perfect form of human expression ever achieved. This was his touchstone, and he judged all subsequent art severely by its standards, continuously referring to certain Egyptian heads and figures. Comparatively few artists were admitted into Bacon's pantheon, and even they tended to be pared down to one or other aspect of their oeuvre as time went by. Michelangelo, for instance, was admired above all for his drawings of the male nude (which Bacon considered particularly "voluptuous") and Degas mainly for his pastels. Similarly, Picasso (the single greatest influence on Bacon) was praised without reservation for his so-called biomorphic images of 1927–29, but denigrated for his late work. Velázquez was perhaps the exception, though Bacon became obsessed by only one of the Spaniard's masterpieces, the portrait of *Pope Innocent X* (see p. 24), of which he made so many versions showing the pontiff at various stages of what looks like a protracted fit of screaming hysteria (Cat. no. 12).

Henri Michaux, India ink drawing, 1962

Bacon had numerous passing fancies in art, very much as he did in his private life. He would suddenly become fascinated by this or that contemporary artist, at times going so far as to buy a work. Although he never appeared to keep anybody else's painting for long and certainly never hung a picture on his living room walls, Bacon did acquire quite a variety of work over his lifetime. At one point, for instance, he bought an ink drawing by the Belgian-born painter-poet Henri Michaux (right), whose ability to conjure figures out of chance marks fascinated him for a while. Similarly, he encouraged the occasional younger artist by taking an interest, however passing, in his or her work. With age, Bacon reduced even his basic pantheon

passing, in his or her work. With age, Bacon reduced even his basic pantheon drastically. As Picasso shone above all for Dinard figure studies, so Giacometti, with whom Bacon had enjoyed a brief but important friendship, was admired almost exclusively for his drawings.[5] But throughout his long career Bacon underwent a wide variety of influences, even though he subsequently disavowed many of them. It seems clear — although Bacon would have rejected the notion out of hand — that Matisse had a central influence on his use of color as well as his articulation of space. And although Bacon would have disagreed quite violently, having made them the butt of his scorn for decades, the Abstract Expressionists surely opened up the way for him when he got to know their work in the late 1950s and began to use flat bands of color to form the background to his central image. At that time Bacon grew noticeably more spontaneous and fluid in his brushwork, making the occasional but distinct experiment with dripped paint.[6]

To talk and look at art with Bacon was a uniquely stimulating experience. He was categorical in his opinions and tolerated no dissent, but when he began to analyze what he admired in paintings that had been key to him, such as Monet's *Nymphéas* at the Musée de l'Orangerie or Goya's *La Junta* (left) in Castres, he gave unusual insights not only into the works themselves but also into his own aesthetic. What drew him to the *Nymphéas* was the ambiguity that allowed them to hover on the verge of abstraction while delineating sky, trees and lake — "a complete interlocking of subject and technique," in Bacon's words. And he grew lyrical about Goya's ability to depict light so skillfully that "you sense it weave between and somehow create all those figures that make up the 'Junta.'"

Webs of Allusion

"I think you have to break technique, break tradition to do something really new. You always go back into tradition, but you have to break it and reinvent it first."

— Francis Bacon (in conversation)

The astonishing litter that covered Bacon's studio floor contained old shoes, expensive art books, coagulated brushes, newspapers, paint-caked cashmere sweaters, the odd passport, reading glasses, acrylic sprays, and dinner plates or frying pans that had been pressed into service as palettes. But most noticeable were the masses of photographs, paint-strewn and crumpled, gazing out of the intensely visual mess with scores of urgent, conflicting messages. They were what Bacon liked to call

remain attentive to the way this extraordinary sea of athletes and animals, Old Masters and lovers, friends and newspaper disasters changed as he kicked a path through it. In a sense Bacon's entire imaginative life depended on this "heap of broken images" (he himself referred to it more sardonically as his "compost heap"); and although it would be naive to think he actually culled specific ideas from it, it created the atmosphere of visual excitement, with incongruous couplings and chance similarities, that stimulated his staccato attacks on the canvas.

Nowhere was Bacon's visual voracity more evident than in his lifelong fascination with every kind of photograph and reproduction (he often found his favorite paintings, by Velázquez, Van Gogh or Degas, more "stimulating" when reproduced). Many of his particular interests are well-known: the pioneering experiments of Muybridge and Marey, the "Picture Post" shots of Nazi leaders, the studies of birds in flight and animals of every kind, the boxers and cricketers (right, bottom). Bacon's eye liked to take in the most contrasting images at one and the same time, and in the mid-1950s he had a montage pinned up in his studio showing Goebbels, *Innocent X,* and Baudelaire juxtaposed with a closeup of the mouth and scene of a crowd fleeing during the Russian Revolution (see p. 12). It was not so much the "violence" suggested by many of these images that interested Bacon as the shock of their unexpectedness. I remember going over some photographs with him in the studio once, and when I asked him whether it was the sense of panic that had drawn him to the St. Petersburg crowds in flight, he explained how certain shapes in the moving mass of people put him in mind of quite different images, such as a buffalo charging. He also pulled out some innocuous-looking photos, like an army officer sitting in a deck-chair and a curious, little wooden hut with a stovepipe sticking through one wall (p. 36), simply saying: "I'm not sure why I keep these, but for some reason I always think I may use them some day." The more incongruous an image, the more Bacon tended to cherish it. He had always been fascinated, he said, by photographs of industrial filters, even though he had no idea what his interest meant, adding slyly: "Though I suppose, when you come to think of it, the human body itself is like a filter."

Bacon was very adept at manipulating the public's perception of him, and although he was in some respects a disarmingly candid man, he also tended to a certain secretiveness, letting people know only what he wanted them to know. Thus he insisted to all and sundry that he never drew, indeed that, never having received the proper training, he could not draw. As Bacon grew older, he discouraged any mention of the preparatory sketches a few people knew he did, just as he refused to have any work prior to his *Three Studies* of 1944 included in an exhibition. Since his death in 1992, a number of important new facts and documents have surfaced. Firstly, there is already abundant proof, not only that Bacon drew, but that some of his drawings have an admirable incisiveness and fluency. The figure studies reproduced here for the first time (p. 36) recall Michaux's India ink figures arising out of a series of apparently random marks, but they also communicate a tortured, willful energy that could only be Bacon's. They demonstrate at first hand the artist's desire to manipulate human frame and flesh almost out of recognition, in his belief that only by deforming the known facts could a new truth be revealed. Like most painters, Bacon in fact drew quite regularly to work out ideas and compositions

Page from Marius Maxwell's Stalking Big Game with a Camera in Equatorial Africa, *1924*

Second test match, India vs. England, Calcutta

The First Film Studio
14

For the Street and figure

ABOVE:
The first film studio

ABOVE CENTER:
Francis Bacon,
Ink sketches of figures

ABOVE RIGHT:
Page from book showing owl and
snake encoiled

BELOW LEFT:
Page from
De l'Angoisse à l'extase,
a book of clinical photographs

BELOW RIGHT:
Trotsky's study in Mexico after his
assassination, 1940

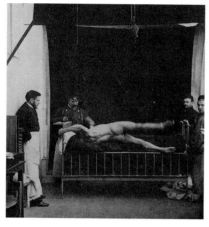

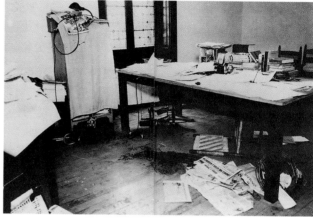

before he made his characteristic, initial outline of brushstrokes on canvas; even his diaries contain the occasional, very rudimentary sketch of a picture that he was turning over in his mind. The difference was that Bacon made a general point of scrapping his drawings, because he considered them as unaccomplished and certainly uninteresting. A few of those to have escaped being trashed have come to light — rapid notations in gouache and ballpoint pen that mostly relate to specific paintings; and it seems very probable that other batches of preparatory studies will resurface before long.

Similarly, several key photographs that Bacon kept in the studio have now surfaced.[7] Some of them, like the beautiful and terrifying image of an owl pouncing on a snake (above, upper right), fall into a well-known category of the artist's interests, but they say a great deal about Bacon's fascination with "double" images and the way one form dissolves into or suggests another. Particularly revealing is the interest he showed in the whole phenomenon of male hysteria. He had in fact bought a book of photographs of male patients in convulsions, photographed in the Salpêtrière Hospital in 1882, when Freud was studying under Charcot (above, lower left). Bacon had, of course, always shown a vivid interest in clinical photography, especially of pathological conditions. As a homosexual who enjoyed pushing intimate entanglements to a sadomasochistic extreme, he was certainly alive to every variation of emotional discharge; he frequently referred to his suicidal lover, Peter Lacy, as "completely hysterical, even mad at times." For the art historian, these photographs of male bodies in convulsions, arched like lovers on their iron bedsteads

or somersaulting like acrobats, provide fascinating comparisons with the artist's own studies of the naked body.[8] In Bacon's sardonic vision, one suspects, the act of love fundamentally resembled a hysterical fit for two.

Other photographs gathered from the Reece Mews studio floor have a demonstrable bearing on certain of Bacon's paintings. The photograph of Trotsky's room in Mexico at the time of his assassination (opposite) relates very clearly to the right-hand panel of *Triptych, 1986–87* (Cat. no. 70), a picture with uncharacteristically direct, almost unmediated photographic sources (the left-hand panel is a near-literal transposition of a photograph of Woodrow Wilson). More revealing, however, because of its totally unforeseeable origin, is a plate in a book called *Fundamentals of Soil Science* (right, bottom), which Bacon kept and, unaccountably enough, found sufficiently stimulating to incorporate almost unaltered into *Two Men Working in a Field* of 1971 (above). Other photographs still, such as a misshapen French woman in a hooped skirt (resembling everyone's nightmare Parisian concierge), remain distinctly puzzling. Was it purely the way the figure engulfs the chair's legs, becoming a kind of portmanteau image, a literal chairwoman, that fascinated the artist? Or was it the ghastly intimacy created by this strange creature, cooped up with her caged bird and her memories?

Bacon's paintings remain essentially ambiguous, and much of their force comes from the unanswered questions they trail behind them. Like the ancient oracles, they are open to quite contrary interpretations. Their origins have been masked and blended by a master artificer in combinations that became so much second nature to him that even he could not always tell the Muybridge from the Michelangelo, the lover from the anonymous athlete, the scream from the smile. That is their strength, the magic and power of their enigma.

ABOVE:
President Wilson leaving the Quai d'Orsay during the Versailles Conference, 1919

CENTER:
Francis Bacon, Two Men Working in a Field, *1971*

BOTTOM:
Page from Fundamentals of Soil Science

Three Interviews with Francis Bacon

BY MICHAEL PEPPIATT

Francis Bacon talked very much as he painted. He had a handful of big themes — life and death, love, and art — and he came back to them incessantly. He always thought, as with painting, that he might succeed in expressing his subject more brilliantly and concisely each time he got to grips with it. Bacon would return to a particular definition a dozen times or more in the course of an evening, looking for the single phrase that would sum it up and nail it down — if not for good, then at least until he felt like pouncing on it again.

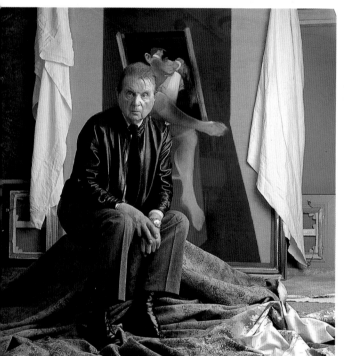

It was both a necessity and a game for him. "What's the good of talking at all," he would ask, opening his arms in a grandly rhetorical gesture, "if one can't make things a little clearer and more precise?" He talked as if he might be constantly on the edge of a revelation, as if by pushing this definition further and further he might arrive at an unassailable truth. But he also talked for the sheer pleasure of it, making pithy or dramatic statements about figure painting or homosexual love, then refining them until they could be reduced no further. In the process he used words, again very much like paint, without regard for convention, often willfully (but skillfully) combining them to see what random effects he might achieve. A sensation only became memorable, he believed, when it had found a memorable form; and he sought that perfect form both for his thoughts and his images with relentless energy. "What I really like," he once said, "are phrases that *cut* me."

Francis Bacon in 1989, aged 80

Much of the brilliance of Bacon's conversation came from his ability to yoke unlikely concepts together. He talked famously about wanting his pictures "to look as if a human being had passed between them, like a snail, leaving a trail of the human presence," and his hope that he would one day be able to paint the mouth as Monet painted a sunset. But although he visibly enjoyed his verbal prowess, allowing one bon mot to spark off a series of repeatable aphorisms, Bacon never strove for effect. Spontaneity was for him an essential condition for any kind of communication, in work as in talk. "I can't think anything more boring," I remember him saying as we extricated ourselves from a group of artistic "personalities" in a drinking club, "than those ghastly things who spend all morning rehearsing what they're going to say when they see each other at night."

Bacon was a great admirer of French literature, from Racine and Saint-Simon to Baudelaire and, above all, Proust. What he appreciated most keenly was their skill at analyzing human passion and behaviour, and he set out to distil his own reactions to life

with the same elegance and brevity. "After all," he might say (to give one instance), "who enjoys an unhappy love affair more than the spectator," or again: "I always think of friendship as where two people can really tear each other to pieces."

❖ ❖ ❖

My relationship with Bacon began in 1963 with an interview, and in a sense that interview continued until the artist died nearly thirty years later. I was always curious to know what Bacon was thinking, and since he enjoyed having a young admirer who knew his work and his world well, he usually opened up, even when he was hung over or in a foul mood, and talked unreservedly. Often our conversations would begin over a well-wined lunch at Wheeler's fish restaurant in Soho, a favorite haunt of Bacon's during the 1960s, then continue through a round of private drinking clubs before we went to dinner and more clubs or the occasional casino. A single séance might last for fifteen hours or so, with the talk constantly shifting in tone and emphasis and often becoming repetitive as the drink took over; but almost always a new facet of Bacon's personality, or several new facts about his life, would surface in the course of this extended odyssey from bar to restaurant and back again.

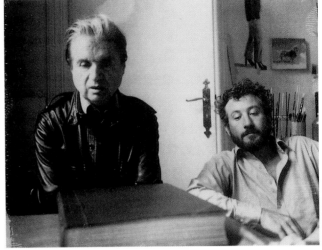

I never carried a tape recorder with me because I knew that the idea of going "on record" would automatically inhibit Bacon and I would not get the occasionally startling insights into his mind that the chance remark or memory opened up. So I made a habit of noting down the most salient things said in an evening (a task made easier by Bacon's habit of repeating himself and drumming his phrases home) as

Francis Bacon with Michael Peppiatt, photographed by David Hockney in his studio, Paris, c. 1975

soon as I got home, often adding to them the following morning as the mists of the inevitable hangover began to lift. Later, I would describe whole sessions with Bacon, in London or Paris, traveling in France or, on one occasion, in North Africa, in the diary that I kept for many years.

Nevertheless, however much both he and I preferred talking off the record, moving easily between gossip about mutual friends and the loftier themes of art and existence, there were times when a formal, or at least publishable, interview became necessary. The first one which I did with him, during the summer and autumn of 1963, was not recorded but built up over a period of several months. I was still a student and I had been editing an undergraduate magazine called *Cambridge Opinion.* Very little was being written about contemporary art in Britain at the time, and I thought it would be a

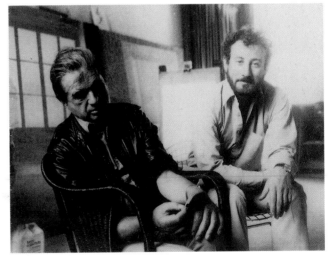

good moment to put together an issue on the subject. Bacon, who had had a retrospective exhibition at the Tate Gallery not long before, already dominated the art scene, so I decided naively enough to go down to London, lie in wait for him in his favorite Soho pub and ask for an interview. Instead of being rudely dismissive, as I had heard (with some trepidation) that he could be, Bacon was charm itself. He took me to lunch and

then on to a couple of Soho drinking clubs, and I enjoyed myself so much I began to go back to see him regularly, noting down the gist of our conversation each time until I had enough material for my magazine.

More than twenty years went past before I asked Bacon again to talk for publication. Our friendship had gone through many phases. I had moved to Paris, which Bacon had loved as a very young man and still considered the most desirable place on earth to live. Whenever I was in London or he came to Paris, we spent as much time as possible together. I had written an intimate portrait of him, which he encouraged at first, feeding me with all sorts of fascinating scraps of information, then later asked me not to publish — a change of mind that I accepted, although I was bewildered and deeply disappointed. I also found him a place to live and work in my *quartier,* and his regular, extended visits strengthened the bond between us. When I began publishing my own art magazine, *Art International,* Bacon immediately offered his support, and for the first issue, which came out in the autumn of 1987, he let me interview him.

The main subject of the interview was the group of painters, known as the "School of London," of which he was considered the nominal head. I had recently organized an exhibition on the theme, with Bacon's support, and it had included eight pictures of his. But being Bacon, the inveterate individualist passionately opposed to any notion of groups or movements, he nevertheless regarded the whole notion of a "School" as misguided. In his view, man, and above all the artist, remained irremediably alone. Something of the conflict between this conviction and the desire to be useful to a friend comes through in Bacon's clipped answers and veiled asides. But his tone, so different from the wide-ranging spontaneity that characterizes the first interview, also reflects the need Bacon felt later in life to control as closely as possible all information about himself and his work.

The desire to control seemed totally at odds in a person as provocatively iconoclastic and libertarian as Bacon. Yet it became an increasingly dominant force as he grew older and ever more famous. My third interview is a case in point. In 1989 *Art International* decided to devote a special issue to Bacon to honor the artist's eightieth birthday. Once again, Bacon had given his support. But when I arrived in his studio to record our talk before going to dinner, he appeared to forget that there had been any mention of an interview. Before too much champagne had been consumed, I nervously edged my tape recorder on to the table between us. "Oh — are we *doing* something," Bacon asked in a disapproving arch tone. I mumbled something to the effect that the special issue on him depended on it, and I asked the first question. To my despair, he said nothing. All that could be heard for two long minutes was the slight squeak of a tape turning to no purpose. Then mercifully, when I ventured a second question, Bacon began to talk. His replies were economic, not to say reductive; and once we had ranged over a number of topics, he made it clear he had said all he was prepared to say for publication.

We went to dinner, and the conversation soon returned to its old, unpredictable and frequently outrageous form. It was a pity, I felt, not to be recording the more unbuttoned, *je m'en foutiste* Bacon as he moved with theatrical flair from a definition of sexual jealousy to deftly savaging another painter's recent work. None of this, it seemed to me, had come through in our interview. A few days later, when I got down to editing the

material, I was astonished to find not only that we had covered a great deal of ground but that there was virtually nothing to change. Although Bacon had resisted the idea of talking on the record, he had nevertheless given a concise, word-perfect performance, clearly stating some of his fundamental attitudes. And, unpredictable to the last, Bacon telephoned me when the piece appeared and emphasized just how much he had enjoyed doing the whole thing.

(1) *Cambridge Opinion, 1964*

FROM A CONVERSATION WITH FRANCIS BACON

We can try to enjoy life — and hope to go on exciting ourselves in different ways. What else is there? To find this excitement one should be allowed the greatest possible freedom in order to drift. Valéry puts it very clearly: What we want nowadays is the sensation without the boredom of its conveyance. That's very precise, isn't it? Apart from that, we can watch our own decay in the interval that separates life from death.

You remember that steak we ate just now? Well, that's how it is. We live off one another. The shadow of dead meat is cast as soon as we are born. I can never look at a chop without thinking of death — that probably sounds very pompous. . . .

With Nietzsche I believe that man must remake himself. We shall woo the doctors and the scientists in the attempt to renew and alter ourselves, but there will be a lapse of time before their religious hangover will allow them to act freely.

The division between the sexes has to a large extent been invented. Only a comparatively small number of people are active within this division. The rest? They are waiting for something to happen or to be done to them. But society has attempted to make moral differences. We must have the freedom to drift and find ourselves again.

I have deliberately tried to twist myself, but I have not gone far enough. My paintings are, if you like, a record of this distortion. Photography has covered so much: in a painting that's even worth looking at the image must be twisted if it is to make a renewed assault upon the nervous system. And that is the peculiar difficulty of figurative painting now. I attempt to recreate a particular experience with greater poignancy in the desire to live through it again with a different kind of intensity. At the same time I try to retain the greatest possible tension between the original and the re-created experience. And then there is always the desire to make the game a little more complicated, to give the tradition a new twist. Abstract art is free fancy about nothing. Nothing comes from nothing. One needs the specific image to unlock the deeper sensations, and the mystery of accident and intuition to create the particular. Cézanne gradually formed a system out of his desire to trap the images which moved and excited him. Cubism was a kind of decoration on Cézanne — although it did create a few beautiful things. Now I want to do

portraits more than anything else because they can be done in a way outside illustration. It is a gamble composed of luck, intuition and order. Real art is always ordered no matter how much has been given by chance.

Man is haunted by the mystery of his existence and is therefore much more obsessed with the remaking and recording of his own image on his world than with the beautiful fun of even the best abstract art. Pop art is made for kicks. Great art gives kicks too, but it also unlocks the valves of intuition and perception about the human situation at a deeper level.

There is another way, I think, which could open up all sorts of possibilities, probably of a secondary intensity — kinds of organic forms made about the human and animal world. They have of course been suggested by many artists — Picasso, Brancusi, Moore — and I tried to do something of that kind in the *Three Figures at the Base of a Crucifixion*. Abstract and Pop art are a kind of middle way. But now more than ever there is nothing between the police record and real art which manipulates the facts of the record in a way which the particular can unlock and deepen the channels of intuition and sensation.

(The passages above have been condensed from a number of conversations between Francis Bacon and Michael Peppiatt that took place in August and December 1963.)

(2) Art International, 1987

FRANCIS BACON:
REALITY CONVEYED BY A LIE

BY MICHAEL PEPPIATT

The interview took place first in Francis Bacon's studio in London, then during a visit by the artist to *Art International* in Paris.

How is your latest triptych coming on?

It's impossible to tell about these things, of course, but it seems to have started well. It's based on that famous poem of Lorca's, you know, where the line "*A las cinco de la tarde*" keeps coming back. It's a very long and beautiful poem about his friend the bullfighter being killed. I haven't seen a bullfight for a long time — I must have only seen three or four of them in my lifetime — but when you have seen one, it remains in your mind forever.

It takes you back.

It goes back to very ancient times — right back to Mycenae, when they did that

athletic feat of jumping through a bull's horns. They're very, very different things, of course, but in that sense I find the Lorca poem extremely evocative.

Because it's about death?

It is about death. But it's about death in the sunlight, and for me that does conjure up all kinds of images. In the end, I doubt if the painting will have much to do with Lorca at all, but it's a starting point.

Degas talked about art, really accomplished art, being the "perfect crime." I suppose that means covering one's traces.

I love Degas. I think his pastels are among the greatest things ever made. I think they're far greater than his paintings. Some of the paintings are nothing in comparison, it's very curious. But to me Van Gogh got very close to the real thing about art when he said, I can't remember the exact words, it's in one of those extraordinary letters to his brother, which I read over and over again. "What I do may be a lie," he said, "but it conveys reality more accurately." That's a very complex thing. After all, it's not the so-called "realist" painters who manage to convey reality best. I mean, I saw an extraordinary picture by Monet in an art exhibition in London the other day. I'd never seen it before, even in reproduction. It was one of his views of the Thames, but you couldn't make anything out in the first instant because everything was covered with seagulls. It's the most extraordinarily inventive thing, and yet very real — a kind of fog of seagull wings over the Thames.

There's not much in contemporary art that interests you, is there?

There isn't, no. As I say, I thought Frank Auerbach a very remarkable painter, and I like Lucian Freud's new work a great deal. I've always admired Lucian's early portraits too, like the head in the Tate he did of me in 1952 — I'm not saying that because it's of *me*. But to find something that really interests me in this century I have to go back to Picasso. I don't like the late paintings, even though people are now saying they're among the greatest things he ever did. The period that interests me most is the late twenties and early thirties — you know, the beach scenes at Dinard where you see those very curious figures turning keys in the beach huts. And for me that is real realism, because it conveys a whole sensation of what it's like to be on the beach. They're endlessly evocative, quite beyond their being extraordinary formal inventions. They're like the bullfights. Once you've seen them they remain in the mind.

I thought of a "School of London" exhibition above all as a way of bringing these six artists together. But it seems to me that they come out of a certain epoch and milieu, and that they do interact.

To me it's not a "school" at all. I mean, I think perhaps the Americans had a school of Abstract Expressionism, but the last real school was the Impressionists, when there were a number of people attempting to do, not the same thing, but who were interested in the same aspects of color and way of conveying things.

Though that was a very loose association.
It was also very loose.

I mean to the extent that Degas had so little in common with Renoir or Cézanne. But there has been a great deal of interaction in this group. You have had a considerable influence, for instance.
I wouldn't have thought so.

The fact that you were painting powerful figures at a time when so many other artists had gone abstract was very important for the other painters in this exhibition.
I think the people in the School of London would have always been figurative. I don't think I had any influence at all.

But you showed the possibility of being figurative at a time when it was by no means an evident course to follow.
I don't think I have any link with them at all, beyond the fact of being one of six figurative painters . . .

When it comes down to it, I'm not sure that the word "school" means anything more than artists with a very general similar interest. When you think of the links between the Impressionists, some of them studied together, it's true, but then some of these six painters studied together . . .
Well, in a different way, because she had no money or anything, Helen Lessore played the part that Vollard did. And to that extent she only showed the people who interested her and she did make her gallery a place where those artists wanted to show when they were young.

It must have been thought of as pretty retrograde to do figures at that time.
Well, I don't know that it was really, because you've always had figurative painters all through, even when abstraction was going on. After all you had Giacometti, you had Balthus, you had Picasso. In fact, the most interesting painters have always remained figurative. It was really only the Americans who tried to take to real abstraction.

Auerbach and Kossoff, I think, saw themselves as being obsessed with something that had been discarded, that other people thought of as old hat.
I don't think it was that. When I first saw Frank Auerbach's work, I thought something really new and exciting was happening, and it was. They were marvellous heads in thick paint — but at the time he couldn't sell anything. I often wonder how many people have any kind of eye for painting. They buy when the artist is famous — and perhaps no longer doing his best work. But when there's something marvellous and new, they don't see it.

Do you think that painting generally has become more interesting in London? I personally think one would be hard put to find another six painters of comparable interest in another country. That's another reason for saying "school." It's to draw attention to the fact that London has become over

the past few years a center of art — for the first time ever, really. There's more invention here, isn't there?

Yes. I think there is. I mean, there's always been a lot of invention in this country, but not specifically in painting. It's generally gone into engineering or some other thing of that kind, but it just happens that a certain number of people have come along who are interested in painting. But this country has always been an inventive country.

Interest here seems to be much more centred on painting than it used to be, more so than when I lived here twenty years ago. Certainly when you compare it with the little that's going on elsewhere. Paris, for instance, seems incredibly dead as far as new pictorial invention is concerned.

But there's nothing new here either . . . What I do feel is that figuration — painting — will take on tremendous vitality once again, now that we've been through that very depressing, decorative period of abstraction. Not only in England, but anywhere. I think it will come about.

Well, curiously, people seem absolutely fascinated by painting. Otherwise, I suppose, there wouldn't be those huge queues outside the museum and the huge prices.

Well, they are fascinated by painting because of the enormous prices. That's one of their reasons. I'm not saying that that's why the painters are fascinated, but the public are.

Perhaps the prices are the result of something. Perhaps there is a real fascination. I don't think people go to museums simply because they know that certain pictures are worth millions of dollars. I think there's a real fascination, the way there is in football fans at soccer matches. It draws them.

I think it's lots of passing the time too. I mean, I think that football fans are much more enthusiastic when they go to matches than when people go to galleries.

Well they don't actually cheer — and they can't have a good fight.

Not yet.

They leave that up to the artists.

(3) Art International, 1989

AN INTERVIEW WITH FRANCIS BACON: PROVOKING ACCIDENTS PROMPTING CHANCE

BY MICHAEL PEPPIATT

The following interview was recorded in Francis Bacon's London studio earlier this year.

You told me recently that you'd been to the Science Museum and you'd been looking at scientific images.

> Yes, but that's nothing of any interest. You see, one has ideas, but it's only what you make of them. Theories are no good, it's only what you actually make. I had thought of doing a group of portraits, and I went there thinking that, amongst various things, I might find something that would provide a grid on which these portraits could be put, but I didn't find what I wanted and I don't think it's going to come off at all.

Are there certain images that you go back to a great deal, for example Egyptian images? You look at the same things a lot, don't you?

> I look at the same things, I do think that Egyptian art is the greatest thing that has happened so far. But I get a great deal from poems, from the Greek tragedies, and those I find tremendously suggestive of all kinds of things.

Do you find the word more suggestive than the actual image?

> Not necessarily, but very often it is.

Do the Greek tragedies suggest new images when you reread them, or do they just deepen the images that are already there?

> They very often suggest new images. I don't think one can come down to anything specific, one doesn't really know. I mean you could glance at an advertisement or something and it could suggest just as much as reading Aeschylus. Anything can suggest things to you.

For you, it's normally an image that is suggested though, it's not sound, it's not words sparking off words. Words spark off images.

> To a great extent. Great poets are remarkable in themselves and don't necessarily spark off images, what they write is just very exciting in itself.

You must be quite singular among contemporary artists to be moved in that way by literature. Looking at, for example, Degas, doesn't affect you?

No. Degas is complete in himself. I like his pastels enormously, particularly the nudes. They are formally remarkable, but they are very complete in themselves, so they don't suggest as much.

Not so much as something less complete? Are there less complete things which do? For example, I know you admire some of Michelangelo's unfinished things. And recently you were talking about some engineering drawings by Brunel and it sounded as though you were very excited by them.

In a certain mood, certain things start off a whole series of images and ideas which keep changing all the time.

Is there a whole series of images that you find haunting? There are specific images, aren't there, that have been very important to you?

Yes, but I don't think those are the things that I've been able to get anything from. You see, the best images just come about.

So that's almost a different category of experience.

Yes, I think my paintings just come about. I couldn't say where any of the elements come from.

Did you ever experiment with automatism?

No. I don't really believe in that. What I do believe is that chance and accident are the most fertile things at any artist's disposal at the present time. I'm trying to do some portraits now and I'm just hoping that they'll come about by chance. I want to capture an appearance without it being an illustrated appearance.

So it's something that you couldn't have planned consciously?

No. I wouldn't know it's what I wanted but it's what for me at the time makes a reality. Reality, that is, that comes about in the actual way the painting has been put down, which is a reality, but I'm also trying to make that reality into the appearance of the person I'm painting.

It's a locking together of two things?

It's a locking together of a great number of things, and it will only come about by chance. It's prompted chance because you have in the back of your mind the image of the person whose portrait you are trying to paint. You see, this is the point at which you absolutely cannot talk painting. It's in the making.

You're trying to bring two unique elements together.

It has nothing to do with Surrealist idea, because that's bringing two things together which are already made. This thing isn't made. It's got to be made.

But I mean that there is the person's appearance, and then there are all sorts of sensations about that

particular person.

I don't know how much it's a question of sensation about the other person. It's the sensations within yourself. It's to do with the shock of two completely unillustrational things which come together and make an appearance. But again it's all words, it's all an approximation. I feel talking about painting is always superficial. We have lost our real directness. We talk in such a dreary, bourgeois kind of way. Nothing is ever directly said.

But are there things that really jolt you? I know you love Greek tragedy, Shakespeare, Yeats, Eliot and so on, but do odd things, like newspaper photographs, jolt you every now and then?

I don't think photographs do it so much, just very occasionally.

You used to look at photographs a lot. Do you still look at books of photographs?

No. Dalí and Buñuel did something interesting with the *Chien andalou,* but that is where film is interesting and it doesn't work with single photographs in the same way. The slicing of the eyeball is interesting because it's in movement . . .

But is your sensibility still "joltable"? Does one become hardened to visual shock?

I don't think so, but not much that is produced now jolts one. Everything that is made now is made for public consumption and it makes it all so anodyne. It's rather like this ghastly government we have in this country. The whole thing's a kind of anodyne way of making money.

I suppose one doesn't have to be jolted as such to be interested, to be moved. One can be persuaded or convinced by something without it actually shocking one's sensibility. And I am sure that people have come to accept images that begin by seeming extremely violent, war pictures for instance.

They are violent, and yet it's not enough. Something much more horrendous is the last line in Yeats' "The Second Coming," which is a prophetic poem: "And what rough beast, its hour come round at last, /Slouches towards Bethlehem to be born?" That's stronger than any war painting. It's more extraordinary than even one of the horrors of war pictures, because that's just a literal horror, whereas the Yeats is a horror which has a whole vibration, in its prophetic quality.

It's shocking too because it's been put into a memorable form.

Well, of course that's the reason. Things are not shocking if they haven't been put into a memorable form. Otherwise, it's just blood spattered against a wall. In the end, if you see that two or three times, it's no longer shocking. It must be a form that has more than the implication of blood splashed against a wall. It's when it has much wider implications. It's something which reverberates within your psyche, it disturbs the whole life cycle within a person. It affects the atmosphere in which you live. Most of what is called art, your eye just flows over. It may be charming or nice, but it doesn't change you.

Do you think about painting all the time, or do you just think about things?

I think about things really, about images.

Do images keep dropping into your mind?
Images do drop in, constantly, but to crystallize all these phantoms that drop into your mind is another thing. A phantom and an image are two totally different things.

Do you dream, or remember your dreams? Do they affect you at all?
No. I'm sure I do dream but I've never remembered my dreams. About two or three years ago I had a very vivid dream and I tried to write it down because I thought I could use it. But it was a load of nonsense. When I looked at what I'd written down the next day, it had no shape to it, it was just nothing. I've never used dreams in my work. Anything that comes about does so by accident in the actual working of the painting. Suddenly something appears that I can grasp.

Do you often start blind?
No, I don't start blind. I have an idea of what I would like to do, but, as I start working, that completely evaporates. If it goes at all well, something will start to crystallize.

Do you make a sketch of some sort on the canvas, a basic structure?
Sometimes, a little bit. It never stays that way. It's just to get me into the act of doing it. Often, you just put on paint almost without knowing what you're doing. You've got to get some material on the canvas to begin with. Then it may or may not begin to work. It doesn't often happen within the first day or two. I just go on putting paint on, or wiping it out. Sometimes the shadows left from this lead to another image. But, still, I don't think those free marks that Henri Michaux used to make really work. They're too arbitrary.

Are they not conscious enough, not willed enough?
Something is only willed when the unconscious thing has begun to arise on which your will can be imposed.

You've got to have the feedback from the paint. It's a dialogue in a strange sense.
It is a dialogue, yes.

The paint is doing as much as you are. It's suggesting things to you. It's a constant exchange.
It is. And one's always hoping that the paint will do more for you. It's like painting a wall. The very first brushstroke gives a sudden shock of reality, which is cancelled out when you paint the whole wall.

And you find that when you start painting. That must be very depressing.
Very.

Do you still destroy a lot?

Yes. Practice doesn't really help. It should make you slightly more wily about realizing that something could come out of what you've done. But if that happens . . .

You become like an artisan?

Well, you always are an artisan. Once you become what is called an artist, there is nothing more awful, like those awful people who produce those awful images, and you know more or less what they're going to be like.

But it doesn't become any easier to paint?

No. In a way, it becomes more difficult. You're more conscious of the fact that nine-tenths of everything is inessential. What is called "reality" becomes so much more acute. The few things that matter become so much more concentrated and can be summed up with so much less.

Francis Bacon: Catalogue

BY DENNIS FARR

All measurements are given first in inches and then centimeters; height precedes width.

Under "Lit:" only the essential references are given; under "Exh:" only the first exhibition
in which the painting was shown (if known), and subsequent major retrospective exhibitions are given.

1. CRUCIFIXION, 1933
OIL ON CANVAS, 24¾ × 18½ INCHES (60.5 × 47 CM)
LIT: R + A 6
EXH: *ART NOW,* MAYOR GALLERY, LONDON, OCT. 1933 (2);
PARIS + MUNICH 1996–7 (1)
PRIVATE COLLECTION

The influential critic and theorist of modern art, Herbert Read, reproduced a photograph
of this work in *Art Now,* published in 1933, and it became the best-known of Bacon's
early paintings. It was bought by telegram from the Mayor Gallery, on the strength of
the reproduction, by Sir Michael Sadler, who also later acquired two further Crucifixions
of the same year. As Sadler was not only the foremost collector of contemporary art in
England, but the first private collector to buy the artist's pictures, this support much
encouraged Bacon and marked his first success as a painter. In 1946 it was acquired by
Sir Colin Anderson, shipowner and a noted patron of British artists.

Sadler later sent Bacon an X-ray of his skull, which the artist incorporated as a form
of "portrait" in a Crucifixion (see p. 23). The ghostly, shadowy image of the body, exe-
cuted against a dark background in impasted grisaille, suggests an X-ray plate. The
skeletal forms, enveloped in a veil-like penumbra, seem to float in space, and already
Bacon is using a tentative, cagelike structure to suggest three-dimensional space.

Although most of the other Bacon paintings shown at the two Mayor Gallery group
exhibitions in 1933 were destroyed, contemporary reviews suggest that *Crucifixion* was
typical of the artist's style at this time.

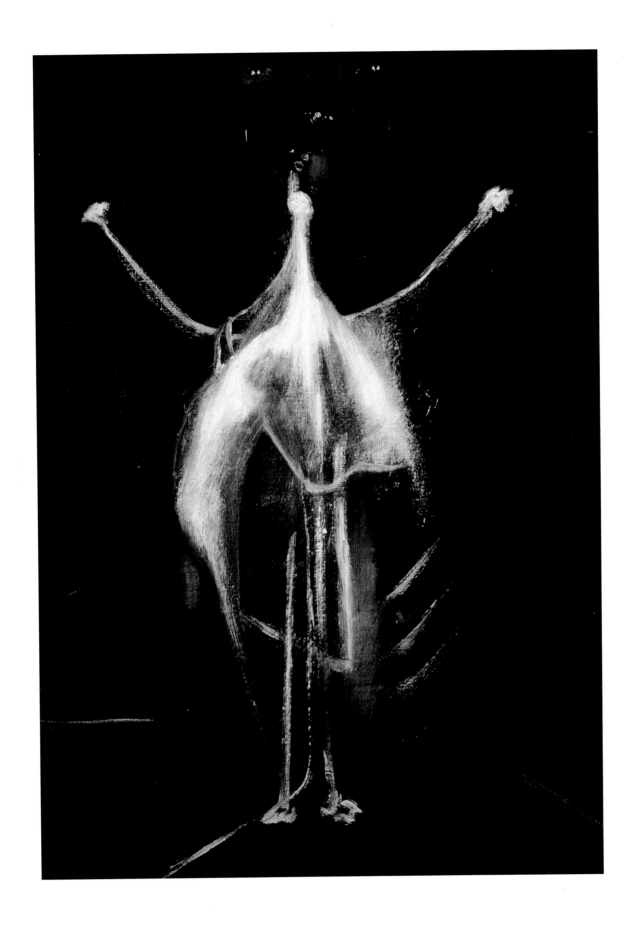

2. UNTITLED,

1943 OR 1944
OIL ON BOARD, 37 × 29⅛ INCHES (94 × 74 CM)
EXH: LONDON 1998 (1)
PRIVATE COLLECTION

A hitherto unrecorded and unpublished variant of the right-hand panel of the triptych, *Three Studies for Figures at the Base of a Crucifixion,* 1944 (Tate Gallery; see p. 11), this was first shown at the Hayward Gallery, London, in the *Francis Bacon: The Human Body* exhibition, 5 February–5 April 1998. It is the same size as the Tate panels, and contains the same basic elements of a gaping-mouthed, serpentlike figure perched on a stiltlike arm/leg, which rests on a patch of coarse grass. In the Tate version, a second supporting limb, seen in shadow, is bled off to the right, whereas here it stands free, though still in shadow. Unlike the Tate version, however, the monster sucks greedily at a bunch of flowers (roses?), which seem to be proffered by an unseen hand. There are also minor differences in the framing lines in the background — the deep orange color of which is modified by broader areas of lighter yellow-orange in the foreground on either side of the creature's limbs — from those that occur in the Tate picture. Bacon has, in effect, simplified the final composition to achieve a more dramatic impact.

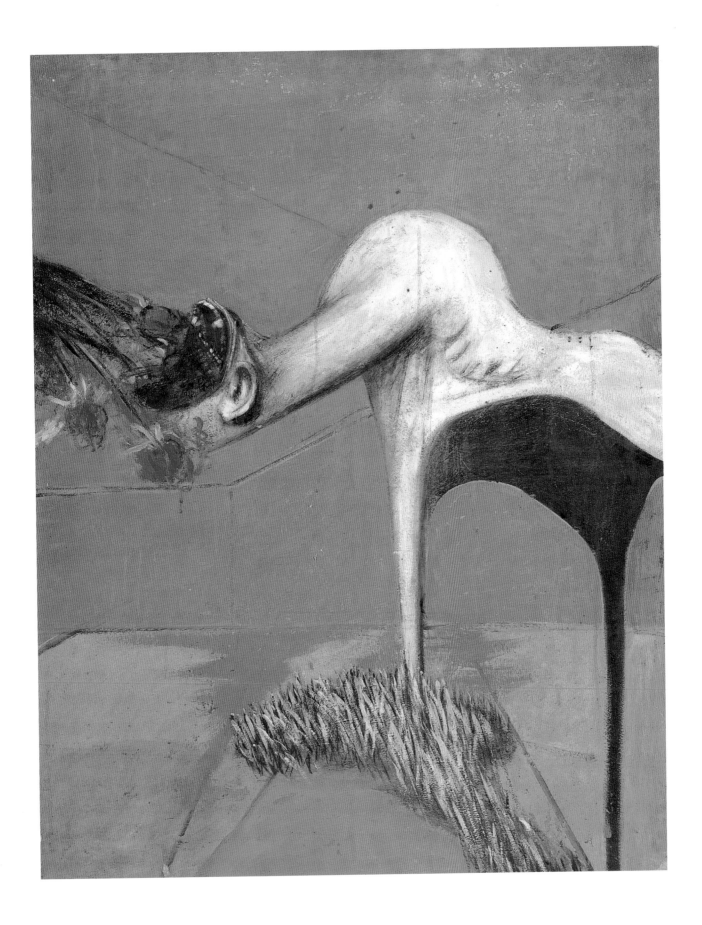

3. FIGURE STUDY II, 1945–46

OIL ON CANVAS, 57¼ × 50¾ INCHES (145 × 128.5 CM)

LIT: R + A 18

EXH: *RECENT PAINTINGS BY BEN NICHOLSON, GRAHAM SUTHERLAND . . . JULIAN TREVELYAN*, LEFEVRE GALLERY, LONDON, FEB. 1946 (15); PARIS 1971–2 (3); TOKYO 1983 (2); TATE 1985 (4); PARIS + MUNICH 1996–7 (7); LONDON 1998 (2) KIRKLEES METROPOLITAN COUNCIL, HUDDERSFIELD ART GALLERY, HUDDERSFIELD, ENGLAND

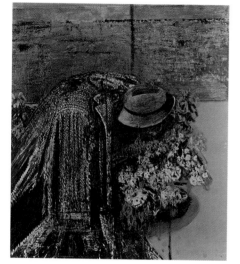

Francis Bacon, Figure Study 1, *1945–6*
Scottish National Gallery of Modern Art

Figure Study II belongs to a series of variations on the theme first announced in *Three Studies for Figures at the Base of a Crucifixion* of 1944 (Tate Gallery), which created a sensation when it was first exhibited at the Lefevre Gallery, London, in April 1945. Although given a religious connotation, Bacon has said that he was inspired by the vengeful Erinyes, or Furies, who pursued Orestes in Aeschylus's tragedy, the *Oresteia*. Nevertheless, the allusion to Christ's Crucifixion has persisted in so far that *Figure Study I,* 1945–6 (Scottish National Gallery of Modern Art) was known as "Study for a Human Figure at the Base of the Cross," and its pendant, *Figure Study II,* was called "The Magdalen." Bacon categorically rejected these allusions.

The open mouth of the woman, if less raw than the hideous, half-animal, bared teeth of two of the snarling creatures in *Three Studies,* conveys in subtler style the mood of anguished tragedy set, incongruously, in an anonymous palm-fronded foyer to a private hell.

Figure Study II is larger than *Figure Study I,* and although less thickly impasted, it has the same strident orange background and indeterminate space. The woman's gaping mouth is a distant echo of the shrieking mother in the foreground of Poussin's *Massacre of the Innocents,* which had so impressed Bacon when he first saw it at the Musée Condé, Chantilly, in 1927.[1] Bacon told David Sylvester that "I've had a desire to do forms, as when I originally did three forms at the base of the Crucifixion. They were influenced by the Picasso things which were done at the end of the twenties. And I think there's a whole area there suggested by Picasso, which in a way has been unexplored, of organic form that relates to the human image but is a complete distortion of it."[2] The detailed rendering of the herringbone tweed coat draped over the back of the kneeling figure heightens the sense of mystery, and this incongruous juxtaposition of carefully defined but seemingly unrelated objects is a device that had often been used by the Surrealists. David Mellor also draws attention to Bacon's appropriation of the pose of the classically-draped sculpted mourner, so common in late seventeenth- and eighteenth-century funerary sculpture, but transformed by twentieth-century dress.[3]

1. Bacon-Sylvester, *Interview 1* (1962), p. 35.
2. Ibid., p. 3.
3. Mellor in Venice, 1993, pp. 97–98.

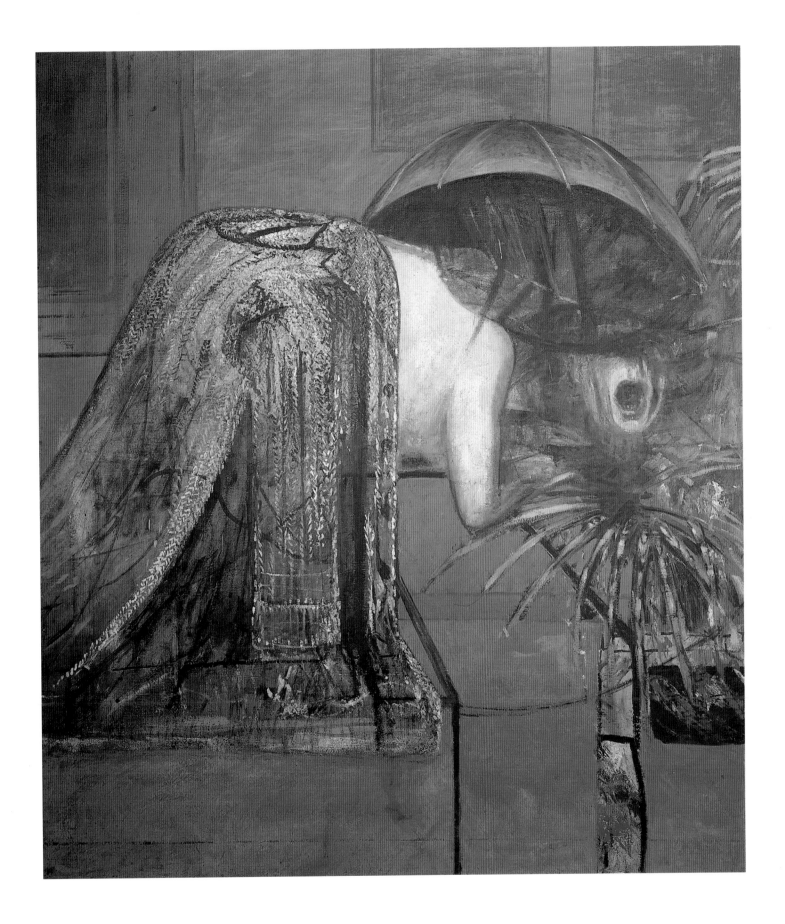

4. HEAD I, 1948

OIL AND TEMPERA ON HARDBOARD, 39½ × 29½ INCHES (100 × 75 CM)
LIT: R + A 20; PEPPIATT 1996, PP. 127–29.
EXH: *SUMMER EXHIBITION,* REDFERN GALLERY, LONDON, JULY–SEPT. 1948 (161);
TATE 1985 (6); PARIS + MUNICH 1996–7 (8)
RICHARD S. ZEISLER COLLECTION, NEW YORK

One of a series of six heads shown at the Hanover Gallery in November–December 1949, of which this was the first, probably painted in 1948 (or 1947–48), the others in 1949. There are echoes of Grünewald here, but the work could equally well have been triggered by press photographs. Bacon said that his paintings were not intended to have a precise meaning: "They are just an attempt to make a certain type of feeling visual. . . . Painting is the pattern of one's own nervous system being projected on the canvas."[1] This work is executed in heavy impasto, about which Bacon remarked: "One of the problems is to paint like Velázquez, but with the texture of a hippopotamus skin."[2] He also recalled that "There was an early one of a head against curtains. It was a small picture, and very, very thick. I worked on that for about four months, and in some curious way it did, I think, perhaps, come through a bit."[3] Of his fascination with open mouths, he remarked: "I've always been very moved by the movements of the mouth and the shape of the mouth and the teeth . . . I like, you may say, the glitter and color that comes from the mouth, and I've always hoped in sense to be able to paint the mouth like Monet painted a sunset."[4]

In *Head I,* Bacon deliberately exploits the ambiguous relationship between the hanging tassel and the ear to suggest, at first glance, that the head is hooked by it and painfuly yanked sideways. There is also the suggestion of a corner of a room and a railed headboard.

1. "Survivors," *Time,* LIV, 21 Nov. 1949, p. 28, quoted in R+A p. 42.
2. Ibid.
3. Bacon-Sylvester, *Interview 1* (1962), p. 18.
4. Bacon-Sylvester, *Interview 2* (1966), pp. 48–50.

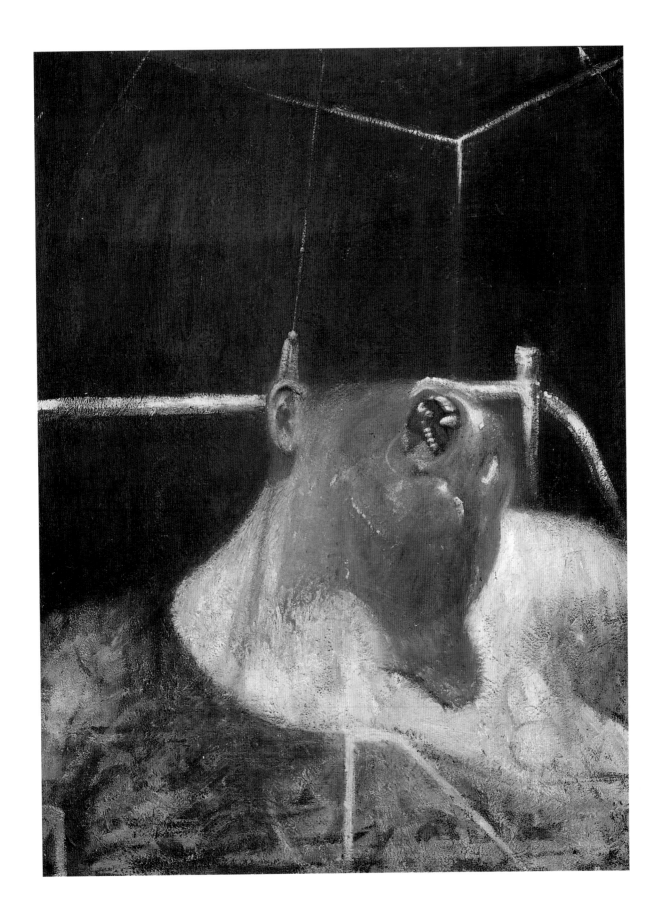

5. STUDY FOR PORTRAIT, 1949
OIL ON CANVAS, $58^{3}/_{16} \times 51^{7}/_{16}$ INCHES (148 × 130.7 CM)
LIT: R + A 27
EXH: *FRANCIS BACON,* HANOVER GALLERY, LONDON, NOV.–DEC. 1949 (12);
TATE 1985 (11); PARIS + MUNICH 1996–7 (12, SHOWN ONLY IN MUNICH)
COLLECTION MUSEUM OF CONTEMPORARY ART, CHICAGO. GIFT OF JOSEPH AND
JORY SHAPIRO

Shown at Bacon's first one-man exhibition at the Hanover Gallery in 1949, along with the series of six *Heads,* these paintings, with their cruel distortion of the human form, provoked a horrified reaction from the public. They can be linked with the series of popes based on the famous Velázquez portrait of Innocent X and the image of the screaming nurse in Eisenstein's film, *The Battleship Potemkin* (1925), which Bacon probably first saw in Berlin in 1927. Once again, Bacon focuses our attention on the open mouth from which no sound escapes; Hugh Davies has suggested the analogy of a radio announcer confined within a studio box, but whose shouting voice and trembling hands convey the atmosphere of a harsh interrogation worthy of George Orwell's novel, *1984.*[1] John Russell has also seen the glass box, which loosely defines the space inhabited by this anonymous victim, as prefiguring the look of Adolf Eichmann in his glass cage.[2] The indistinct outline of a figure, which appears as a cast shadow in blue along the bottom foreground, heightens the air of menace, although, as always, Bacon refused to acknowledge any illustrative "story-line" in his work.[3]

The spatial ambiguities in this painting are deliberately compounded by Bacon's use of a grayish-green background color, which on the left merges with a vertical strip of similar hue at the top, only for it to change to a warm orange-brown at the base, the same orange-brown with which he has painted the "interior" of the glass booth.

The painting, once known as *Man in a Blue Box,* seems to be a paradigm for the human predicament, and this anguished, tormented soul appears in other guises throughout Bacon's early work.

1. Davies 1978 (Ph.D. thesis published by Garland), p. 88, cited by Anna Hiddleston in Paris + Munich 1996–7.
2. Russell 1971–93, p. 68, and ibid.
3. Bacon- Sylvester, *Interview 1* (1962), p. 23.

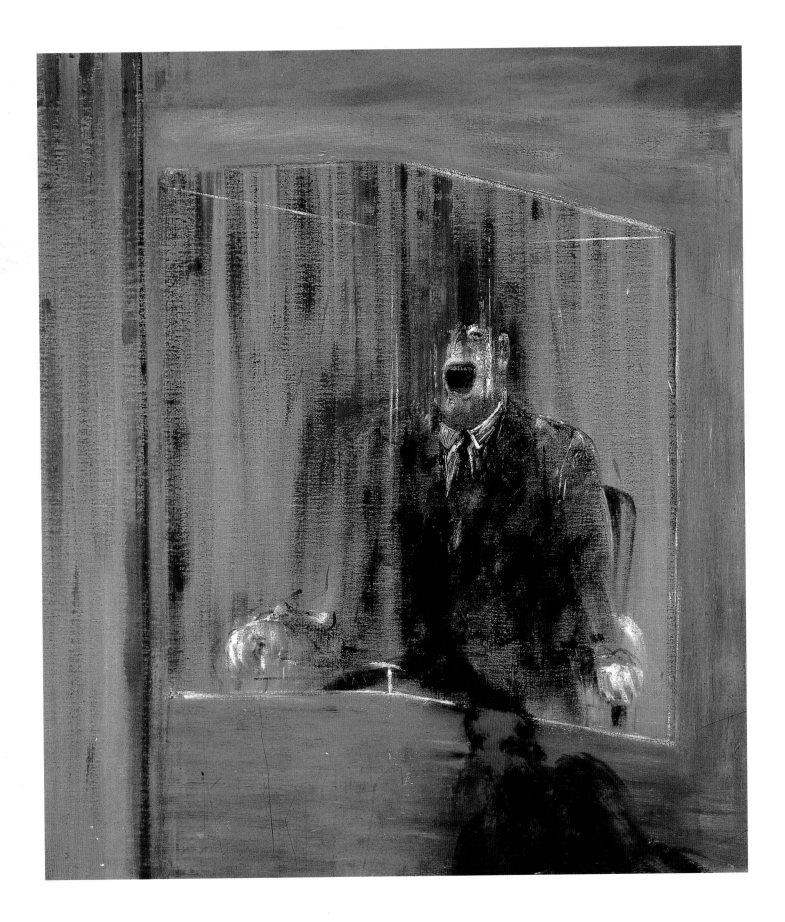

61

6. STUDY FOR A NUDE, 1951
OIL ON CANVAS, 78 × 54 INCHES (198 × 137 CM)
LIT: R + A 32
EXH: *FRANCIS BACON,* HANOVER GALLERY, LONDON, DEC. 1951–FEB. 1952
(NO CAT.); TATE 1962 (13); LUGANO 1993 (10); VENICE 1993 (7); *BACON-FREUD:*
EXPRESSIONS, FONDATION MAEGHT, SAINT-PAUL, 4 JULY–15 OCT. 1995 (1);
PARIS + MUNICH 1996 (15); LONDON 1998 (5)
THE COLLECTION OF SAMUEL AND RONNIE HEYMAN

Although Bacon always insisted that he did not draw and, by implication, did not make preparatory studies, there is evidence that he brushed in broad outlines of a composition directly onto the canvas. In this instance, a preliminary idea for the curtain background appears in a photograph of a woman jumping a hurdle, over which Bacon has boldly brushed vertical lines and a rectangular frame so as to enclose and focus attention upon the jumping figure.[1] He uses the curtain to frame the shadowy crouching figure, half-human, half-monkey, in this painting, which is based on an Eadweard Muybridge photo in *The Human Figure in Motion* (1887),[2] and he retains the calibrated bar, which appears in the Muybridge photo. "I've always wanted to paint curtains. I love rooms that are hung all round with just curtains hung in even folds."[3] The forms of the crouching figure are deliberately left indistinct, as if to suggest "memory traces," which here relate to a primitive, ancestral memory of man's animal origins.[4]

1. Paris + Munich 1996, pp. 104–5, 235. The book was Hans Surén,
Man and Sunlight (1927).
2. See also *Study for Crouching Nude* 1952 (below, no. 8)
3. Russell 1971–93, p. 35.
4. Jill Lloyd and Michael Peppiatt, Lugano 1993, sv. 10.

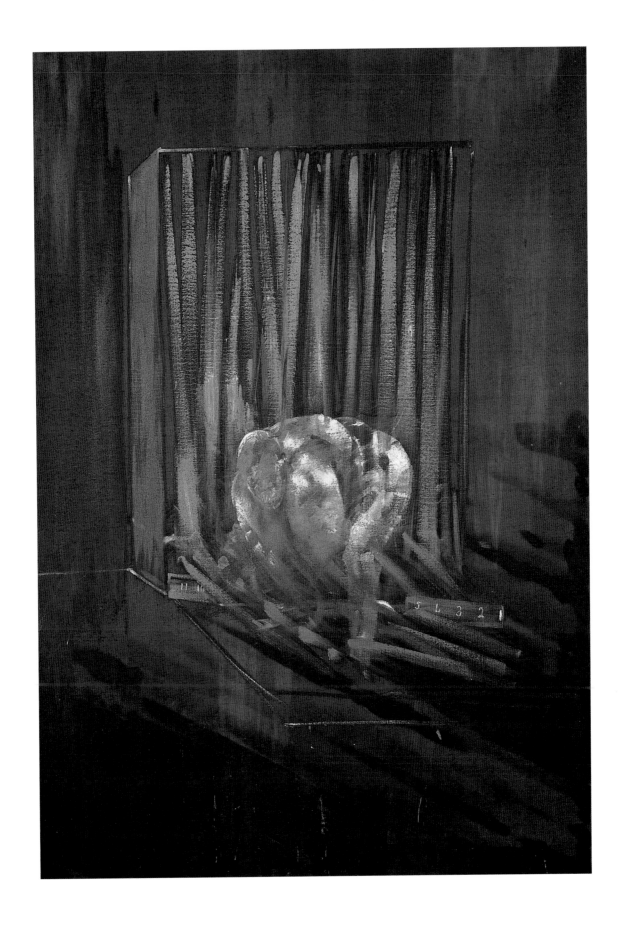

7. POPE I, 1951

OIL ON CANVAS, 78 × 54 INCHES (198 × 137 CM)
LIT: R + A 34; RUSSELL 1971–93, P. 46; DAVIES + YARD 1986, PP. 24–25;
PEPPIATT 1996, PP. 139–42
EXH: *FRANCIS BACON,* HANOVER GALLERY, LONDON, DEC. 1951–FEB. 1952 (NO
CAT.); VENICE *BIENNALE,* 1954 (BRITISH PAVILION 62); *V BIENAL,* SÃO PAULO,
SEPT.–DEC. 1959 (BACON 5); TATE 1962 (14); SOLOMON R. GUGGENHEIM MUSEUM,
NEW YORK, OCT. 1963–JAN. 1964 (13); PARIS 1971–2 (13); TOKYO 1983 (5);
TATE 1985 (12); HIRSHHORN 1989–90 (9); LUGANO 1993 (11)
ABERDEEN CITY ART GALLERY AND MUSEUMS, ABERDEEN, SCOTLAND

This is the first of a series of three large pictures of a pope, all of them to some extent paraphrases of Velázquez's *Portrait of Pope Innocent X* in the Doria Pamphili Gallery, Rome, and painted in the autumn of 1951. An earlier series of three, painted in 1950, was destroyed. This, and its two companions were not only Bacon's first completed series of the pope, but also the first completed series showing the actions of the same figure in sequence. In this version, Bacon has also used a photograph of Pope Pius XII being carried in a *sedia gestatoria* above the heads of the crowd. The delicately outlined fan vaulting suggests that the pope is being borne through a room in the Vatican.

Bacon was interested in the pope more as a man than as a spiritual leader; here he emphasizes less the pope's authority than his human vulnerability and anxiety. For a more detailed discussion of Bacon's attitude to the pope, see below, *Study for the Head of a Screaming Pope,* 1952 (Cat. no. 12).

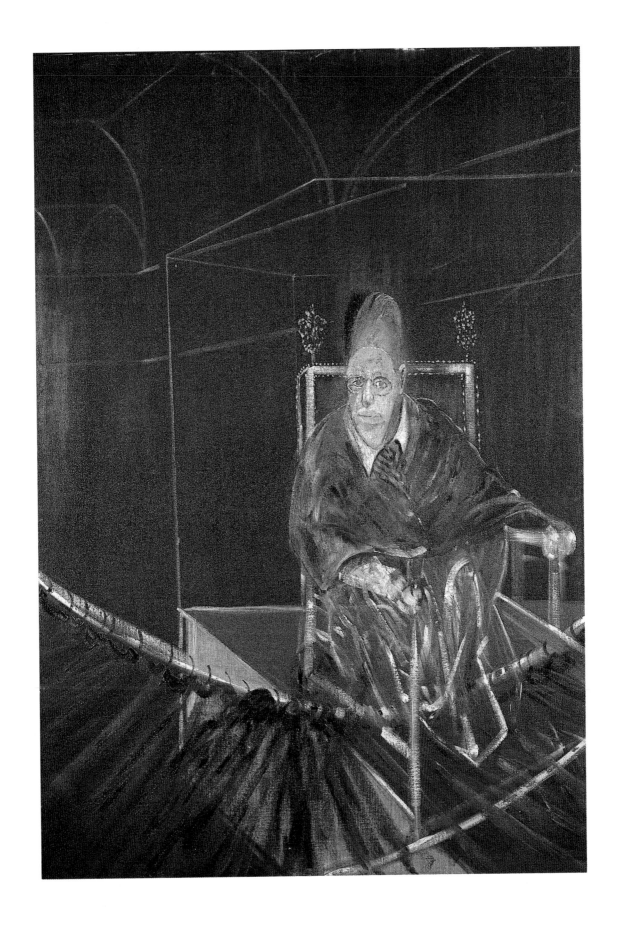

8. STUDY FOR CROUCHING NUDE, 1952

OIL AND SAND ON CANVAS, 78 × 54 INCHES (198 × 137 CM)
LIT: R + A 37
EXH: *RECENT TRENDS IN REALIST PAINTING,* INSTITUTE OF CONTEMPORARY ARTS, LONDON, JULY–AUG. 1952 (HORS CAT.); PARIS 1971–2 (8); PARIS + MUNICH 1996–7 (16)
THE DETROIT INSTITUTE OF ARTS, DETROIT. GIFT OF DR. WILHELM R. VALENTINER

The pose of the crouching man is based on an Eadweard Muybridge photograph (c.1885), of "Man Performing Standing Broad Jump," published in his *The Human Figure In Motion* (1887). Bacon has twisted the pose through 45 degrees, and set the figure on a tubular steel framework reminiscent both of gymnastic equipment and 1930s modern furniture. He has also kept the grainy quality found in the original photograph, as well as the numbered scale, which is here transposed from ground level to the curving top rail in the background that bisects the composition. Davies has observed that the artist placed the figure in a fetal position, the posture for defecation, and — in *Triptych May–June* (1973) — the position assumed in death. Such a pose is the antithesis of the upright, classically inspired, heroic stance.[1]

Technically, *Study for Crouching Nude* is a development from *Study from the Human Body* (1949, National Gallery of Victoria, Melbourne) and *Painting* (1950, Leeds Museums and Galleries), where the musculature of the flesh is modeled in semi-transparent tones. In the *Crouching Nude* the body has become even more insubstantial and shadowy, as if to suggest a figure in movement.

The figure appears to be caged and sealed in a windowless, anonymous space, like some unfortunate inmate of an asylum or prison.[2] Bacon said of this painting: "I tried to make the shadows as much *there* as the image. In a funny way, and though I hate the word, our shadows are our ghosts."[3] He also told Sylvester that he had thought about making sculptures "on a kind of armature," such as occurs in *Crouching Nude,* but the armature would be used to set off the figure.[4]

1. Davies + Yard 1986, pp. 29–30.
2. Ibid.
3. Russell 1971–93, p. 92.
4. Bacon-Sylvester, *Interview* 4 (1974), pp. 108–10.

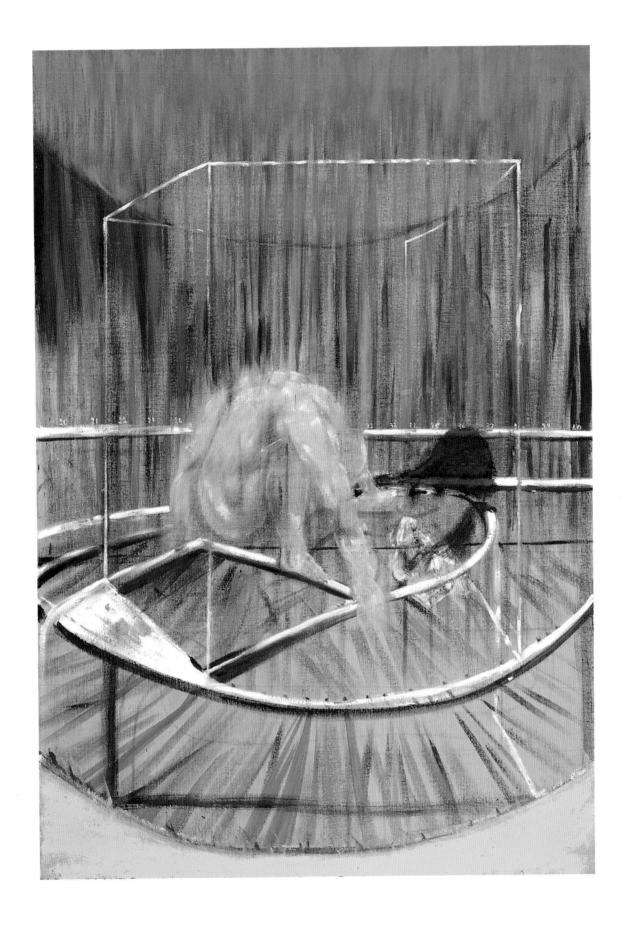

9. STUDY FOR A PORTRAIT OF A MAN IN BLUE, 1952

INSCRIBED WITH MONOGRAM, L. R.
OIL ON CANVAS, 24 × 20 INCHES (61 × 51 CM)
LIT: R+ A 44
EXH: *BACON, SUTHERLAND, HILTON, WYNTER, PIPER, MACKENZIE, DAVIE, NICHOLSON,* LUCA SCACCHI GRACCO, MILAN, SUMMER 1961 (NO NUMBERS), AS "BUSINESS MAN 2"; *FRANCIS BACON: RETROSPEKTIVE,* GALERIE BEYELER, BASEL, 12 JUNE–12 SEPT. 1987 (2)
PRIVATE COLLECTION, BELGIUM

This is one of a sequence of four head-and-shoulder "portraits," the first and third of which (R + A 41 and 43) feature the papal attributes of pince-nez, skullcap, and cape, which in the other two paintings are transformed into the somber attire of businessmen or politicians. Unlike the other three versions, where the sitters' mouths are opened as if screaming, here the figure has his mouth closed, and his features are blurred. This is possibly a portrait of Peter Lacy, whom Bacon had met by the spring or summer of 1952. The background of broad vertical stripes of red and blue give the portrait an extra dramatic dimension.

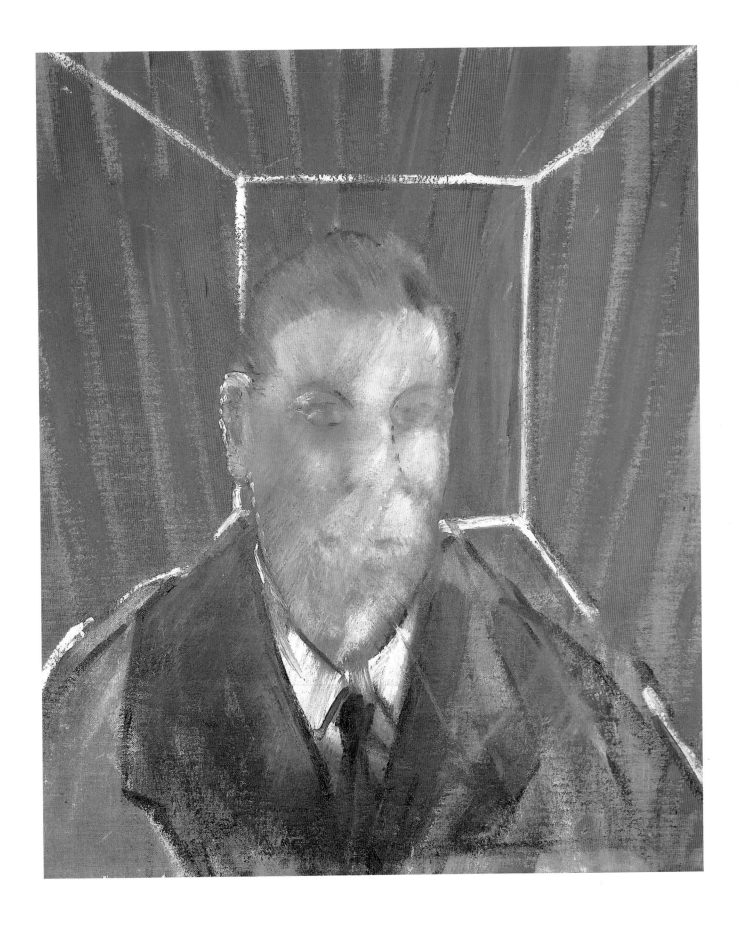

10. MAN KNEELING IN GRASS, 1952
OIL ON CANVAS, 78 × 54 INCHES (198 × 137 CM)
LIT: R + A 48
EXH: *FRANCIS BACON*, HANOVER GALLERY, LONDON, DEC. 1952–JAN. 1953 (NO CAT.); *FRANCIS BACON* GALLERIA CIVICA D'ARTE MODERNA, TURIN, SEPT.–OCT. 1962 (19); PARIS 1971–72 (12); LUGANO 1993 (16, WRONGLY DATED 1953)
PRIVATE COLLECTION VITTORIO OLCESE

In 1952, Bacon painted several pictures that feature men or animals in windswept long grass, partly inspired by his visit to the Kruger National Park game reserve in South Africa. The pose of the kneeling man is again a paraphrase of a Muybridge photograph, but is used here as a starting point to create a highly personal image quite different from the Muybridge photo. Bacon admired Seurat's monumental *Une Baignade, Asnières* (1884, National Gallery, London) for the way in which the French artist could freeze natural appearances in a highly artificial, tightly controlled composition.

Here, Bacon has produced a stagelike effect, as if the crouching man had been picked out from the encompassing gloom by car headlights while performing some illicit act.[1]

1. Jill Lloyd and Michael Peppiatt, Lugano 1993, sv. 16, make this point.

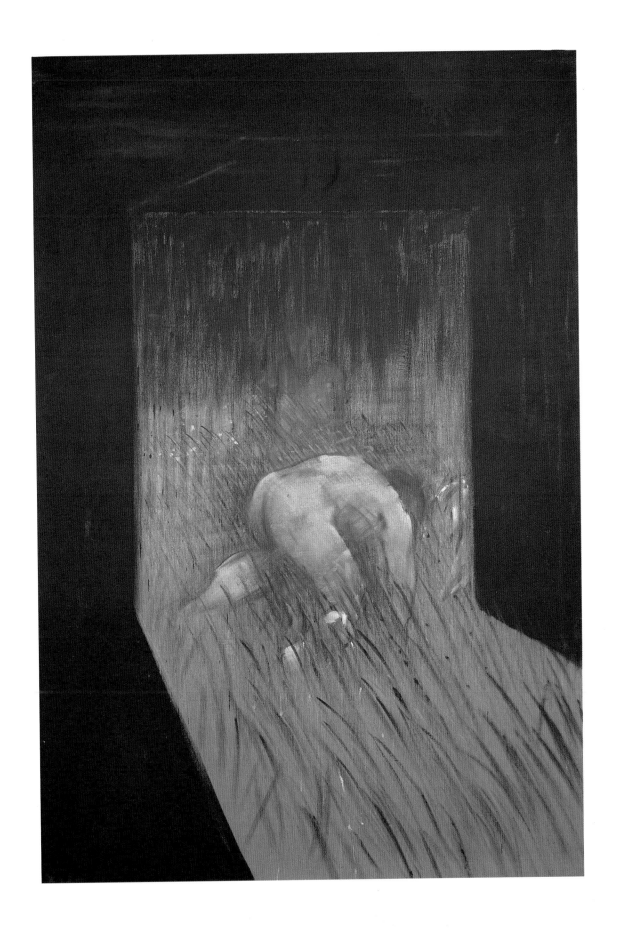

11. ELEPHANT FORDING A RIVER, 1952
OIL ON CANVAS, 78 × 54 INCHES (198 × 137 CM)
LIT: R + A 49; PEPPIATT 1996, PP. 137–38
EXH: *FRANCIS BACON,* HANOVER GALLERY, LONDON, DEC. 1952–JAN. 1953
(NO CAT.)
COURTESY OF IVOR BRAKA LTD., LONDON

This is one of a number of wild-life paintings inspired by the artist's visit to Kruger National Park during his stay in South Africa in the winter of 1950–51. He visited South Africa again in the spring of 1952, and this painting was done soon after his return.

Bacon worked both from memories of what he had seen there and from photographs. He had begun to paint African scenes even before his visits, for he had become greatly interested in Marius Maxwell's *Stalking Big Game with a Camera in Equatorial Africa* (London, 1924), which contained a fascinating sequence of photographs of wild animals in their natural habitats (see p. 35).[1] Characteristically, he has chosen moments when the animals are either lurking in the bush or suddenly breaking cover. Here, the elephant treads ponderously across the middle foreground, the light reflected off one of his tusks, wide ripples spreading out from his tracks. But even so, the majestic animal appears dwarfed by his surroundings.

1. Ronald Alley, Tate 1962, p. 18, sv. 19, *Landscape* 1952.

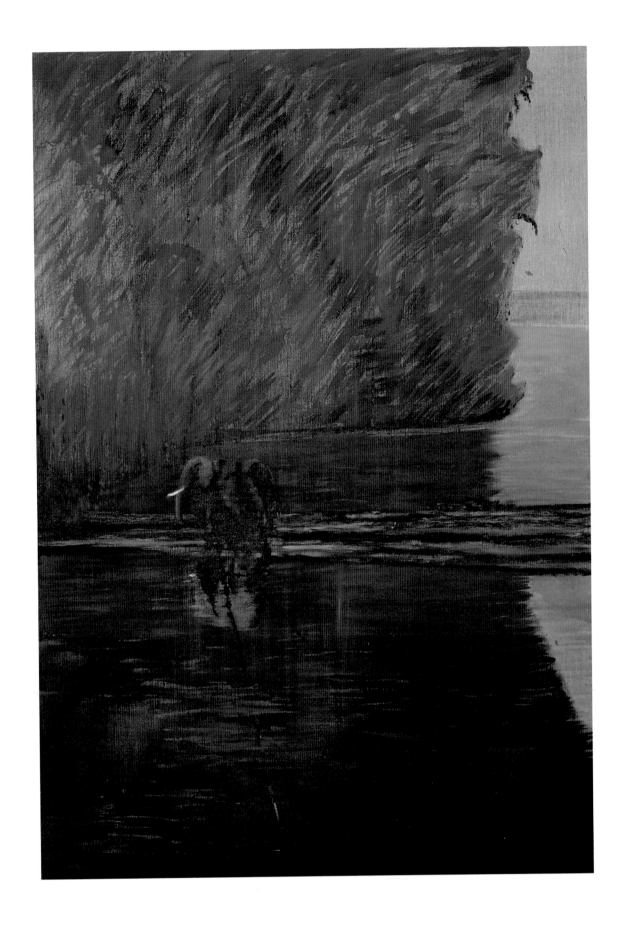

12. STUDY FOR THE HEAD OF A SCREAMING POPE, 1952

OIL ON CANVAS, 19¾ × 16 INCHES (50 × 40.5 CM)
LIT: R + A 41 (AS *STUDY OF A HEAD*); DAVIES, LUGANO 1993, PP. 50–52
EXH: *NEW YEAR EXHIBITION 1953,* LEICESTER GALLERIES, LONDON, JAN. 1953 (99)
YALE UNIVERSITY, NEW HAVEN. GIFT OF BEEKMAN C. AND MARGARET H. CANNON

Bacon began to paint a series of three paraphrases of Velázquez's *Portrait of Pope Innocent X* in September–October 1950, but only two of them were completed and he later destroyed them. Three more *Popes* were painted about a year later, in autumn 1951 (see *Pope I* above, no. 7). The *Study for the Head of a Screaming Pope* is one of three head-and-shoulders studies of anguished figures, in which elements of papal regalia — purple soutane and skullcap — are combined with those of the still of the murdered nurse from Eisenstein's film, *The Battleship Potemkin*: the shattered pince-nez spectacles, screaming mouth, and bloodstained face. There is a suggestion of a tubular steel throne (or headboard?), with a cursorily brushed-in rectangular framework in the background, all of which could also be interpreted as the trappings of a room in a mental hospital.

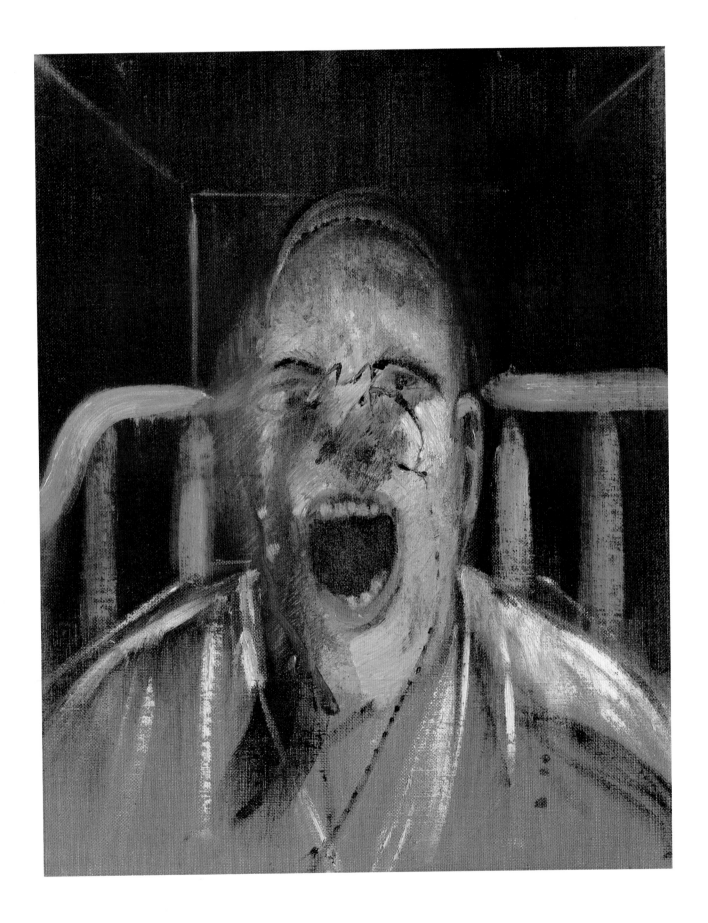

13. DOG, 1952
OIL ON CANVAS, 78¼ × 54¼ INCHES (199 × 138 CM)
LIT: R + A 45.
EXH: *FRANCIS BACON,* HANOVER GALLERY, LONDON, DEC. 1952–JAN.1953
(NO CAT.); *V BIENAL,* SÃO PAULO, SEPT.–DEC. 1959 (BACON 6); TATE 1962 (20)
MUSEUM OF MODERN ART, NEW YORK. WILLIAM A.M. BURDEN FUND

This is the first of three paintings of dogs that Bacon made after his return from Africa in the summer of 1952. Like the others, it was based on photographs by Muybridge of a mastiff walking. In this version, Bacon blurs the form of the dog and leaves a faint trail of paw marks to suggest movement. The dog's near hind leg is elongated and set at an awkward angle, almost as if it were lame. The checkerboard setting, which is based on a photograph of the stadium built by the Nazis at Nuremberg for their annual rallies, appears in several other compositions (see nos. 14 and 18).

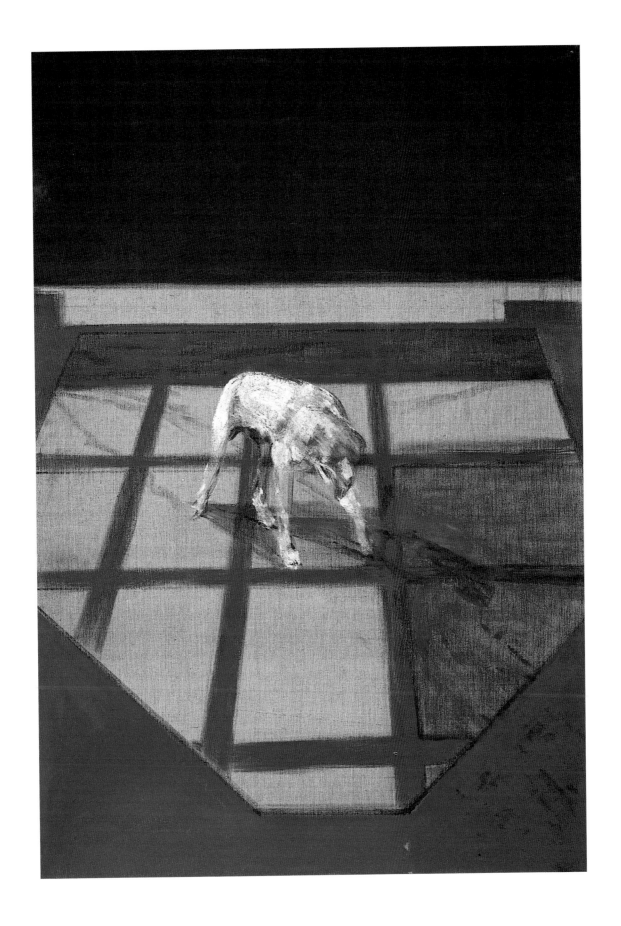

14. DOG, 1952
OIL ON CANVAS, 78 × 54½ INCHES (198 × 138.5 CM)
LIT: R + A 50; DAVIES + YARD 1986, P. 35
EXH: *FRANCIS BACON,* HANOVER GALLERY, LONDON, DEC. 1952–JAN. 1953
(NO CAT.; ADDED IN THE COURSE OF THE EXHIBITION); LUGANO 1993 (12)
PRIVATE COLLECTION — COURTESY FINE ARTS & PROJECTS, MENDRISIO

This is the last of three paintings of dogs that Bacon made on his return from Africa in 1952. The dog was freely based on a Muybridge photograph of a mastiff walking (entitled *Dread Walking*),[1] seeming to suggest forward movement. The hexagonal-shaped stage is an echo of the gigantic stadium built for the Nazis' annual Nuremberg rally, of which Bacon had seen a photograph; it appears again in more elaborate form in *Sphinx II* (see below, no. 18), and in the earlier versions of *Dog* (no. 13 above and R + A 39). In this variant, Bacon emphasizes the contrast between the hot ocher and red areas, which form the flower bed and frame the hexagon, and the inky dark desert sky, which fills the top third of the picture.

1. Davies + Yard 1986, p. 35.

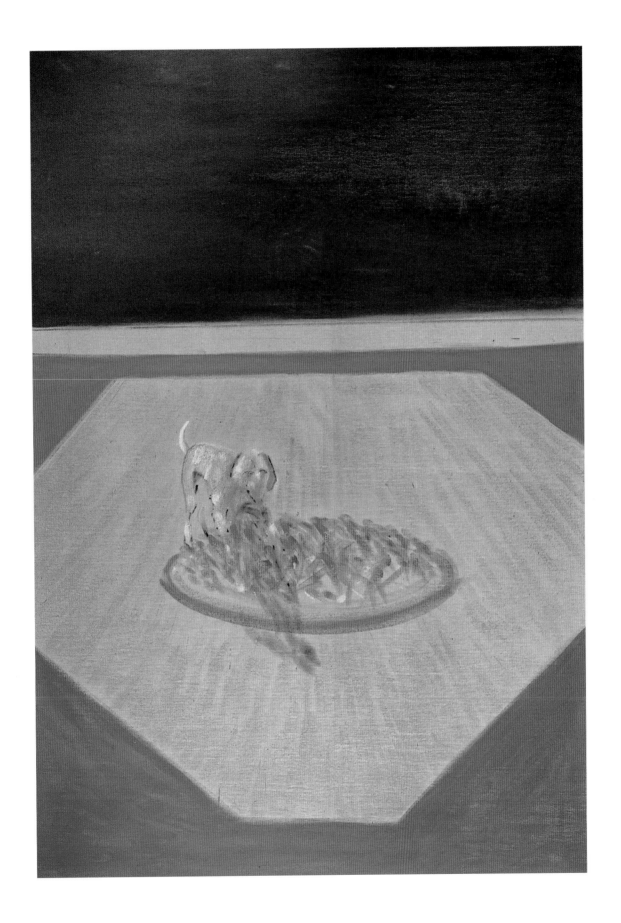

15. LANDSCAPE, SOUTH OF FRANCE, 1952
OIL ON CANVAS, 50 × 39¾ INCHES (127 × 101 CM)
LIT: R + A 51
EXH: *TODAY AND YESTERDAY,* ARTHUR TOOTH & SONS, LONDON, FEB.–MARCH 1954
(22) AS "ELEPHANT IN JUNGLE GRASS"; LUGANO 1993 (13)
PRIVATE COLLECTION — COURTESY FINE ARTS & PROJECTS, MENDRISIO

Although this painting has been known as *Elephant in Jungle Grass,* it is not one of Bacon's African pictures, nor does it show an elephant. The artist insisted that no animal was intended. Nevertheless, the painting was completed immediately after his return from his second visit to South Africa, and is plainly influenced by his experiences of watching animals breaking cover in the bush. He likened the painter to a hunter, waiting to trap images. It is more accurately an artificial variation on the paintings he had already made. Bacon has used the unprimed side of the canvas, and this imparts an overall tawny hue to the picture. He has juxtaposed two viewpoints: the foreground windswept bush grass is seen in close-up, with an indeterminate shape in the middle distance; behind this lies a flattened strip of coastline with palm trees and a passing car, reminiscent of the background in *Fragment of a Crucifixion,* 1950 (Stedelijk van Abbemuseum, Eindhoven) and *Dog,* 1952 (Tate Gallery), which was copied from a picture postcard of Monte Carlo.[1]

1. Jill Lloyd and Michael Peppiatt, Lugano 1993, sv. 13.

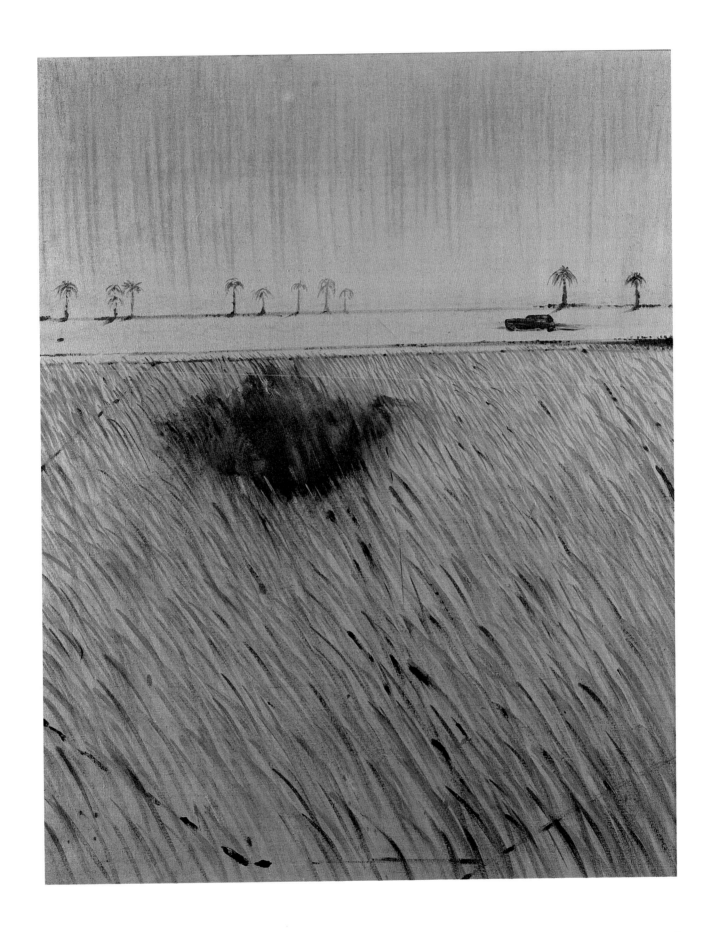

16. STUDY FOR PORTRAIT II, 1953
OIL ON CANVAS, 60⅛ × 46 INCHES (152.7 × 116.9 CM)
LIT; R + A 60; RUSSELL 1971–93, PP. 91–92
EXH: GROVER CRONIN STORE, WALTHAM, MASS., JAN. 1955; *SUMMER EXHIBITION*,
DURLACHER BROS., NEW YORK, JUNE–JULY 1955 (NO CAT.); LUGANO 1993 (17)
PRIVATE COLLECTION

This is the second of eight studies of a pope painted in the summer of 1953. The first of them began as a portrait of the critic David Sylvester, who sat about four times for it until it turned into a pope. The whole series was finished within a fortnight, and is one of the longest in Bacon's body of work to be completed; he painted the studies one after the other, the last one suggesting the next. Loosely based on the Velázquez *Pope Innocent X,* each painting in the sequence projects a subtle change of mood, usually by a combination pose and gesture. Here, the pope turns sharply away, as if trying to avoid a gold tasseled cord that swings across his face. Although seated on an elaborate throne, he is a curiously insubstantial figure; the lower half of his body appears to sink away into an opaque boxlike structure. As in *Study for Portrait VI* (see below, no. 17), Bacon explores the private anguish of the public figure, who despite the outward trappings of power, seems impotent to control events.

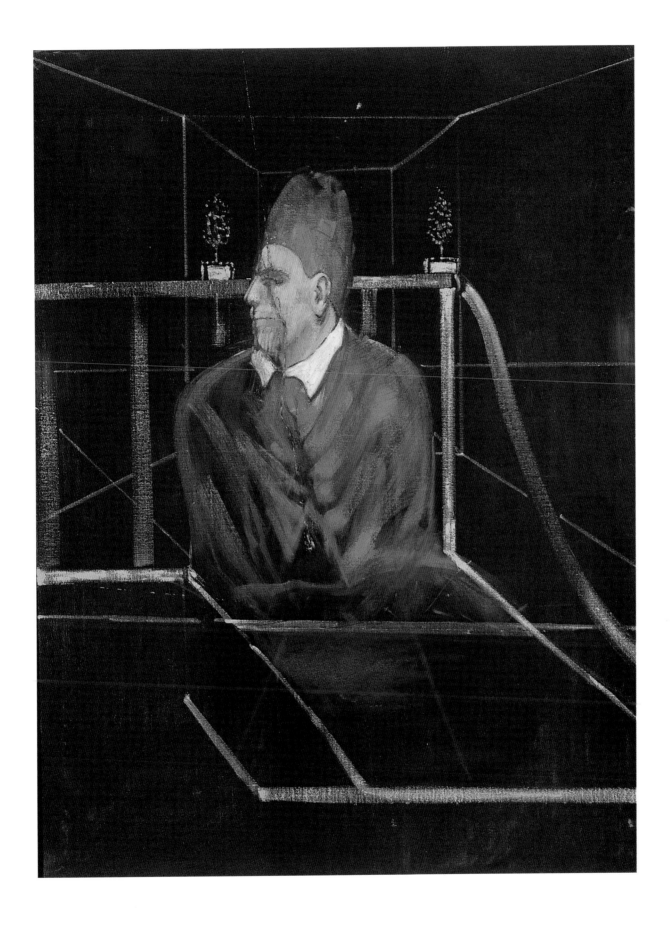

17. STUDY FOR PORTRAIT VI, 1953
OIL ON CANVAS, 60 × 46 INCHES (152.5 × 117 CM)
LIT: R + A 64
EXH: *REALITY AND FANTASY 1900–1954,* WALKER ART CENTER, MINNEAPOLIS,
MAY–JULY 1954 (6)
THE MINNEAPOLIS INSTITUTE OF ARTS, MINNEAPOLIS, THE MISCELLANEOUS WORKS
OF ART FUND

One of eight studies of a pope painted over a period of a fortnight or so in the summer of 1953, the series has been compared to a sequence of stills from a film. *Study for Portrait I* began as a portrait of David Sylvester, who sat for the artist four times, only to see himself transformed into a pope. All eight pictures were sent to Durlacher Brothers, New York, but only five (and not *Study for Portrait VI*) featured in Bacon's first one-man exhibition in the United States, held at Durlacher's, October–November 1953. As the sequence unfolds, the pope becomes more and more agitated, until at the end, he collapses in convulsive hysteria.[1] The pope series alternates with a series of portraits of businessmen, formally clad in dark blue suits and somber ties, as if the types were, in Bacon's eyes, complementary.[2] Bacon confessed he had "always wanted and never succeeded in painting the smile," but he "did hope one day to make the best painting of the human cry."[3]

1. Alley 1964, p. 71, sv. 59.
2. Valérie Breuvart, Paris + Munich 1996–7, p. 112.
3. Bacon-Sylvester, *Interview 2* (1966), pp. 34, 50.

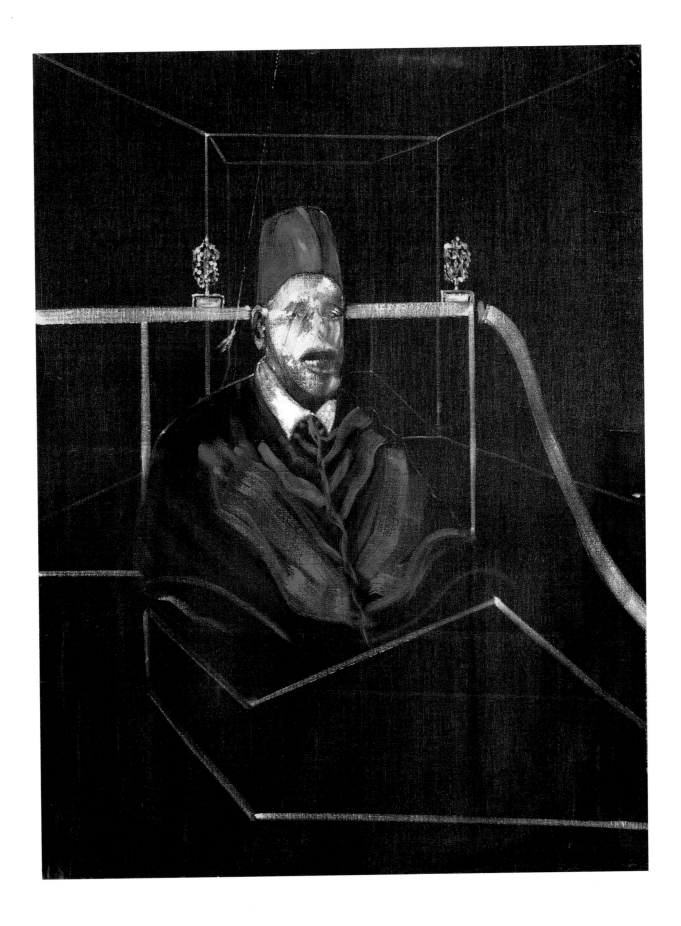

18. SPHINX II, 1953
OIL ON CANVAS, 78⅛ × 54 INCHES (199 × 137 CM)
LIT: R + A 68
EXH: *FRANCIS BACON,* DURLACHER BROS., NEW YORK, OCT.–NOV. 1953 (11);
PARIS 1971–2 (16); PARIS + MUNICH 1996–7 (24)
YALE UNIVERSITY ART GALLERY, NEW HAVEN. GIFT OF STEPHEN CARLTON CLARK,
BA 1903

Shown at Durlacher's, New York, in 1953 as *Study of the Sphinx,* this was the second of two versions of this subject painted in the summer of 1953. The setting in both was derived from a photograph of the stadium prepared for the Nazis' Nuremberg rally, while the image of the Sphinx was treated as semitransparent, yet solid enough to cast a strong shadow — a typical Baconian paradox. In *Sphinx I,* the shadow takes the form of a man with a gun; in the second version the shadow is less defined.

Bacon had passed a day or two in Cairo on the way back from his first journey to South Africa in 1950–51, and the antiquities he saw there confirmed his belief that Egyptian art "was the highest form of visual expression ever achieved by man."[1] The enigmatic power of that ancient culture, of which the Sphinx was an archetypal embodiment, remained a potent formative element in Bacon's own artistic development.[2]

The composition is sharply divided into two along a high horizon: the inky-black desert night sky is contrasted with the yellow sand (actually unprimed canvas, left bare, which has darkened), which is further defined by a hexagon edged in strong red. The Sphinx is outlined in white and blue-black.

1. Peppiatt 1996, p. 138.
2. Ibid.

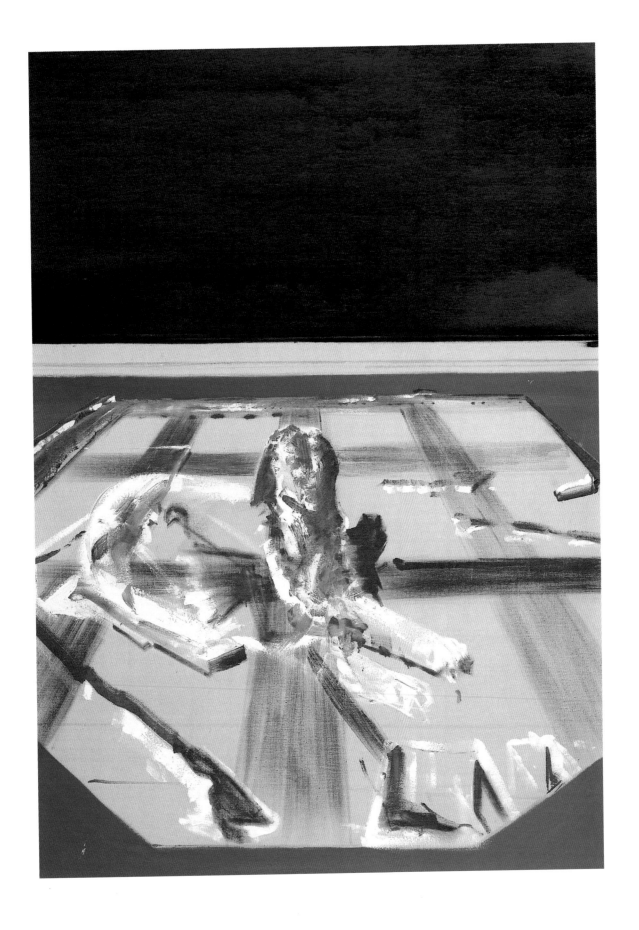

19. MAN WITH DOG, 1953

OIL ON CANVAS, 60 × 46 INCHES (152.5 × 117 CM)

LIT: R + A 58

EXH: *FRANCIS BACON,* HANOVER GALLERY, LONDON, JUNE–JULY 1954 (NO CAT.); PARIS 1971–2 (15); TOKYO 1983 (9); TATE 1985 (18); *BACON-FREUD: EXPRESSIONS,* FONDATION MAEGHT, SAINT-PAUL, 4 JULY–15 OCT. 1995 (2); PARIS + MUNICH 1996–7 (22)

ALBRIGHT-KNOX ART GALLERY, BUFFALO, NEW YORK. GIFT OF SEYMOUR H. KNOX, 1955

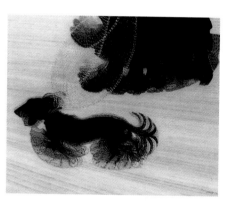

Giacomo Balla, Leash in Motion
*(*Guinzaglio in Moto*), 1912*
Oil on canvas, 35 x 45 ½"
Albright-Knox Art Gallery, Buffalo.
Bequest of A. Conger Goodyear and
gift of George F. Goodyear, 1964.
© Estate of Giacomo Balla/VAGA,
New York, NY

Painted in June 1953, the dog is based on a photograph by Muybridge of a mastiff walking, but freely adapted by Bacon to suggest a greater illusion of movement by blurring the forms. He was almost certainly equally inspired by Giacomo Balla's famous Futurist painting of *Leash in Motion* (*Guinzaglio in Moto*; 1912), which had been shown at the Tate Gallery in 1952. Unlike Balla, however, Bacon has chosen a soft, velvety technique, and only the sinuous spatter of spots of white paint used to define the movement of the dog lead recalls the succession of simultaneous outlines used by the Futurists to convey a sense of motion. Bacon's rapid brushstrokes impart a dynamism to the picture, and the bluish-gray tonalities suggest ghostly moonlight, not the harsh artificial light preferred by the Futurists. There are other ambiguities to tease the imagination: the dog's left hind leg appears to be willfully dislocated and to spring from its right flank; the dark shadowy form of human legs has been variously interpreted as representing the legs themselves, while others have seen them as the shadow of a man's legs cast on a convex wall.[1] The precision with which the drain in the gutter has been defined only points up this contrast between the clearly legible elements and the deliberately opaque.

1. Hervé Vanel in Paris + Munich 1996–7, p. 108.

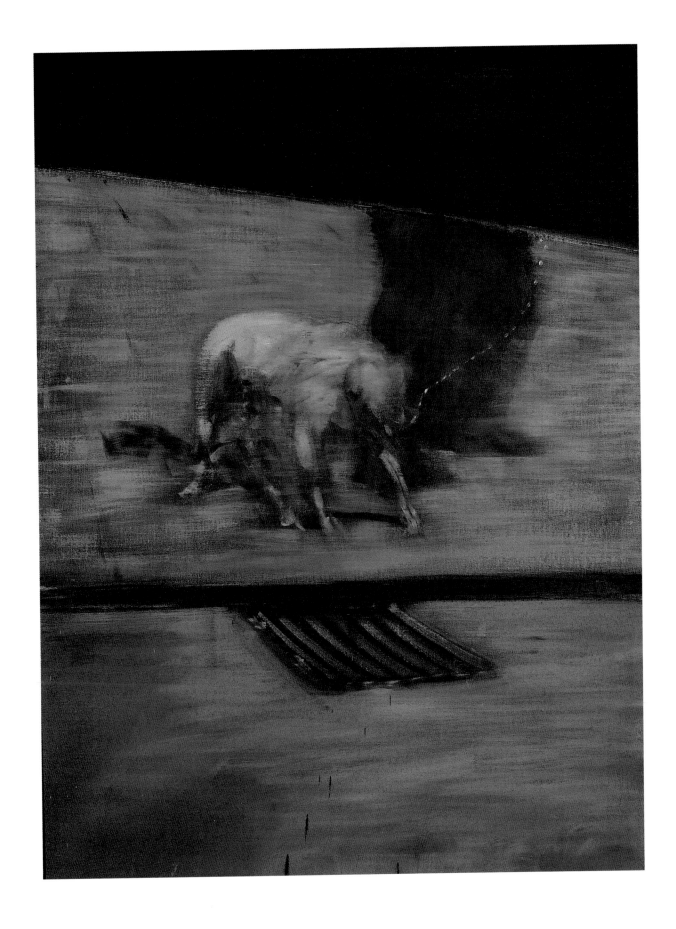

20. STUDY OF A BABOON, 1953
OIL ON CANVAS, 78 × 54 INCHES (198 × 137 CM)
LIT: R + A 69; PEPPIATT 1996, P. 148
EXH: *FRANCIS BACON,* DURLACHER BROS., NEW YORK, OCT.–NOV. 1953 (10);
TATE 1962 (30); PARIS 1971–2 (17); TATE 1985 (20); HIRSHHORN 1989–90 (15)
MUSEUM OF MODERN ART, NEW YORK. JAMES THRALL SOBY BEQUEST

Bacon's interest in wild animals has already been discussed. In this *Study of a Baboon* completed by August 1953, he captured the caged animal in the act of yawning or screeching. He also painted two studies of chimpanzees in 1955 and 1957 (R + A 100 and 128), and because of the evolutionary link between these anthropoids and man, one may surmise that Bacon is also making a sardonic comment on human behavior, too.

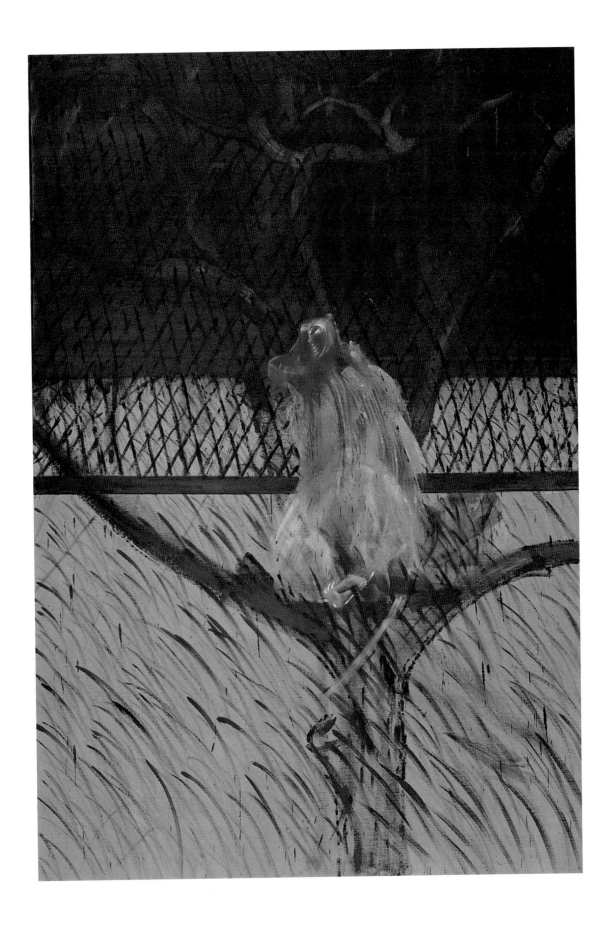

21. STUDY FOR FIGURE II, 1953 AND 1955
OIL ON CANVAS, 78 × 54 INCHES (198 × 137 CM)
LIT: R + A 71
EXH: *FRANCIS BACON,* DURLACHER BROS., NEW YORK, OCT.–NOV. 1953 (13) AS
"STUDY FOR A PORTRAIT–NO. 2"; *FRANCIS BACON,* GALERIE RIVE DROITE, PARIS,
FEB.–MARCH 1957 (5); HANOVER GALLERY, LONDON, MARCH–APRIL 1957 (3);
FRANCIS BACON, GALLERIA CIVICA D'ARTE MODERNA, TURIN, SEPT.–OCT. 1962 (27);
LONDON 1998 (8)
MR. AND MRS. J. TOMILSON HILL

This, and a companion picture, *Study for Figure I,* 1953, belong to a series on life in hotel bedrooms, but they also relate to the later series, *Man in Blue I–VII,* of 1954 (see below, nos. 25 and 26). Bacon repainted the head in *Study for Figure II* after the work was returned from Durlacher's in America in April 1955, but made no radical changes to it.

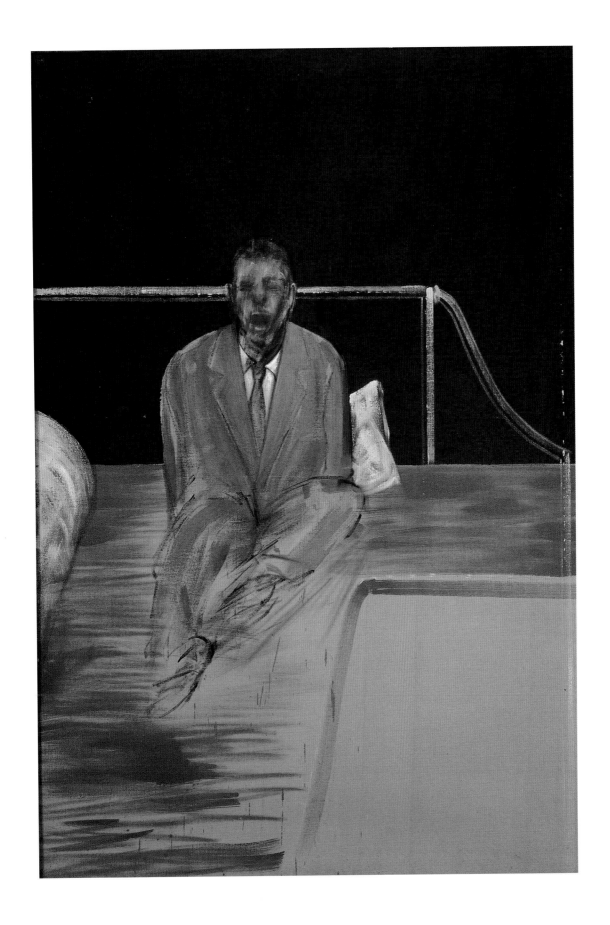

22. THREE STUDIES OF THE HUMAN HEAD, 1953

OIL ON CANVAS, TRIPTYCH, EACH PANEL 24 × 20 INCHES (61 × 51 CM)
LIT: R + A 74; RUSSELL 1971–93, PP. 92–94; LEIRIS 1988, PL. 10;
PEPPIATT 1996, PP. 150–51
EXH: *NEW PAINTINGS BY FRANCIS BACON,* BEAUX ARTS GALLERY, LONDON,
NOV.–DEC. 1953 (NO CAT.); TATE 1962 (33); VENICE 1993 (10)
PRIVATE COLLECTION — COURTESY FINE ARTS & PROJECTS, MENDRISIO

This triptych was painted in August–September 1953. The third picture was completed first;[1] Bacon had not originally intended to make a series. The other two heads are similar to the candid portrait photographs published in *Time* and *Picture Post,* which tend to show people caught unawares in some expressive and revealing action — shouting, laughing, or grimacing — a type of photo-journalism pioneered in Germany in the 1920s by Dr. Erich Salomon.[2] Alley has noted that the central picture bears a strong resemblance to a photograph of the Canadian prime minister Louis St. Laurent, published in *Time,* 20 July 1953, that is, just before these pictures were painted.

The stippled effect of pigment systematically dotted with the end of a paintbrush all over the face in the left-hand picture might suggest that Bacon was trying to mimic the dot pattern of press photographs.

1. Bacon-Sylvester, *Interview 3* (1971–73), p. 84.
2. Russell 1971–93, pp. 67–68. Erich Salomon's *Berühmte Zeitgenossen in unbewachten Augenblicken* ("Famous Contemporaries Caught at an Unguarded Moment," Stuttgart 1931), led the way for Stefan Lorant, Bill Brandt, and to a lesser degree, Henri Cartier-Bresson.

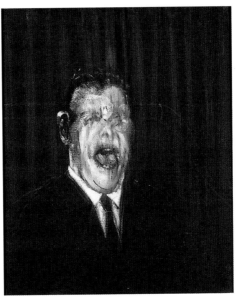

23. SPHINX, 1954
OIL ON CANVAS, 59½ × 45⅝ INCHES (151 × 116 CM)
LIT: R + A 79
EXH: VENICE *BIENNALE* 1954 (BRITISH PAVILION 65); *FRANCIS BACON,* INSTITUTE OF
CONTEMPORARY ARTS, LONDON, JAN. 1954–FEB. 1955 (11); SOLOMON R.
GUGGENHEIM MUSEUM, NEW YORK, OCT. 1963–JAN. 1964 (28); LUGANO 1993 (19)
TOYOTA MUNICIPAL MUSEUM OF ART, TOYOTA, JAPAN

Painted in February 1954, this is the third of four treatments of the subject, and is the most ethereal of them (see above, no. 18). The enigmatic figure of the Sphinx fascinated Bacon; in this picture it appears to hover within a transparent box, with the broad vertical blue and gold streaks suggesting reflections off its front surface, which distort and refract its image.

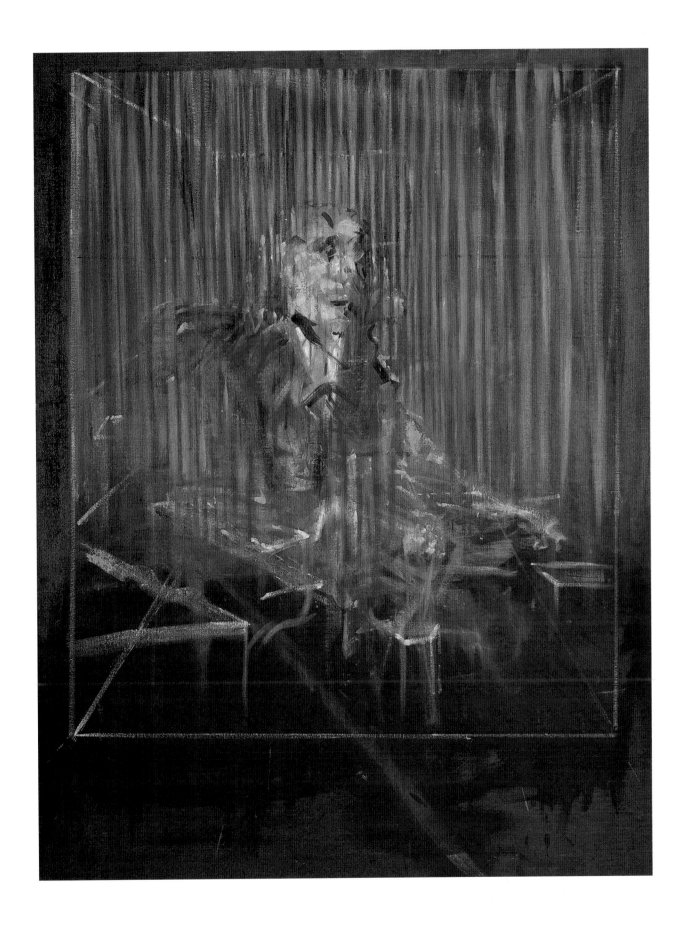

24. SPHINX (SPHINX III), 1954
OIL ON CANVAS, 78⅛ × 53⅞ INCHES (198.5 × 137 CM)
LIT: R + A 88
EXH: *FRANCIS BACON,* HANOVER GALLERY, LONDON, JUNE–JULY 1954 (NO CAT.);
LUGANO 1993 (20)
HIRSHHORN MUSEUM AND SCULPTURE GARDEN, SMITHSONIAN INSTITUTION,
WASHINGTON, DC, GIFT OF JOSEPH H. HIRSHHORN, 1966

Bacon's admiration for Egyptian art has been noted above. This is the fourth of his Sphinx paintings, of which this and the third (see above, no. 23) were executed between February and May 1954, and this version, shown at the Hanover Gallery, June–July 1954. The setting is similar to that used in the series *Man in Blue,* of about the same date. The Sphinx is again treated as a semitransparent image, almost as if it were an X-ray plate; the facial characteristics hover between the human and the simian. The dominant flat, blue-black background sets off the pinkish-white "flesh" tones of the Sphinx, which is, nevertheless, treated in a strongly sculptural manner. The surrounding boxlike structure evokes a glass museum showcase.

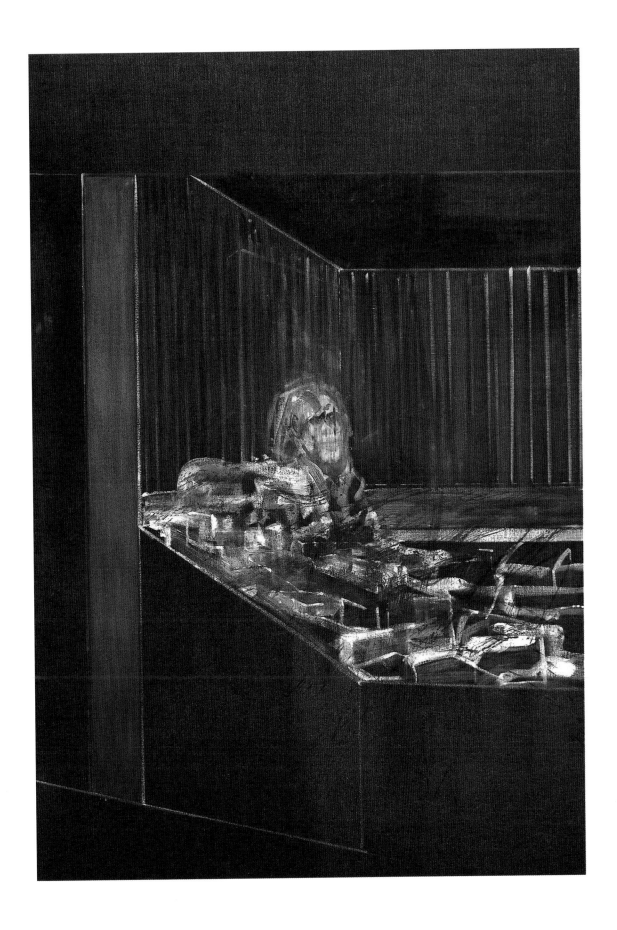

25. MAN IN BLUE III, 1954
OIL ON CANVAS, 60 × 46 INCHES (152.5 × 117 CM)
LIT: R + A 83
EXH: *FRANCIS BACON,* HANOVER GALLERY, LONDON, JUNE–JULY 1954 (NO CAT.)
COURTESY OF IVOR BRAKA LTD., LONDON

One of a series of seven pictures bearing this title, this version has also been known as *Man Trapped.* The evolution of the series is discussed below (see no. 26).

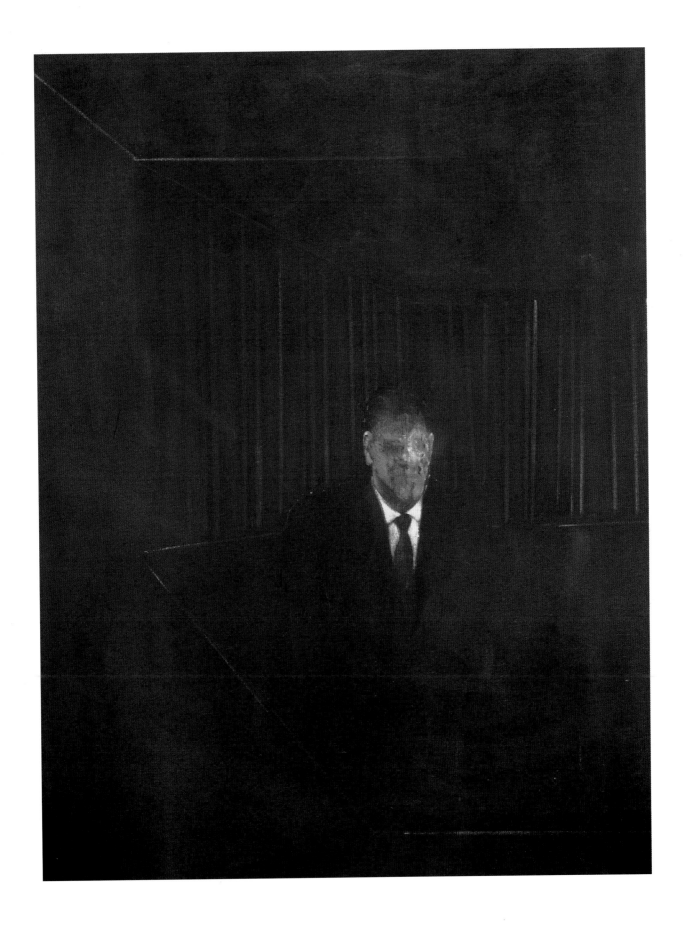

26. MAN IN BLUE IV, 1954

OIL ON CANVAS, 78 × 54 INCHES (198 × 137 CM)
LIT: R + A 84; PEPPIATT 1996, P. 164
EXH: *FRANCIS BACON,* HANOVER GALLERY, LONDON, JUNE–JULY 1954 (NO CAT.);
TATE 1962 (35)
MUSEUM MODERNER KUNST, STIFTUNG LUDWIG, VIENNA

This, and *Man in Blue III,* are two of a series of seven pictures, *Man in Blue,* which Bacon painted between March and early June of 1954. Bacon painted partly from a model, a man to whom he was probably attracted that he met at the Imperial Hotel, Henley-on-Thames, where he was staying. The underlying inspiration may also have been Peter Lacy, a former fighter pilot and a man of violent moods, whom Bacon had met in 1952 and became infatuated with on a grand scale.[1] In an undated letter to his dealer, Erica Brausen (written from the Imperial Hotel), Bacon lamented his inability to complete the paintings he was working on, and begged her to postpone his forthcoming one-man show at the Hanover Gallery (June–July 1954).[2]

The setting appears to be a hotel bar, and only the head, shoulders, and body down to the waist are shown in a typically claustrophobic space. Alley has observed that these paintings differ from earlier series, partly because they were painted from life, but also in that they lack any sense of progression or emotional climax.[3] The sitter is formally attired in dark suit and tie, and could equally well be a prosperous businessman or, in *Man in Blue IV,* an implacable interrogator. In some, the sitter appears more as a victim. The man's features are deliberately imprecise, and they appear to melt into the background. Blue, the dominant hue, sets a chill, neurotic mood.

1. See Peppiatt 1996, for an account of the stormy relationship between the two men.
2. Tate Gallery Archives, TGA 863, cited in Farson and Paris + Munich 1996–7, p. 124.
3. Alley in R + A, p. 86.

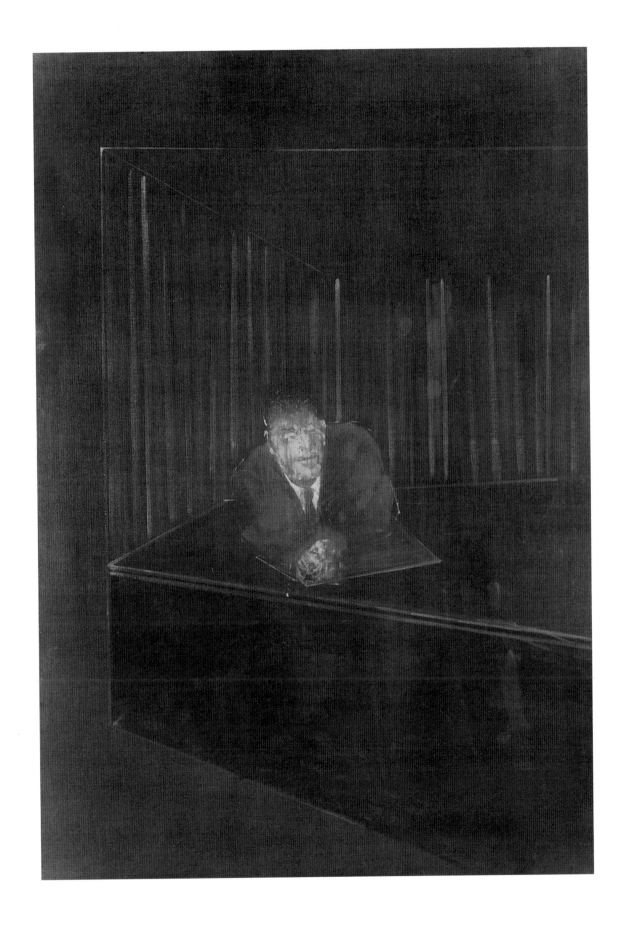

27. SELF-PORTRAIT, 1956
OIL ON CANVAS, 78 × 54 INCHES (198 × 137 CM)
LIT: R + A 110, P. 272; PEPPIATT 1996, P. 167
EXH: *FRANCIS BACON,* NOTTINGHAM UNIVERSITY, FEB.–MARCH 1961 (18); TATE
1962 (52); LUGANO 1993 (24); VENICE 1993 (14); PARIS + MUNICH 1996–7 (31);
LONDON 1998 (9)
PRIVATE COLLECTION — COURTESY FINE ARTS & PROJECTS, MENDRISIO

Painted in January or early February 1956, this is Bacon's earliest surviving self-portrait.
The format is not unlike the *Man in Blue* series, but here Bacon shows himself full-
length. Like all his self-portraits, this was painted from memory and not from a mirror
image; but in its informal pose, with hunched shoulders and leaning forward as if in con-
versation, the figure is unmistakably Bacon. He emerges from a dark blue-black back-
ground, the cubelike space adumbrated by faintly drawn whitish-gray lines, as is the low
couch on which he sits, with its yellow tubular rail defining the backrest. The face and
hands are modeled in bluish-white tones, and the crossed legs show a *pentimento* for the
pose of the left leg; the shoes are cursorily defined in outline. The semitransparent washes
on the face and hands, like the broadly stroked-in blue suit, have the shadowy qualities
of an X-ray plate. There is an air of anxiety, an effect heightened by the sharply raised left
eye socket and cheekbones.

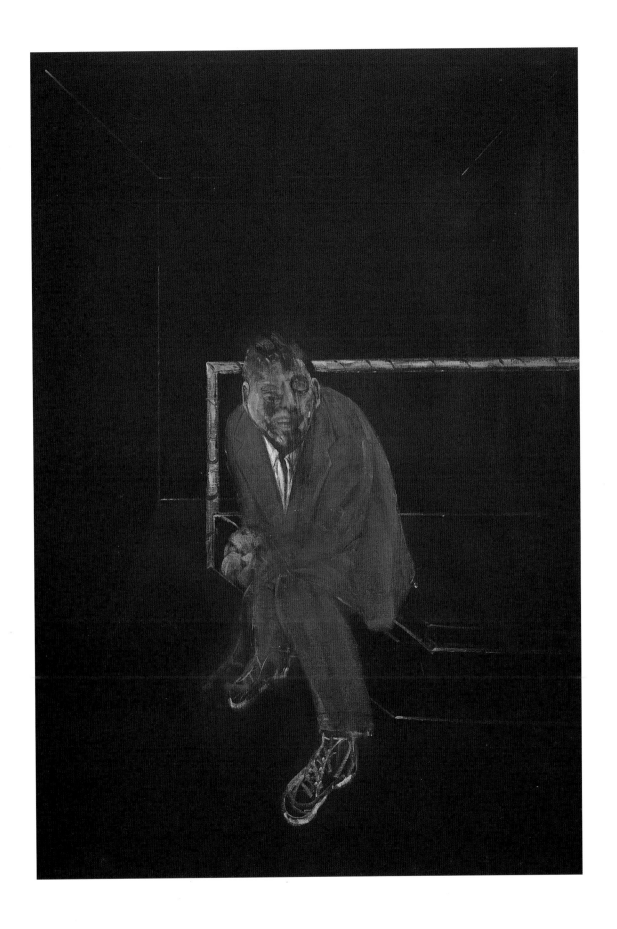

28. OWLS, 1956
OIL ON CANVAS, 24 × 20 INCHES (61 × 51 CM)
LIT: R + A 118; PEPPIATT 1996, P. 172
EXH: *FRANCIS BACON,* GALERIE RIVE DROITE, PARIS, 12 FEB.–10 MARCH 1957 (21);
TATE 1962 (54).
PRIVATE COLLECTION

First shown early in 1957 at Bacon's first one-man exhibition in Paris at the Galerie Rive Droite, and immediately afterwards at the Hanover Gallery, London, this painting is related to one of the four later works completed in a makeshift studio on the sixth floor of a house on Boulevard Mohammed V, in the *ville nouvelle* of Tangier. Bacon wrote about these works to his dealer, Erica Brausen, in the summer of 1958: ". . . I am doing two series, one of the Pope with Owls quite different from the others and a serial portrait of a person in a room. I am very excited about it."[1]

William Blake, Hecate, *c. 1795*
Color monotype, 16¼ × 22"
Tate Gallery, London

That *Owls* was painted two years earlier, in 1956, is also attested by the fact that it was almost given as a Christmas present to Michael Morgan that year.[2] It was subsequently bought by Sir Colin Anderson from the Hanover Gallery in 1957. The unusual bright blue background may be an echo of the strong Mediterranean light that had so struck Bacon when he first encountered it in 1946; the four owls are brushed in with streaks of grayish-brown pigment; two face the spectator, and behind them, two more seem to be seen from the back. In *Painting 1958* (R + A 143), the pope is shown seated on a throne, on the backrest of which, flanking the pope's head, perch two shadowy owls, and this is probably the painting Bacon is referring to in his letter to Erica Brausen, quoted above. The owl, a ghostly, nocturnal predatory bird, associated with Hecate and the underworld, may well have appealed to Bacon on several levels. It is also possible that he knew of William Blake's color print *Hecate* in the Tate Gallery, in which owls loom ominously in the background, for although Bacon disliked Blake's paintings, he greatly admired his poetry. In 1955 he had begun a series of variations based on J. S. Deville's life mask of the poet (1823) in the National Portrait Gallery.

1. Cited by Peppiatt 1996, p. 172.
2. R + A, p. 272 (Appendix C: Further Information about Dating).

107

29. STUDY FOR PORTRAIT X, 1957
OIL ON CANVAS, 78 × 56 INCHES (198 × 142 CM)
LIT: R + A 125; PEPPIATT 1996, P. 178
EXH: *FRANCIS BACON,* GALERIE RIVE DROITE, PARIS, 12 FEB.–10 MARCH 1957 (18);
FRANCIS BACON, HANOVER GALLERY, LONDON, MARCH–APRIL 1957 (9)
PRIVATE COLLECTION — COURTESY FINE ARTS & PROJECTS, MENDRISIO

This is one of several *Studies for Portraits* of 1957, of which *Study for Portrait IX* has been identified as a portrait of Peter Lacy, with whom Bacon had fallen in love in 1952.[1] The figure in this picture bears a close resemblance to those in numbers IV, V, VI, and IX of the sequence. The relationship was a tempestuous one, and in this portrayal, Lacy looks back, a little menacingly, over his shoulder. All the figures are caged within a large box-like structure, as if displayed in a museum showcase.

1. Peppiatt 1996, p. 178.

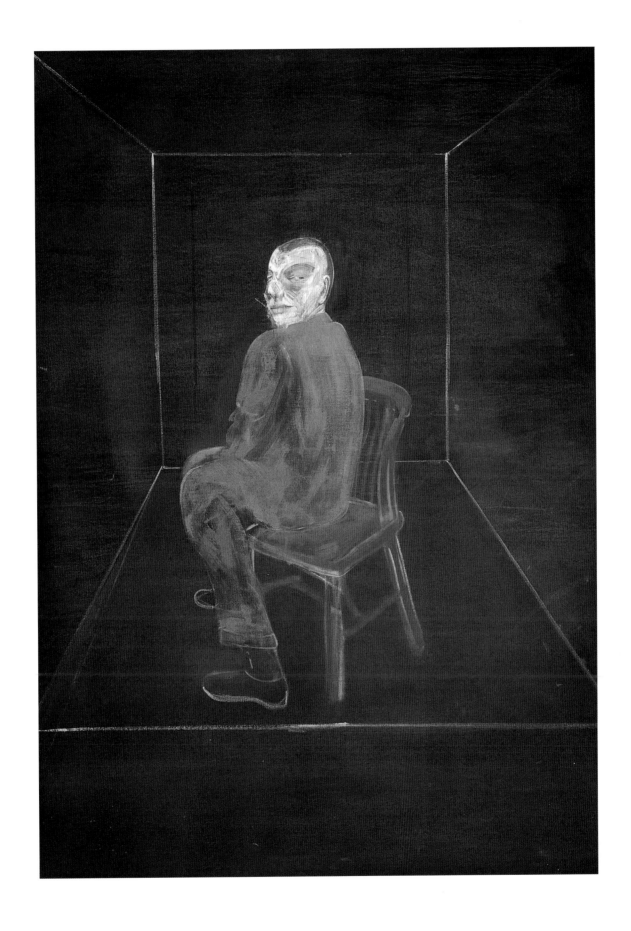

30. STUDY FOR PORTRAIT OF VAN GOGH V, 1957
OIL AND SAND ON CANVAS, 78 × 56 INCHES (198 × 142 CM)
LIT: R + A 132; RUSSELL 1971–93, P. 51; DAVIES + YARD 1986, P. 35;
PEPPIATT 1996, PP. 167–69
EXH: *FRANCIS BACON,* HANOVER GALLERY, LONDON, MARCH–APRIL 1957 (NOT IN
CAT., ADDED DURING COURSE OF EXH.); TATE 1962 (61)
HIRSHHORN MUSEUM AND SCULPTURE GARDEN, SMITHSONIAN INSTITUTION,
WASHINGTON, DC

This version follows Van Gogh's *The Painter on the Road to Tarascon,* July 1888, fairly closely in general composition, but the figure has become more haggard and etiolated. For a discussion of the series, see no. 31 below.

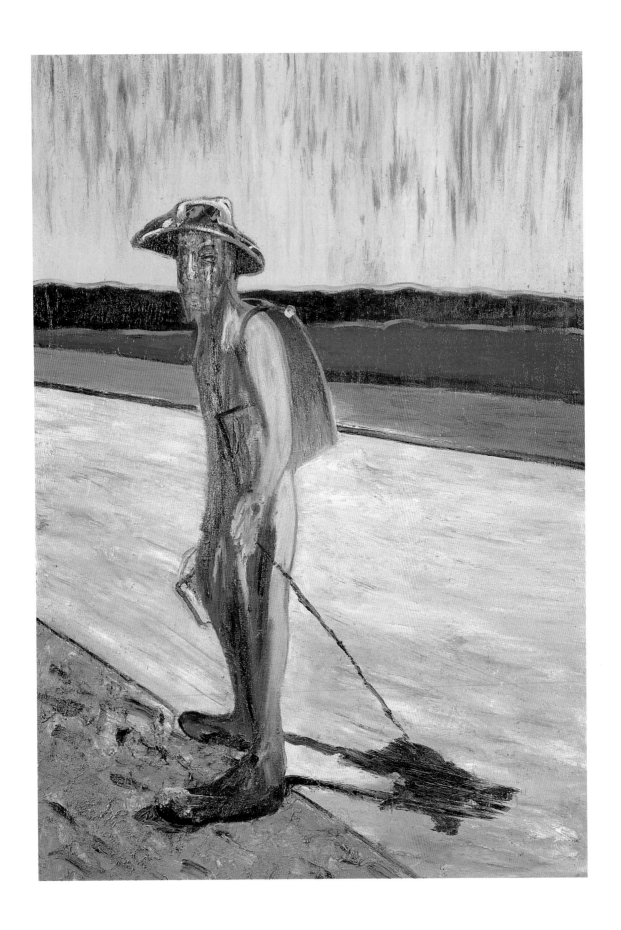

31. STUDY FOR PORTRAIT OF VAN GOGH VI, 1957

Oil on canvas, 79¾ × 56 inches (202.5 × 142 cm)
Lit: R + A 133; Russell 1971–93, p. 51; Peppiatt 1996, pp. 167–9
Exh: *Francis Bacon,* Hanover Gallery, London, March–April 1957 (not in cat.); Tokyo 1983 (13); Tate 1985 (33)
Arts Council Collection, Hayward Gallery, London

Bacon painted his first *Study for Portrait of Van Gogh* in March or April 1956, followed by five others painted at great speed in March 1957 for his Hanover Gallery exhibition, including this picture, which was one of two added — with the paint still wet — after the show had opened. Two more, *Van Gogh in a Landscape* (Centre Georges Pompidou, Paris), and *Van Gogh Going to Work,* followed later in 1957. Bacon's admiration for Van Gogh first showed itself in 1951, when a portrait of a pope turned into one of Van Gogh (now in the Cleveland Museum of Art). The main series was not only inspired by Van Gogh's *The Painter on the Road to Tarascon* of July 1888,[1] but also by Van Gogh's life as the alienated outsider, which struck a response in Bacon. He also sympathized with Van Gogh's artistic beliefs, as reflected in his letters to his brother, Theo: "[R]eal painters do not paint things as they are. . . . They paint them as *they themselves* feel them to be."[2] As the painting was destroyed in the war, Bacon only knew it in color reproduction, but he radically altered the predominantly golden-yellow, green, and brown palette of the lost original to one of hectic reds, blue-blacks and greens. He also changed the strong horizontal emphasis of the Van Gogh into a frenetic all-over pattern of vehemently slapped-in brushstrokes, which seem to envelop and partly dissolve the figure of the painter, so that he truly becomes "a phantom of the road" (see p. 15).[3]

1. Formerly Kaiser-Friedrich Museum, Magdeburg, destroyed in World War II: de la Faille 448, Hulsker 1491. Bacon used the reproduction in L. Goldscheider and W. Uhde, *Vincent Van Gogh,* (Phaidon) 1947, pl. 69.
2. Quoted by Peppiatt 1996, p. 168.
3. Russell 1971–93, p. 51.

32. HEAD II, 1958
OIL ON CANVAS, 24 × 20 INCHES (61 × 51 CM)
LIT: R + A 145
EUROPEAN INSTITUTION COLLECTION

This, and *Head I,* 1958 (R + A 144), are possibly based on Bacon's friend, Peter Lacy.

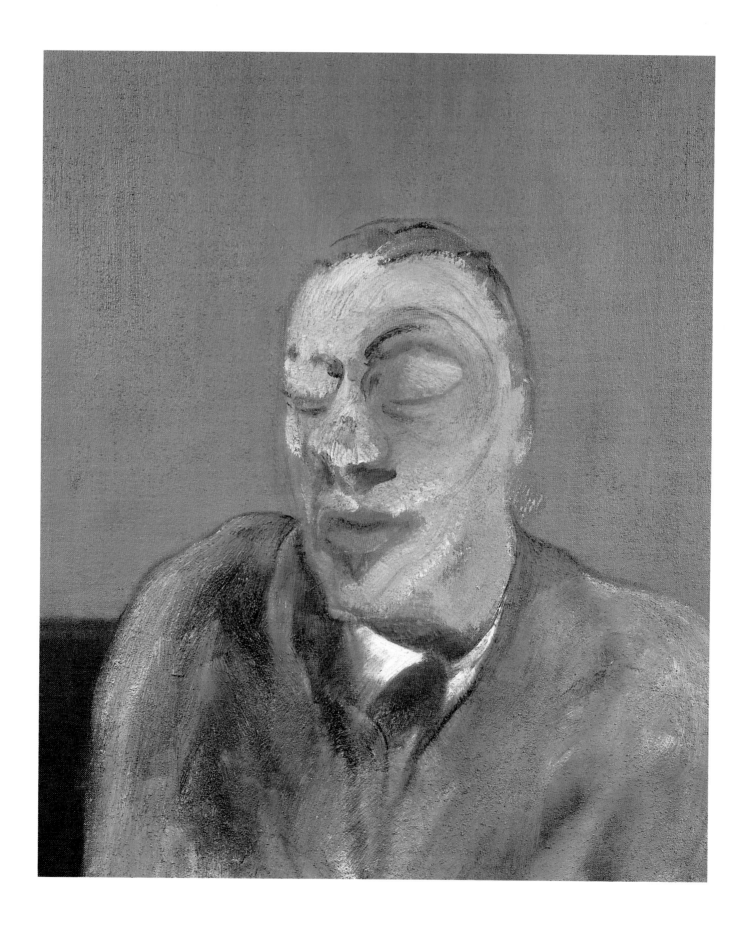

33. RECLINING FIGURE, 1959
OIL ON CANVAS, 78 × 56 INCHES (198 × 142 CM)
LIT: R + A 151
EXH: *NEW WORK,* ALAN GALLERY, NEW YORK, SEPT. 1959 (1)
PRIVATE COLLECTION — COURTESY FINE ARTS & PROJECTS, MENDRISIO

One of a series of *Reclining* or *Lying Figures* that Bacon painted between 1959 and 1961, several of which have a sharply foreshortened figure seen head first, with one leg thrust up against the back of a couch or wall, the other bent under the body, and an arm flung out. Here, the figure is male, and in others the figure is female. The figure in this work appears as a smudge of brilliant flesh colors outlined in dark blue, heightened by touches of stronger red and purplish-blue strokes, which contrast with the dark green sofa and carpet. A streaky pale blue background gives a limited sense of recession to the composition. See also *Reclining Woman,* 1961 (below, no. 35).

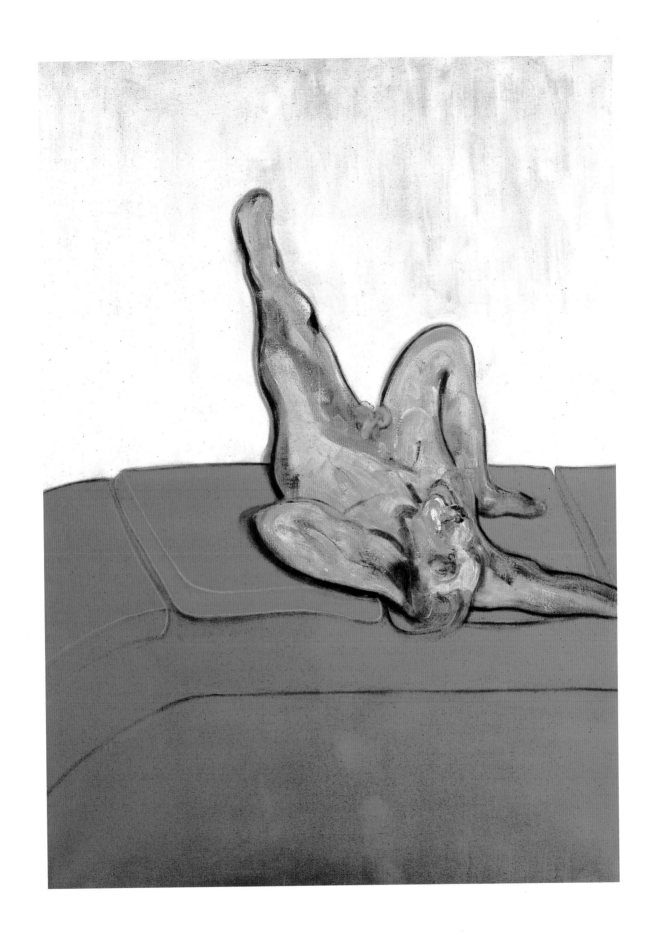

34. WALKING FIGURE, 1959–60

OIL ON CANVAS, 78 × 56 INCHES (198 × 142 CM)
LIT: R + A 163
EXH: *FRANCIS BACON. PAINTINGS 1959–60*, MARLBOROUGH FINE ART, LONDON,
MARCH–APRIL 1960 (24)
DALLAS MUSEUM OF ART, DALLAS, FOUNDATION FOR THE ARTS COLLECTION.
GIFT OF MR. AND MRS. J. O. LAMBERT, JR. AND MR. AND MRS. DAVID GARRISON

First exhibited at Marlborough Fine Art, London, in March 1960, this painting was completed by late February, and is related to a smaller work, *Man with Arm Raised* (40 x 25 inches), of the same date. Both show an almost spectral figure in half profile, emerging from behind a door, and the smaller picture appears to be the first of the sequence. They are both similar in technique to *Miss Muriel Belcher,* in that a thickly impasted figure is contrasted with a thin matt background. *Walking Figure* is descended from Muybridge's sequence of photos of walking men, which he published in *The Human Figure in Motion* (1887), but Bacon invests his figure with an aura of vaguely sensed disquiet. There is also the formal organization of the picture into strongly accented vertical panels, which first appeared in works of the late 1940s, but here is simplified into the broad upright bands reminiscent of those in Barnett Newman's Color Field paintings.[1]

1. Russell 1971–93, p. 110, makes this point.

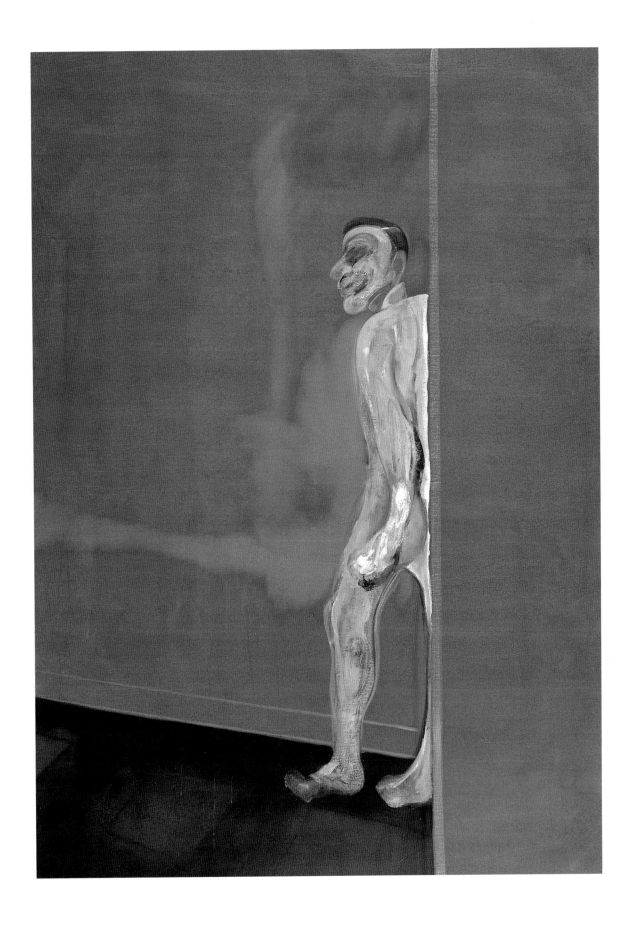

35. RECLINING WOMAN, 1961
OIL AND COLLAGE ON CANVAS, 78¼ × 55¾ INCHES (198.5 × 141.5 CM)
LIT: R + A 180
EXH: TATE 1962 (80); TATE 1985 (37)
TATE GALLERY, LONDON. PURCHASED, 1961

A variation on the *Reclining Figure* theme (see above, no. 33), this was finished early in 1961.[1] The figure of the woman was painted on a separate piece of canvas stuck onto the main canvas. The color scheme is quite different from *Reclining Figure,* 1959.

1. R + A, p. 273 (Appendix C), notes that this painting was photographed on 27 February 1961.

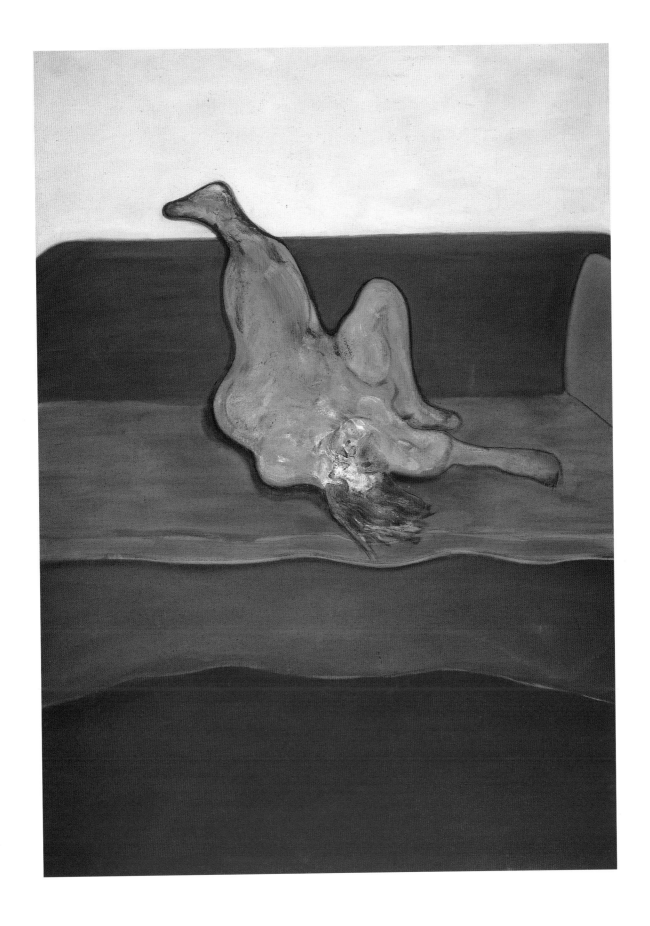

36. STUDY FOR A POPE III, 1961
OIL ON CANVAS, 60 × 47 INCHES (152 × 119 CM)
LIT: R + A 186, P. 273
EXH: TATE 1962 (84 C); LUGANO 1993 (29: 3)
PRIVATE COLLECTION — COURTESY FINE ARTS & PROJECTS, MENDRISIO

This and the two following paintings are three of a series of six "Studies" painted in April–May 1961. They are the last of a consecutive treatment of the theme, although Bacon was to complete further, separate studies from Velázquez's *Portrait of Pope Innocent X* later in the decade. In retrospect, he felt his obsession with the theme to have been misplaced and the resulting paintings failures.[1]

As in *Study for the Head of a Screaming Pope,* 1952 (see above, no. 12), we are presented with the private image of the pope. He is seen here not as an all-powerful spiritual leader, but as a shrunken, rather impotent figure, who seems to be almost engulfed by his throne. In the last two of this sequence,[2] he seems to be on the point of dissolving into the canvas.

1. Bacon-Sylvester, *Interview 3* (1971–73), p. 72; Peppiatt 1996, pp. 139–141.
2. Illustrated in Lugano 1993, pl. 64.

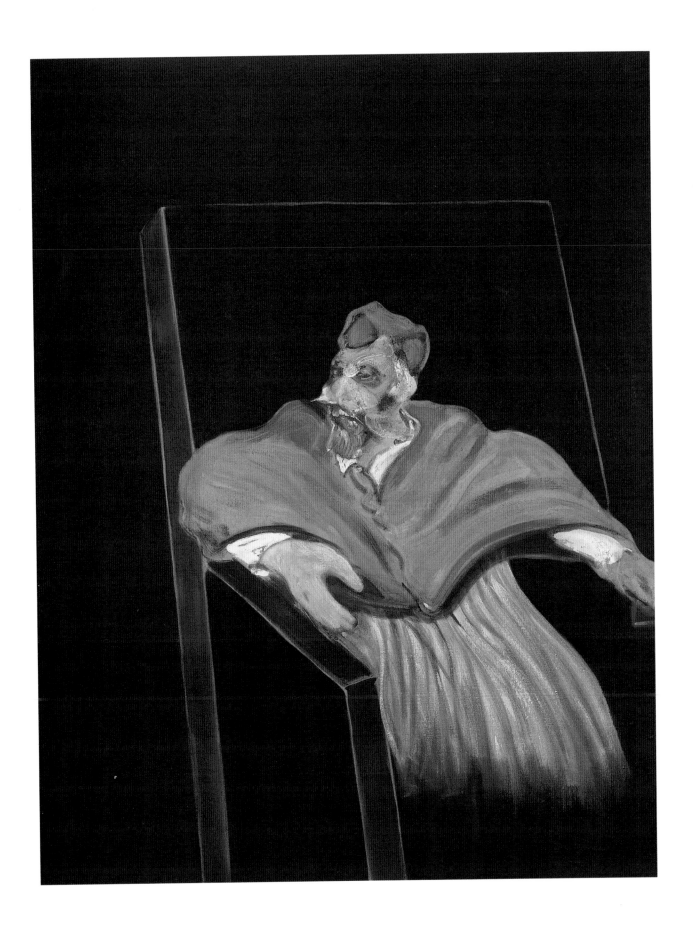

37. STUDY FOR A POPE IV, 1961
OIL ON CANVAS, 60 × 47 INCHES (152 × 119 CM)
LIT: R + A 186, P. 273
EXH: TATE 1962 (84 D); LUGANO 1993 (29: 4); LONDON 1998 (10)
PRIVATE COLLECTION — COURTESY FINE ARTS & PROJECTS, MENDRISIO

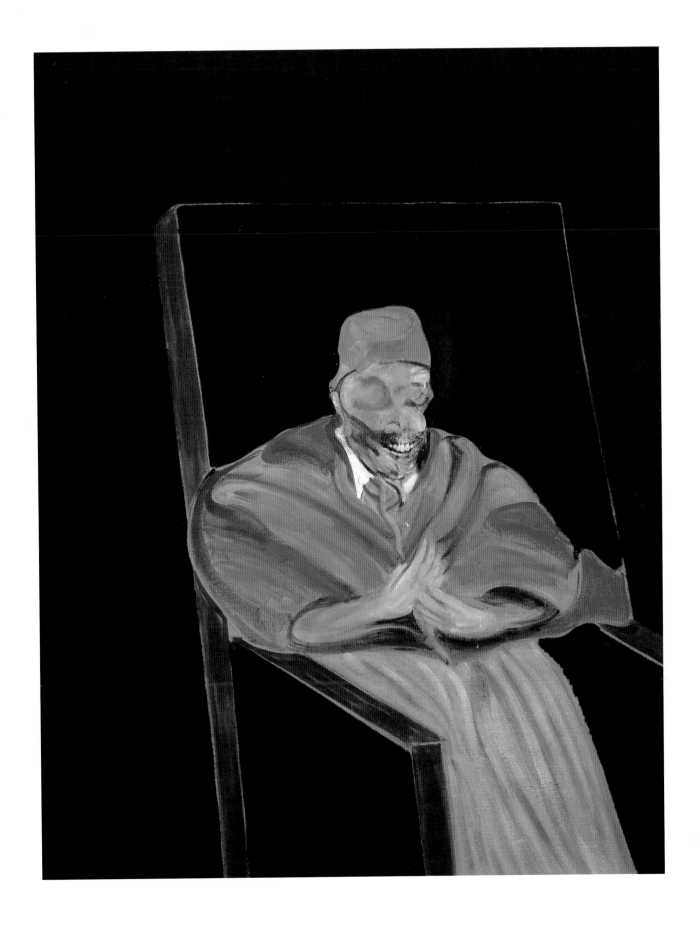

38. STUDY FOR A POPE VI, 1961
OIL ON CANVAS, 60 × 47 INCHES (152 × 119 CM)
LIT: R + A 186, P. 273
EXH: TATE 1962 (84 F); LUGANO 1993 (29:6)
PRIVATE COLLECTION

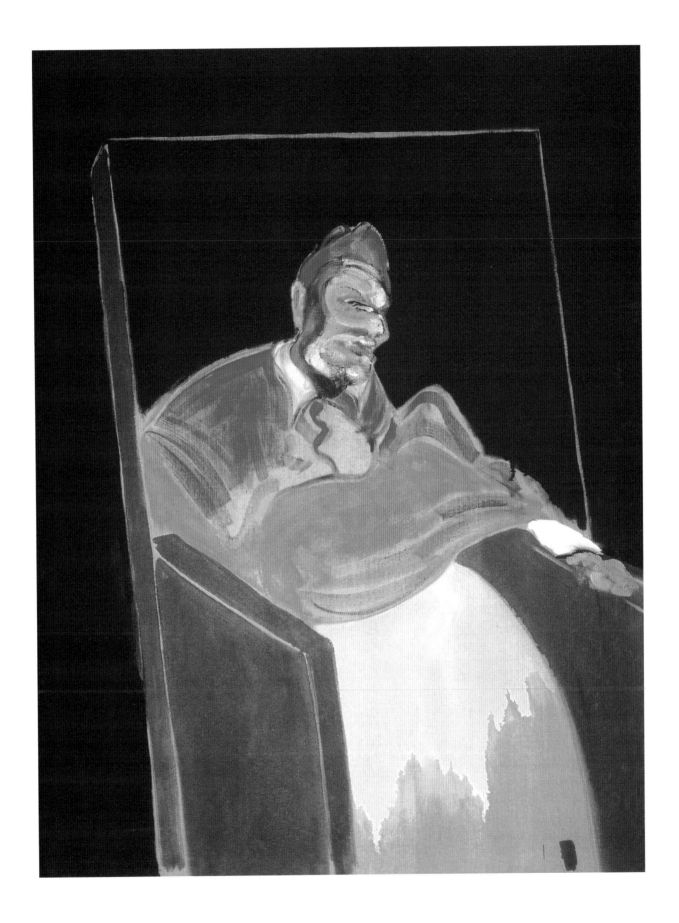

39. LANDSCAPE NEAR MALABATA, 1963

INSCRIBED "LANDSCAPE NEAR MALABATA. TANGIER 1963" ON BACK OF CANVAS
OIL ON CANVAS, 78 × 57 INCHES (198 × 145 CM)
LIT: R + A 215; PEPPIATT 1996, PP. 173, 176
EXH: *FRANCIS BACON: RECENT WORK,* MARLBOROUGH FINE ART, LONDON,
JULY–AUG. 1963 (7); PARIS 1971–2 (47); TOKYO 1983 (20); TATE 1985 (41);
HIRSHHORN 1989–90 (25); LUGANO 1993 (30); PARIS + MUNICH 1996–7 (41)
COURTESY OF IVOR BRAKA LTD., LONDON

Bacon first visited Tangier in 1956 to see his friend, Peter Lacy, and continued to return
for quite long visits until the early 1960s. This, one of his few landscapes, was painted
from memory in London a year after Lacy's death, and it had a particular poignancy for
him, as it shows the landscape in which his former lover had been buried.[1] The authorities in Tangier were tolerant towards the large expatriate homosexual community, which
had included such "Beat Generation" poets as Allen Ginsberg, and authors Tennessee
Williams and William Burroughs (of *The Naked Lunch* notoriety).

The brilliant light and exoticism of Tangier caught Bacon's imagination, although
he found it hard to complete work there, complaining that the light was too strong.[2]
Nevertheless, some of that intensity has been carried over into *Landscape near Malabata,*
where yellow sand is contrasted with a murky, reddish-brown sky and framing foreground. The central elliptical shape appears almost as a stage on which a mysterious
drama unfolds in a furious, whirling desert storm. The speeding dark shape in the foreground may be a hunting dog careering around the track.[3]

1. Peppiatt 1996, p. 173.
2. Bacon-Sylvester, *Interview* 9 (1984–86), p. 190.
3. William Feaver, "Shock Treatment." in *London Magazine,* 11, No. 6 (Feb.–March 1972), p. 123.

40. PORTRAIT OF A MAN WITH GLASSES III, 1963
OIL ON CANVAS, 13½ × 11½ INCHES (33.7 × 28.7 CM)
LIT: R + A 219
EXH: *FRANCIS BACON,* MARLBOROUGH NEW LONDON GALLERY, LONDON, JULY–AUG.
1963 (NOT IN CAT.); PARIS + MUNICH 1996–7 (39)
COURTESY OF IVOR BRAKA LTD., LONDON

The third of four paintings with this title and subject, this is probably the most dramatic and disquieting of the series. The dark voids of the lenses, the sickly flesh tones, and the collapsing forms suggest a death's head, with the eye sockets defined by the spectacles perched lopsidedly on the face. The nose has disappeared, and there is an air of menace, of dissolution. Some of the textural variety has been obtained by pressing coarse-woven cloth into damp pigment.

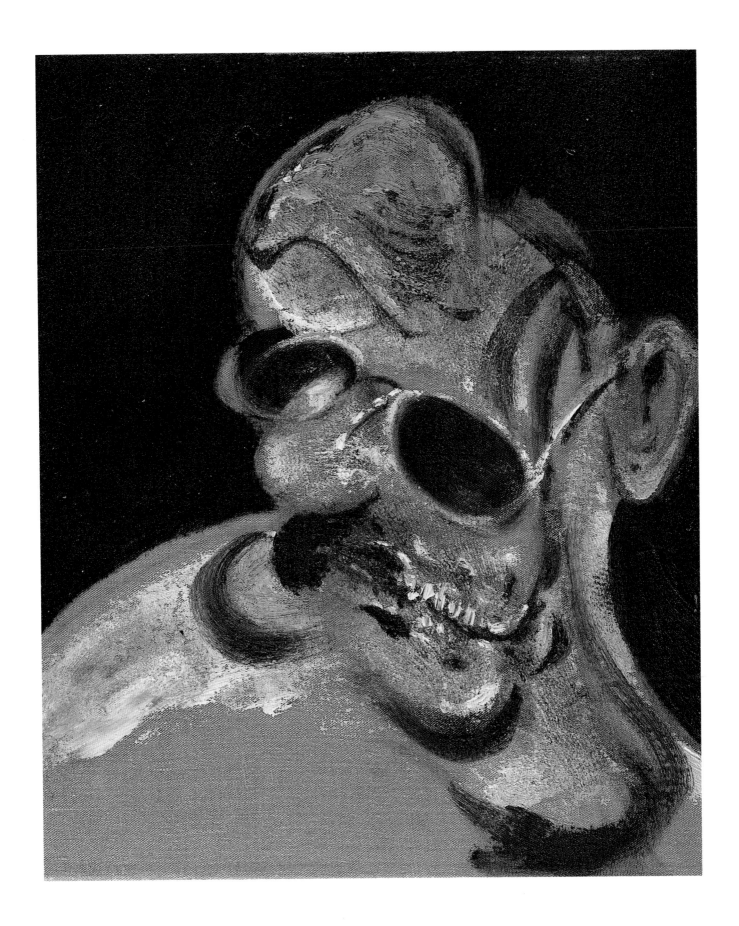

41. STUDY FOR SELF-PORTRAIT, 1964
OIL ON CANVAS, 66 × 55 INCHES (155 × 140 CM)
EXH: *FRANCIS BACON: RECENT PAINTINGS,* MARLBOROUGH FINE ART, LONDON,
JULY–AUG. 1965 (3)
RICHARD NAGY, DOVER STREET GALLERY, LONDON

Compared to his 1956 *Self-Portrait* (see above, no. 27), Bacon has wrought even greater havoc with himself, particularly in the face, where the features are twisted almost beyond recognition. As in the earlier work, the general pose is informal, with legs crossed, and again Bacon is perched on the edge of a couch, his fleshy forearms, of which he was somewhat vain,[1] prominently exposed and his hands clasped into his lap. His left trouser leg seems to be contorted into corkscrew folds, as if both to emphasize the dynamic, twisting pose and paradoxically, to act as an anchor holding the composition together. A dark rectangular shape, which could be a projecting wall cabinet, acts as a foil to the head; paint is lightly airbrushed around this rectangle, recalling the heavily blood-spattered central panel of *Three Studies for a Crucifixion,* 1962 (Solomon R. Guggenheim Museum, New York). The artist inflicted a similarly violent treatment upon himself in *Study for a Self-Portrait,* 1963 (National Museum of Wales, Cardiff), where he depicted himself slouched down on a curved sofa, with his arms again a focal point.

1. Peppiatt 1996, pp. 114–15.

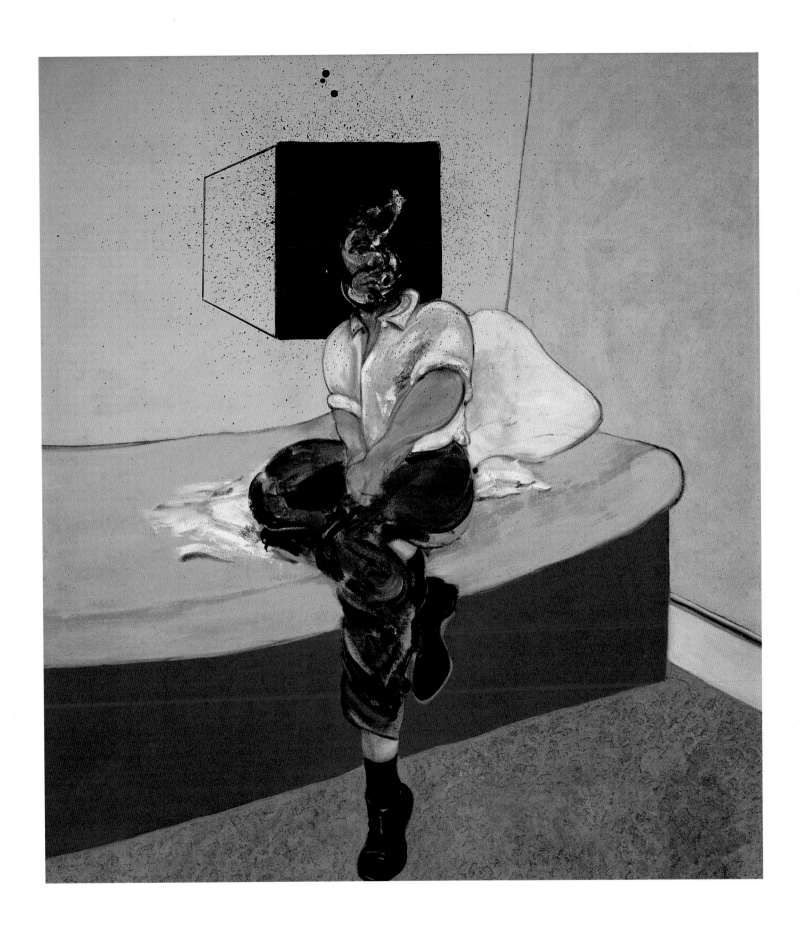

42. STUDY FOR PORTRAIT OF ISABEL RAWSTHORNE, 1964

Oil on canvas, 78 × 56 inches (198 × 147.5 cm)
Lit: Peppiatt 1996, pp. 204–5
Exh: Paris 1971–2 (55); Tate 1985 (43); Lugano 1993 (31)
Private Collection — Courtesy Fine Arts & Projects, Mendrisio

Isabel Rawsthorne

Isabel Rawsthorne (1912–92) became Bacon's close friend in the early 1960s, and was herself a talented artist and stage set designer. The daughter of a master mariner, she was married, first, to the foreign correspondent of *The Daily Express,* Sefton Delmer, then became the wife, successively, of two composers, Constant Lambert and Alan Rawsthorne. She had been the model and assistant to the sculptor Jacob Epstein before studying in Paris at the Grande Chaumière, Montparnasse in the 1930s. There she earned her keep by posing for André Derain and several other artists, including Alberto Giacometti, with whom she had a close, lifelong relationship.

Rawsthorne's strong, handsome features, long auburn hair, and vivacious, forthright personality inspired some of the grandest of Bacon's portraits. She is here shown spotlit, as if in a darkened studio, with the floor space defined by a trapezoidal pink plane; she sits cross-legged on a chair, in a slightly twisted pose, and seems to be caught turning her head. Along the dark foreground strip, a strange shadow appears, which might perhaps be the cast shadow of the painter.

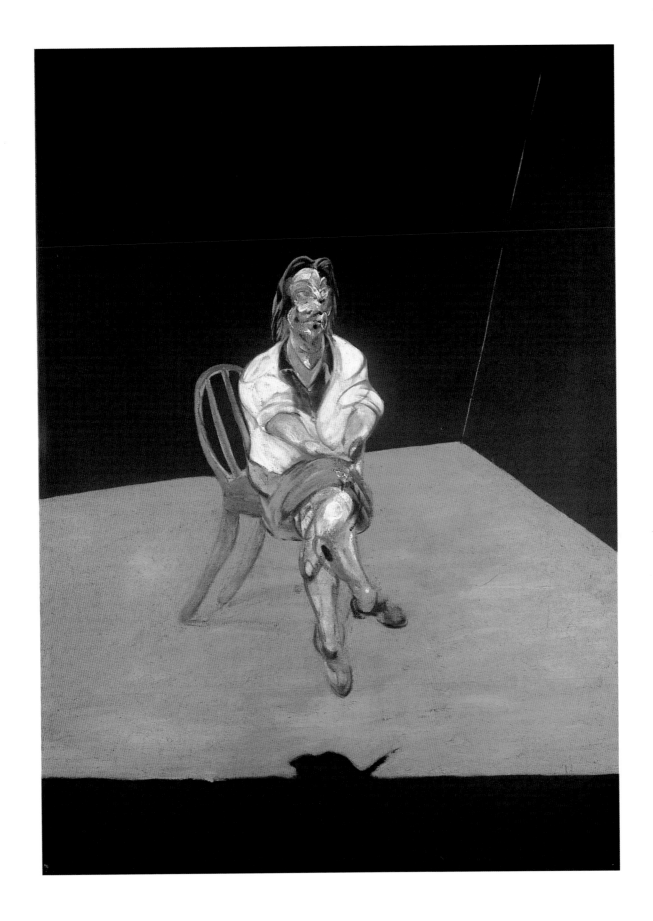

43. THREE STUDIES FOR PORTRAIT OF GEORGE DYER (ON LIGHT GROUND), 1964

Oil on canvas, triptych, each panel 14 × 12 inches (35.5 × 30.5 cm)
Exh: *Francis Bacon: Recent Paintings*, Marlborough Fine Art, London,
July–Aug. 1965 (1); Paris 1971–2 (53); Lugano 1993 (33)
Private Collection, Milan

These studies were painted soon after Bacon met Dyer in the autumn of 1963, when they became intimate friends.[1] Bacon has used the triptych form rather as an extension of the "polyfoto" multiple photographic images obtained from automatic photography booths; following his usual practice, he has worked from memory, complemented by still photographs of the sitter. Dyer's bullet-shaped head, prominent nose, and slicked-back quiff of hair are defining elements in each of the three views, all instantly recognizable despite the apparent distortions. The artist has left the brown canvas bare to describe the fawn-colored sweater worn by the sitter; he always painted on the reverse, unprimed side of the canvas.

1. See below, *Study of George Dyer*, 1971 (no. 51) for further biographical details of Dyer.

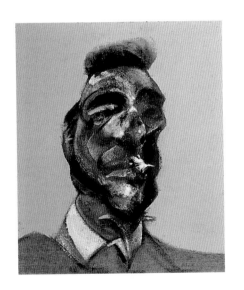 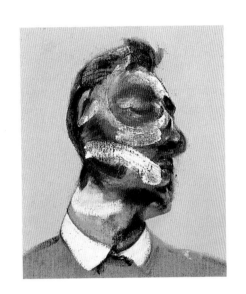 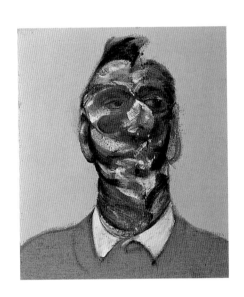

44. PORTRAIT OF GEORGE DYER TALKING, 1966
OIL ON CANVAS, 78 × 58 INCHES (198 × 147.5 CM)
LIT: LEIRIS 1988, PL. 38
EXH: *FRANCIS BACON: RECENT PAINTINGS,* MARLBOROUGH FINE ART, LONDON,
MARCH–APRIL 1967 (8); PARIS 1971–72 (65); LUGANO 1993 (35)
PRIVATE COLLECTION

Bacon painted George Dyer many times and in a variety of ingenious poses: crouching, riding a bicycle, shaving, reflected in a mirror and, as here, seated on a revolving office stool. He appears, center stage, in a luridly colored setting, a blind cord mysteriously swinging above his forehead, its cast shadow seen on the curved wall behind, the whole scene lit by a menacing naked lightbulb — a feature of the artist's own austerely furnished studio.

Dyer appears to writhe in a contorted pose with his legs crossed, as if caught in mid-action as he twirls himself round on the stool, papers scattered away from his summarily sketched-in left foot. His head is framed in an opening which may be either a window or a door, or even a trimmed photograph of Dyer's head pinned to the back wall. Spatial ambiguities abound, as Dyer's body seems to defy the normal conventions of perspective by linking background to foreground.

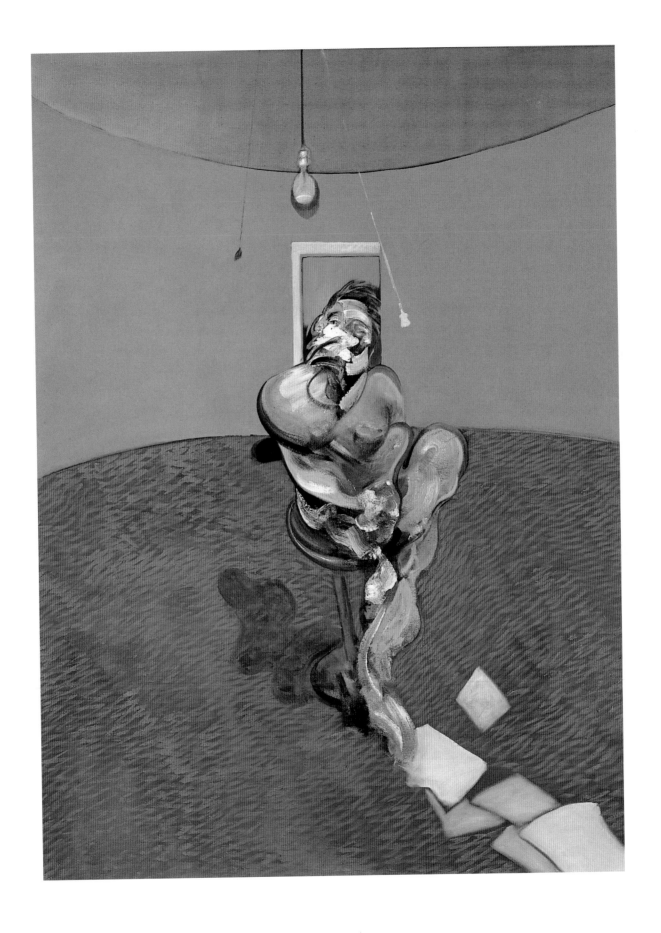

45. THREE STUDIES OF MURIEL BELCHER, 1966
TITLED AND DATED ON BACK
OIL ON CANVAS, TRIPTYCH, EACH PANEL 14 × 12 INCHES (35.5 × 30.5 CM)
EXH: *FRANCIS BACON: RECENT PAINTINGS,* MARLBOROUGH FINE ART, LONDON,
MARCH–APRIL 1967 (11); PARIS 1971–72 (66); TATE 1985 (50); PARIS + MUNICH
1996–7 (49)
PRIVATE COLLECTION

Muriel Belcher (1908–79) ran the Colony Room, Dean Street, in the heart of London's Soho, as a drinking club and meeting place for artists and writers, from 1948 until her death in 1979.[1] She and Bacon became firm friends soon after the opening of the club, and he helped her to create the atmosphere of seedy conviviality for which it became famous. A painting by Michael Andrews (1928–95), *The Colony Room I* (1962) captures the ambience in it; and Bacon is shown, back view, but unmistakably recognizable, seated at the bar and talking to Muriel Belcher; other habitués depicted include Lucian Freud, Henrietta Moraes, John Deakin, and Bruce and Jeffrey Bernard.

The portraits are not likeness in the conventional sense, rather they capture the essence of the sitter: her prominent nose, flowing hair, strongly arched eyebrows, and aquiline profile, all set against a dark gray-green background (see p. 13). She is seen in three positions: half-profile looking to the spectator's right, full-face, and half-profile looking to the spectator's left. Each conveys a subtly varied aspect of the sitter, with changes in the palette to suggest different moods; the last, for example, is painted in predominantly blue-gray tones, in contrast to the fierce, aggressive reds of the center panel, and the light colors of the left-hand panel. This juxtaposing of three views has also been compared to police photographs, or "mug shots," and Bacon is known to have visited the London Metropolitan Police's Black Museum at Scotland Yard.[2] Bacon has used photos taken by John Deakin in 1959, but he has first "destroyed" the image so as to allow himself to reconstruct it. Or, in his own words: "What I want to do is to distort the thing far beyond appearance, but in the distortion to bring it back to a recording of the appearance."[3]

1. Peppiatt 1996, pp. 156–58, 289–90, 333 n. 4.
2. Paris + Munich 1996–7, sv. 49; Russell 1971–93, p. 71.
3. Bacon-Sylvester, *Interview 2* (1966), p. 40.

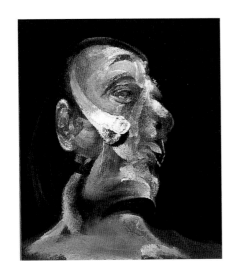 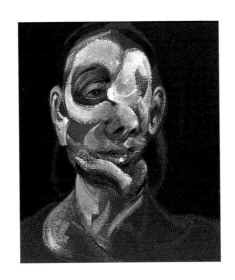 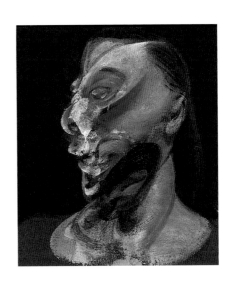

46. THREE STUDIES OF LUCIAN FREUD, 1969

OIL ON CANVAS, TRIPTYCH, EACH PANEL 78 × 58 INCHES (198 × 147.5 CM)
EXH: TATE 1985 (59, RIGHT-HAND PANEL ONLY SHOWN)
PRIVATE COLLECTION—COURTESY FINE ARTS & PROJECTS, MENDRISIO

During the 1960s, Bacon painted several small studies of the head of his fellow painter and close friend, Lucian Freud (born 1922), either singly, or as one of a group of three, or in a series of three. He also completed two large triptychs, *Three Studies for Portrait of Lucian Freud,* in 1964 and 1966, where in one Freud appears seated, in three slightly different poses, on a bench in a sparsely furnished room, and in the other in a purplish-red armchair set on a blue-patterned carpet.[1]

In this triptych, Freud is seated on a cane-bottomed chair like those in Bacon's studio, but he also incorporates a headboard which appears in John Deakin's photographs of Freud sitting on a bed.[2] About the triptych format, which Bacon first used in 1944, he explained: "I see images in series. And I suppose I could go on long beyond the triptych and do five or six together, but I find the triptych is a more balanced unit."[3] He also insisted that the upright format panels, which he preferred, should be framed and hung separately and not together in one frame, for "it ruins the balance. . . . if I'd wanted to do that, I would have painted them a different way."[4] Bacon began to use a curved eye line in these triptychs, an echo of the tall curved bow windows of his childhood homes in Ireland.[5] This heightens the stagelike quality of the setting against which the sitter displays different aspects of his personality. Bacon also begins to use bright, clear colors for his backgrounds, in this picture a sharp lemon yellow.

1. Repr. in Paris + Munich 1996–7, p. 61, and Leiris 1988, no. 39.
2. Davies + Yard 1986, p. 48, and Bacon-Sylvester, *Interview 2* (1966), repr. p. 40.
3. Bacon-Sylvester, *Interview 3* (1971–73), pp. 84ff.
4. Ibid., p. 88.
5. Peppiatt 1996, p. 13; *Francis Bacon in conversation with Michel Archimbaud* (1993), p. 154.

(Illustrated on pp. 154–156)

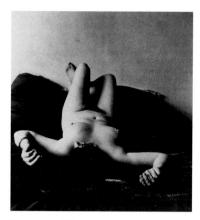

Henrietta Moraes

Edouard Manet
Olympia, *1863*
Oil on canvas, 51 × 74¾"
Musée d'Orsay, Paris

Edouard Manet
A Bar at the Folies-Bergère,
1881–82
Oil on canvas, 37½ × 51"
Courtauld Institute Galleries,
London

47. STUDY OF A NUDE WITH FIGURE IN A MIRROR, 1969

OIL ON CANVAS, 78 × 58 INCHES (198 × 147.5 CM)
LIT: RUSSELL 1971–93, PP. 143–44; DAVIES + YARD 1986, PP. 59–62
EXH: PARIS 1971–2 (88); TATE 1985 (65)
COURTESY OF IVOR BRAKA LTD., LONDON

The sprawling female nude is based on John Deakin's photographs of Henrietta Moraes, former wife of the Indian poet, Dom Moraes, whom Bacon met in the early 1960s when she became one of his favorite models.[1] As always, Bacon did not work directly from her, but knew Henrietta well enough to be able to call on remembered images of her, supplemented by photographs.

Moraes appears as if on an operating theater trolley, and her tortured pose is almost a parody of the classical odalisque, with the added dimension of a smiling bowler-hatted male onlooker, seated on a bar stool, whose reflection is seen in the mirror. It is as if Bacon had painted a composite modern version of Manet's *Olympia* (1863) and *A Bar at the Folies-Bergère* (1881–82). We become the implied voyeuristic observer, much as Degas suggests in his keyhole views of women at their toilet. By including the mirror, Bacon also breaks down the hermetic space inhabited by many of his subjects, for we are asked to imagine the existence of a space outside the confines of the room. The predominantly pastel shades of blue and pink, and the sharply defined cast shadow, add to the hothouse atmosphere of a brilliantly lit arena.

1. Peppiatt 1996, pp. 209–10; See Bacon-Sylvester, *Interview 2* (1966), p. 41, for a photograph of her.

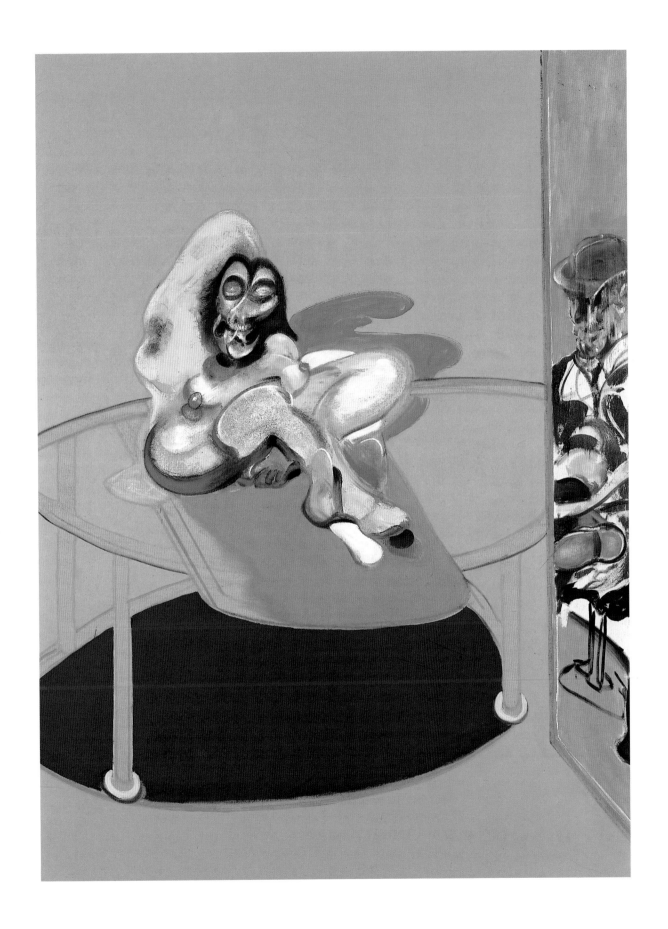

48. THREE STUDIES OF HENRIETTA MORAES, 1969
OIL ON CANVAS, TRIPTYCH, EACH PANEL 14 × 12 INCHES (35.5 × 30.5 CM)
EXH: GALLERIA GALATEA, TURIN, MARCH–APRIL 1970 (9); PARIS 1971–2 (85);
TATE 1985 (63); LUGANO 1993 (40)
PRIVATE COLLECTION — COURTESY FINE ARTS & PROJECTS, MENDRISIO

Bacon's series of triple portrait heads allowed him to explore different facets of his sitter's appearance, a process he described as one of near-total destruction and distortion leading to reconstruction. All his portraits were done from memory, and from photographs of his friends, of whom Henrietta Moraes was one among several women he met in Soho (see above, no. 47).

On a bright yellow background, the three heads show Henrietta Moraes's left and right profiles and a central, full-face view. In the process of destruction and reconstruction Bacon miraculously captures the essence of the sitter's appearance.

147

49. TRIPTYCH — STUDIES OF THE HUMAN BODY, 1970
SIGNED, TITLED, AND DATED ON THE BACK
OIL ON CANVAS, TRIPTYCH, EACH PANEL 78 × 58 INCHES (198 × 147.5 CM)
LIT: RUSSELL 1971–93, P. 102; LEIRIS 1988, P. 16
EXH: PARIS 1971–2 (102); NEW YORK 1975 (10); MEXICO 1977 (2); CARACAS 1978
(2); TOKYO 1983 (25); TATE 1985 (73); *BACON–FREUD: EXPRESSIONS*, FONDATION
MAEGHT, SAINT-PAUL, 4 JULY–15 OCT. 1996 (19); PARIS + MUNICH 1996–7 (60);
LONDON 1998 (17)
MARLBOROUGH INTERNATIONAL FINE ART

This triptych was painted in December 1970. Three female nudes are perched uncomfortably on a curved metal bar, which unites all three panels; the central figure is shaded by a black umbrella. The symbolism of the open umbrella has been interpreted by Freud as a specifically female, vaginal, feature (a closed umbrella being likewise phallic).[1] Russell points out that this feature was derived from a photograph of a bird diving down out of the sky in Rhodesia. The device of objects set in a cagelike structure or strung out along a rod appears in the sculpture of Giacometti of the 1930s, and more recently, in Eduardo Paolozzi's *Forms on a Bow* (1949, Tate Gallery). Bacon greatly admired Giacometti both for his work and his austere style of living.[2] This analogy with sculpture is relevant because Bacon had himself considered making sculptures on a kind of armature, a very large armature made so that the sculpture could slide along it and people could even alter the position of the sculpture as they wanted.[3] There are also distant echoes from Michelangelo's figures of Day and Night, and Dawn and Evening, on the Medici Tombs in S. Lorenzo, Florence. Bacon knew Michelangelo's work well and much admired it — especially the fleshy nudes.[4]

The bland, undifferentiated pale lilac background of all three panels appears to negate space; both the side figures seem to float, while the central anchor figure is given a sort of shallow platform, which suggests there is a solid support or pivot for the figures. Sylvester has noted that the head of the figure in the right-hand panel appears to be a self-portrait.[5] He also observes that the eyes are blind, and speculates that it might be an image of Tiresias, as described in T .S. Eliot's *The Waste Land*: "I Tiresias, though blind, throbbing between two lives,/ Old man with wrinkled female breasts . . ."

1. Peppiatt 1996, pp. 116–17, cites Freud's *The Interpretation of Dreams*.
2. Peppiatt, ibid., p. 206.
3. Bacon-Sylvester, *Interview 4* (1974), p. 108.
4. Peppiatt 1996, pp. 224–26.
5. London 1998, p. 38.

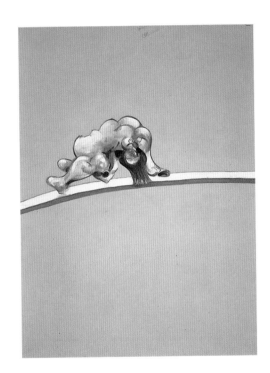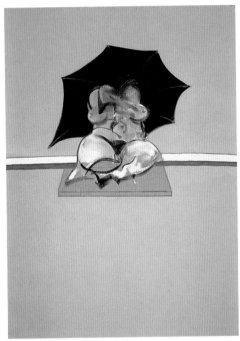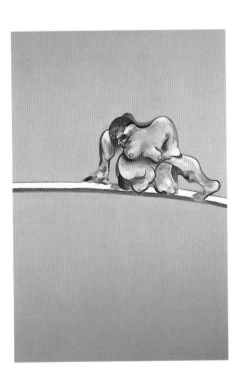

50. TRIPTYCH — STUDIES FROM THE HUMAN BODY, 1970
OIL ON CANVAS, TRIPTYCH, EACH PANEL 78 × 58 INCHES (198 × 147.5 CM)
LIT: RUSSELL 1971–93, PP. 65–66; DAVIES + YARD 1986, P. 77
EXH: PARIS 1970–71 (102); NEW YORK 1975 (10); TATE 1985 (69); LONDON 1998
(16)
PRIVATE COLLECTION

The center panel, which shows two male figures coupling, is a further variation on a
theme first explored in *Two Figures,* 1953 (R + A 75), itself based on a Muybridge pho-
tograph of two wrestlers.[1] Bacon reworked the theme many times, and here he has sim-
plified the forms and made them more sculptural in comparison with the earlier work,
where the figures are brushed in more impressionistically. The left panel is harder to
interpret; it appears to show a dwarflike figure, whose arms are depicted in a flurry of
movement, producing multiple images and shadows, the whole apparently reflected in
an open mirror-plated door, through which is glimpsed part of yet another figure lying
on a couch and conflated with the reflected image.

The motif of the open door is repeated in the right-hand panel, but again, the
voyeuristic photographer, with his old-fashioned, heavy double-lensed camera and stand,
appears partly as a reflected image. Bacon is that photographer, and his body, like the
reflections in the left-hand panel, bleed over the leading edges of the doors. A chilling
blob of bloody ectoplasm quivers menacingly to the right of the photographer. In both
side panels, the hanging tassel, or toggle light-switch, and torn newsprint on the steeply
tilted floor serve to deny the traditional convention of perspectival recession in favor of a
more flattened-out, vertical picture space.

This triptych, with its lurid orange background, presents us with a disquieting
mixture of specific, identifiable elements, and the elusive, yet familiar, cast of Baconian
nightmare imagery, at once indefinable, but which powerfully evokes disturbing emo-
tions within us. As the artist has told us: "I hate a homely atmosphere, . . . I would like
the intimacy of the image against a very stark background. I want to isolate the image
and take it away from the interior and the home."[2]

1. Bacon-Sylvester, *Interview 3* (1971–73) pp. 102–4.
2. Bacon-Sylvester, *Interview 4* (1974), p. 120, cited in Davies +Yard 1986, loc. cit., who also see an echo
of Velázquez's self-portrait in *Las Meninas,* as a prototype for Bacon's inclusion of himself as onlooker.

(Illustrated pp. 157–159)

51. STUDY OF GEORGE DYER, 1971
OIL ON CANVAS, 78 × 58 INCHES (198 × 147.5 CM)
EXH: PARIS 1971–2 (108); NEW YORK 1975 (13)
PRIVATE COLLECTION–COURTESY FINE ARTS & PROJECTS, MENDRISIO

Bacon met George Dyer in the autumn of 1963, while drinking in a Soho public house. Dyer, an illiterate small-time crook from the East End of London, appealed to Bacon's taste for low life.[1] Although well-built and immaculately turned out, Dyer was a vulnerable figure, becoming increasingly addicted to alcohol and finally committing suicide in a Paris hotel at the time of the *vernissage* for Bacon's first major retrospective in France, held at the Grand Palais from 26 October 1971 to 10 January 1972. When first shown, this picture — one of many portraits of Dyer that Bacon painted from 1964 onwards — was the left half of *Diptych — Study of George Dyer, and Images from Muybridge,* which the artist had lent to the Paris exhibition. He later destroyed the right-hand panel, *Images from Muybridge.*[2] Bacon was to paint several posthumous memorial pictures that included George Dyer, notably *Triptych May–June 1973,* 1973.

Dyer is shown seated on a cane-seated chair against a semi-circular screen, as if on display in a shop window, with an opening off to the left behind this screen, which seems to suggest another figure posing; on the right, a vertical blue panel may be a mirror in which is reflected part of a leg. Dyer's unmistakable bullet head and sharp profile are easily recognizable, but his body appears to be caught in a twisting movement, as he crosses one leg over the other. His left foot rests on a newspaper, and Bacon introduces fragments of Letraset (adhesive ready-made letters) to suggest printed text (but which is illegible), a feature that first appears in paintings of a year earlier, such as *Triptych — Studies from the Human Body,* 1970 (see above, no. 50 and pp. 157–159), and which derives ultimately from Cubism.

1. Russell 1971–93, pp. 160–65; Peppiatt 1996, pp. 206–7, 211–16.
2. A fragment of the woman's head appeared in one of the London sale rooms in 1997.

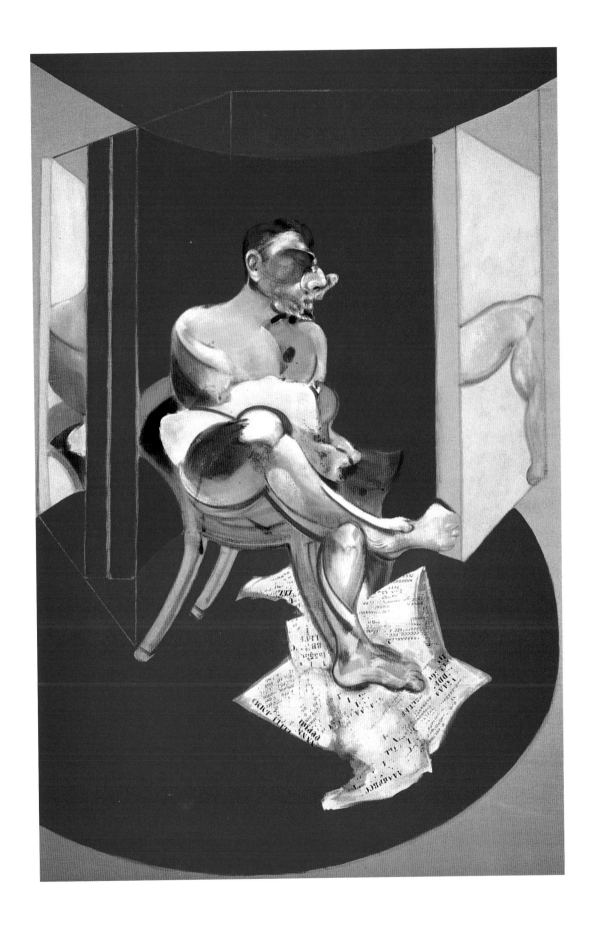

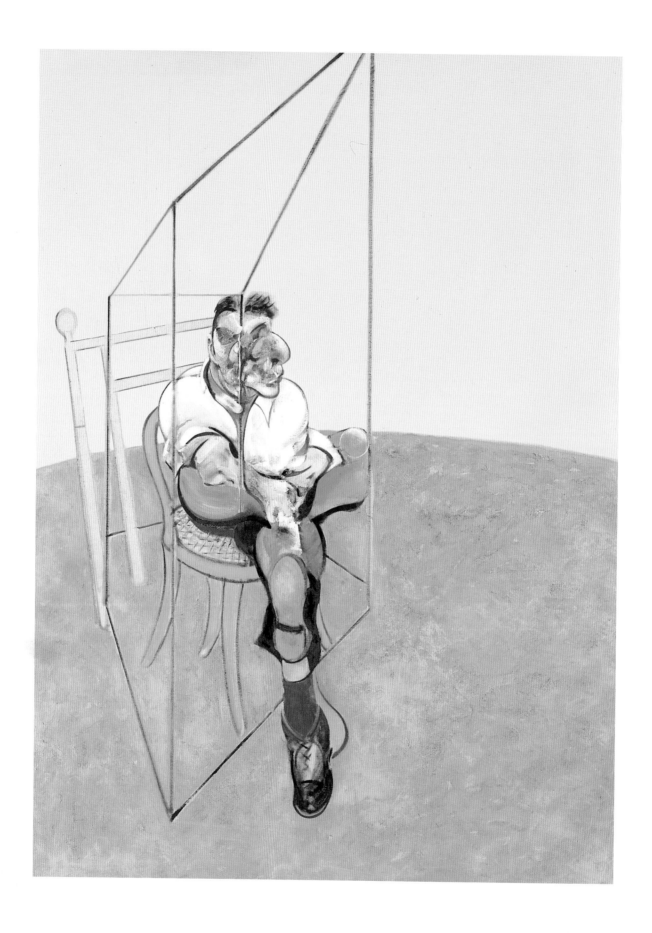

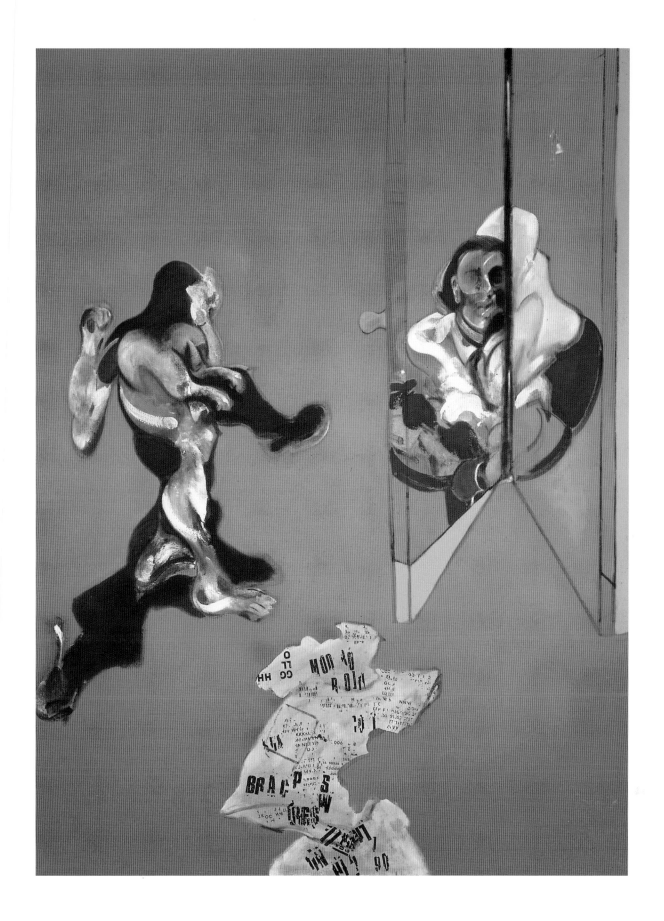

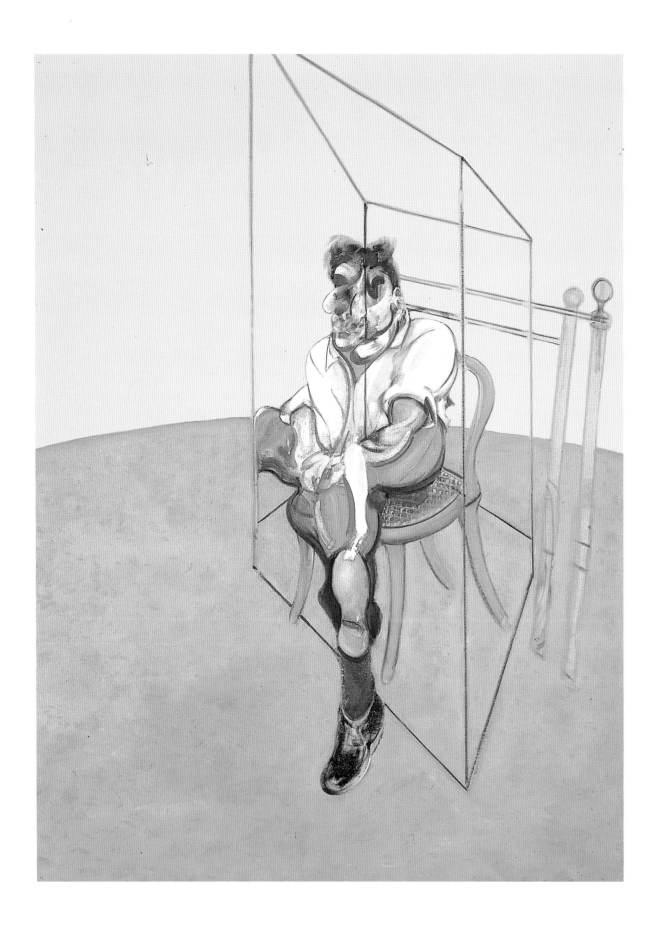

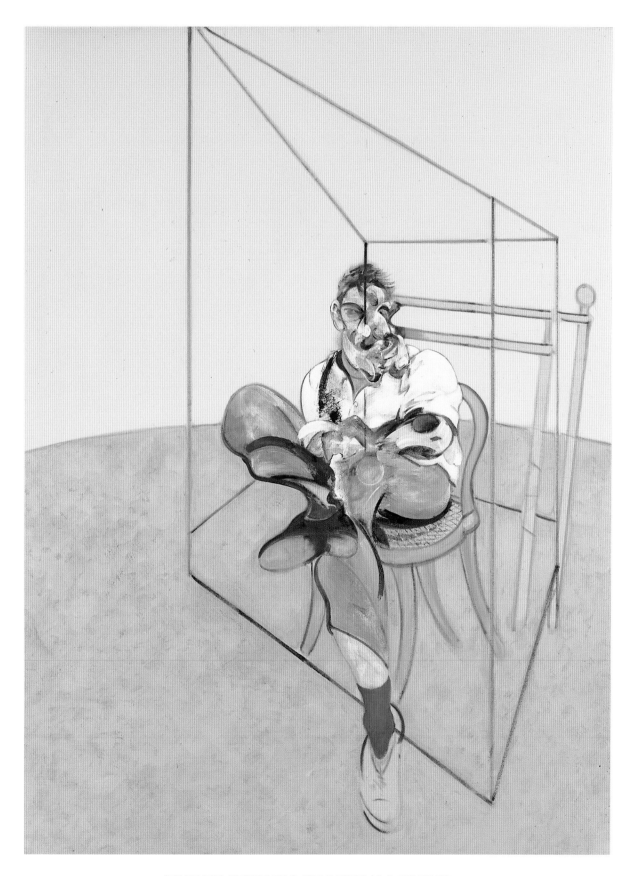

46. THREE STUDIES OF LUCIAN FREUD, 1969

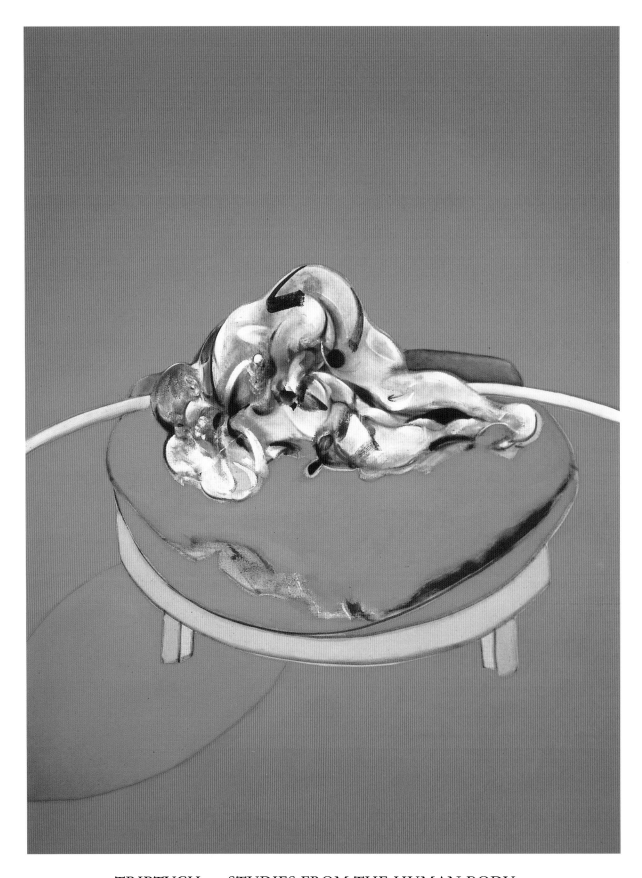

50. TRIPTYCH — STUDIES FROM THE HUMAN BODY, 1970

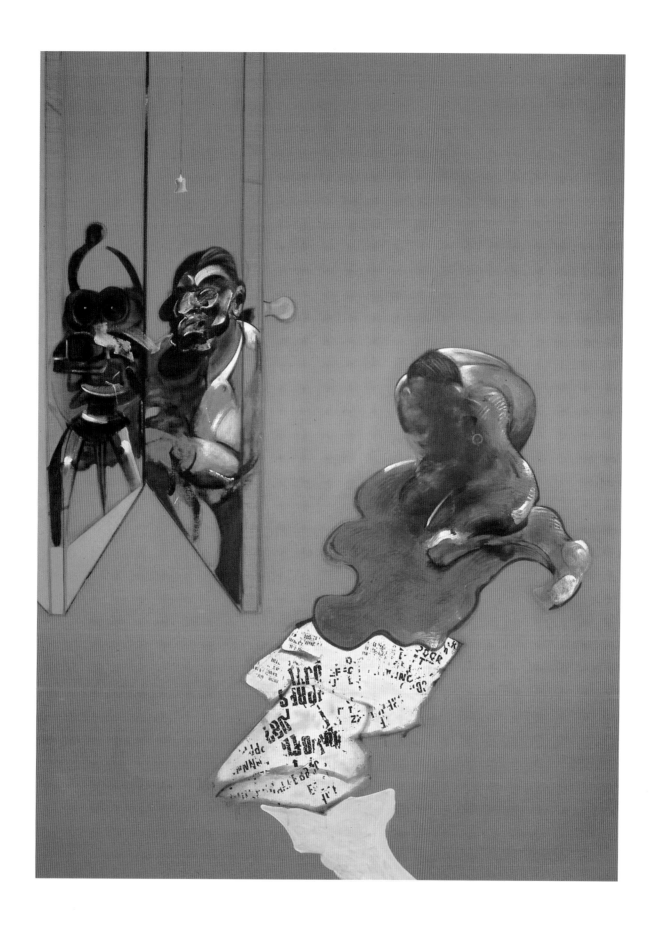

52. STUDY FOR SELF-PORTRAIT, 1973
OIL ON CANVAS, 14 × 12 INCHES (35.5 × 30.5 CM)
EXH: TATE 1985 (83)
PRIVATE COLLECTION

In this profile view of the artist, his right hand and arm are raised to the side of his face,
giving his wristwatch prominence. The image is extraordinarily compressed, its dra-
matic effect heightened by the pale blue background.

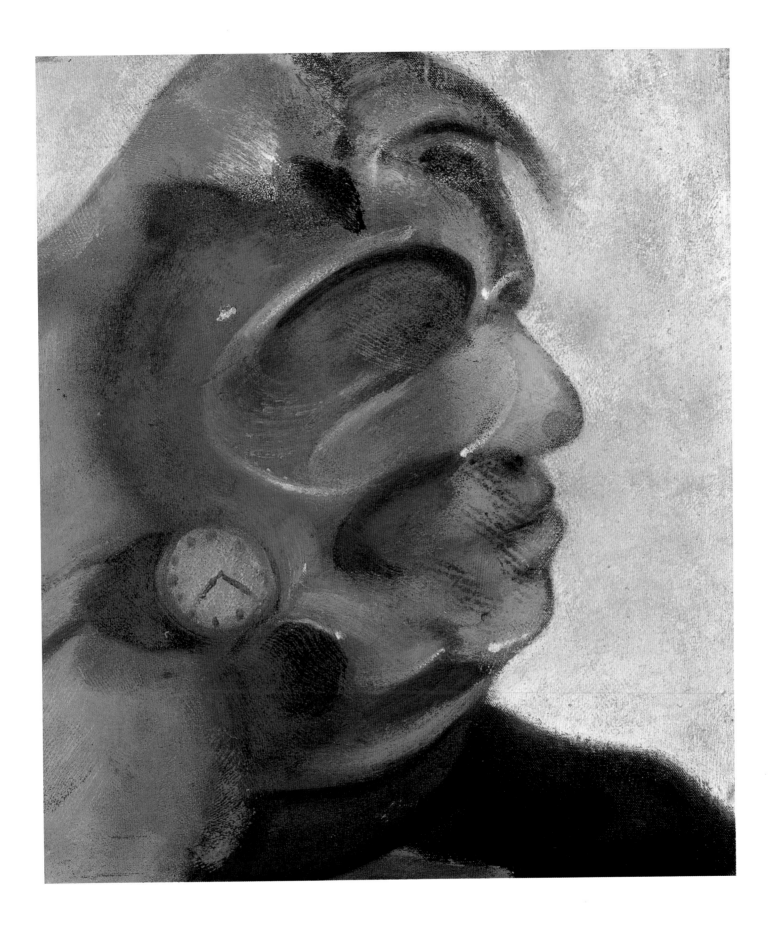

53. SELF-PORTRAIT, 1973
OIL ON CANVAS, 78 × 58 INCHES (198 × 147.5 CM)
EXH: NEW YORK 1975 (28); TATE 1985 (84); LUGANO 1993 (44)
PRIVATE COLLECTION

The full-length *Self-Portrait* of 1956, is the first surviving self-portrait (see above, no. 27).[1] Both that painting and this one show a seated figure, and both were painted from memory, not from looking in a mirror, as indeed were all his self-portraits.[2]

Bacon painted several self-portraits in the wake of George Dyer's death, in both the small (14 x 12 inches) and large formats that he adopted as standard from the 1960s. These encapsulate the torment and grief he felt. The washbasin, poised in unbelievable mid-air, symbolizes Dyer's tragic end in the Hôtel des Saints-Pères, Paris; Bacon's somber clothes, the purple cast shadow, evil-looking naked lightbulb, and above all, his anguished posture — head held in hand — all forcefully convey a mood of mourning and sadness. The mirror behind reflects a back view of the slumped figure, caught off guard. Bacon sadly remarked in 1975: "I loathe my own face, and I've done self-portraits because I've had nothing else to do." . . . "people have been dying around me like flies and I've had nobody else to paint but myself."[3] The wristwatch prominent on his arm also reminds us of the transitory nature of our existence: "Time does not heal. There isn't an hour of the day that I don't think about him [George Dyer]."[4]

1. R + A 110; probably painted January/early February 1956.
2. Peppiatt 1996, pp. 250–51.
3. Bacon-Sylvester, *Interview* 5 (1975), p. 129.
4. Cited by Jill Lloyd and Michael Peppiatt in Lugano 1993, sv. 44.

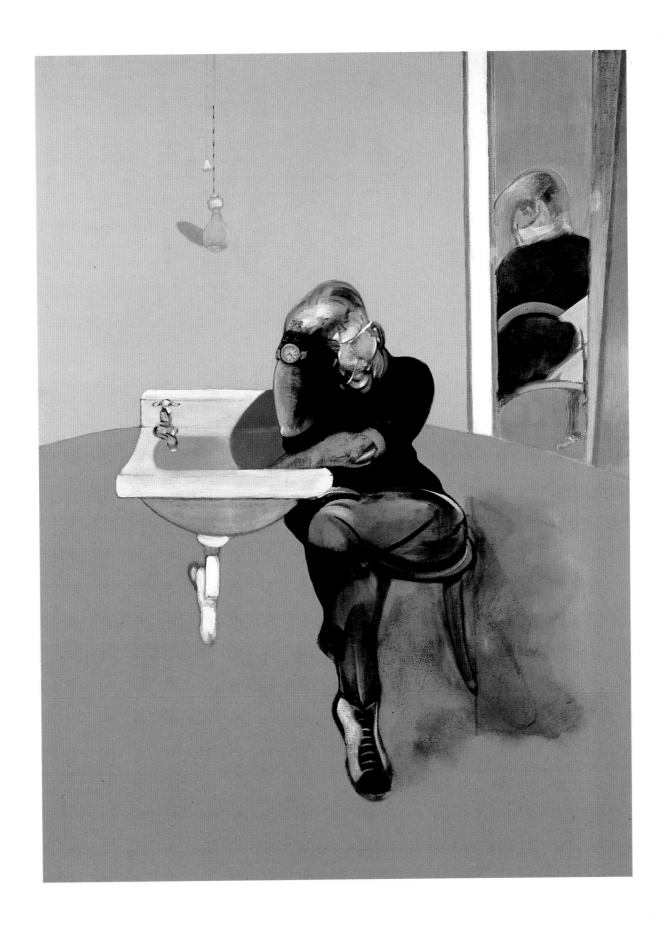

54. SELF-PORTRAIT, 1973
OIL ON CANVAS, 78 × 58 INCHES (198 × 147.5 CM)
EXH: NEW YORK 1975 (30); TATE 1985 (86); LUGANO 1993 (45)
PRIVATE COLLECTION

It is instructive to compare this *Self-Portrait* with the slightly earlier one (see above, no. 53), for both epitomize his emotional turmoil following George Dyer's death, and it is not too fanciful to see the broad black strip of curtain on the left of the painting (and which obliterates a chair) as a symbol of mourning and loss. The artist's pose is even more tense and contorted than in the previous picture; the artist seems about to topple off the chair, and the strong diagonals of the steeply tilted floorboards add to the feeling of catastrophe; the ripped shred of newsprint intrudes across the spotlit lighter area of the floor, and the prominently worn wristwatch once again underlines the transient nature of human life.

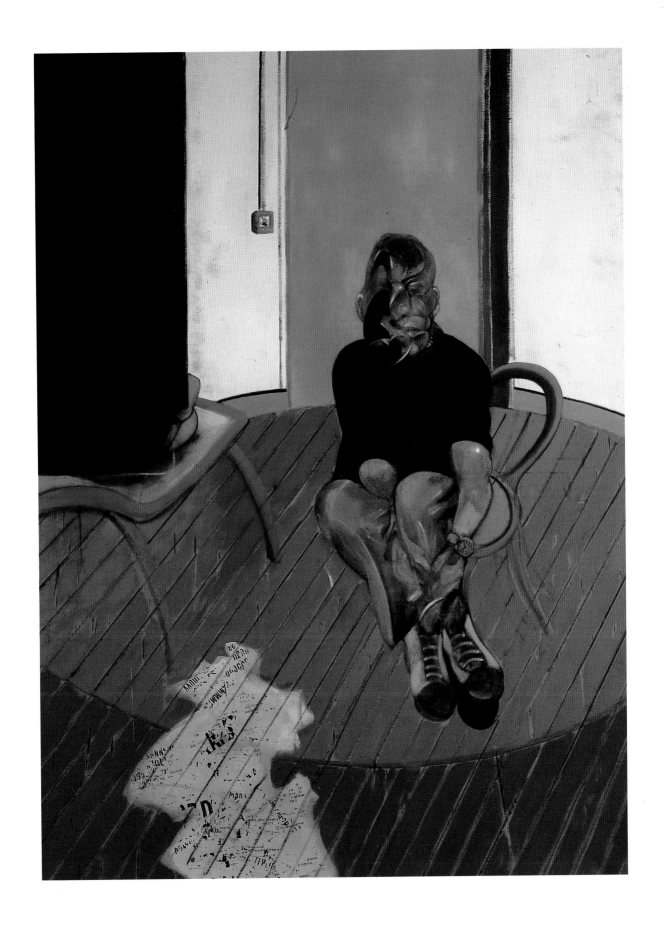

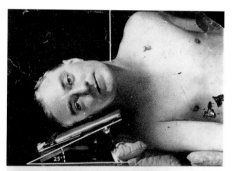

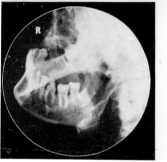

Page from K. C. Clark,
Positioning in Radiography,
1939 (detail).

55. FIGURES IN MOVEMENT, 1973
OIL ON CANVAS, 78 × 58 INCHES (198 × 147.5 CM)
LIT: LORENZA TRUCCHI, *FRANCIS BACON*, MILAN (1975), NO. 173
PRIVATE COLLECTION — COURTESY OF FAGGIONATO FINE ARTS, LONDON

Unusually, Bacon has chosen to place his two figures on what appears to be a street side-walk; they are shown naked, but one figure wears either trainers' or boxers' boots, which suggests two pugilists are perhaps shadowboxing with an almost balletic elegance. A bland, anonymous background, with only the sharp vertical of a dark doorway on the left to contain the composition, gives no hint of the ambience. The artist has used two circles, one of which is only partially complete, to counterbalance the vertical emphasis of the doorway, a convention borrowed from photographs published in Kathleen Clara Clark's *Positioning in Radiography* (1939). Bacon studied the photographs in this book assiduously, and he used them as models for the poses of bodies as well as exploiting the X-ray photographs themselves.[1]

1. Peppiatt 1966, pp. 224, 269, and 333 n. 1. The book consists of a collection of over 2,500 plates compiled by K. C. Clark. See also Lawrence Gowing, "Positioning in Representation," *Studio International*, Vol. 832, no. 940, January 1972, pp. 14–22.

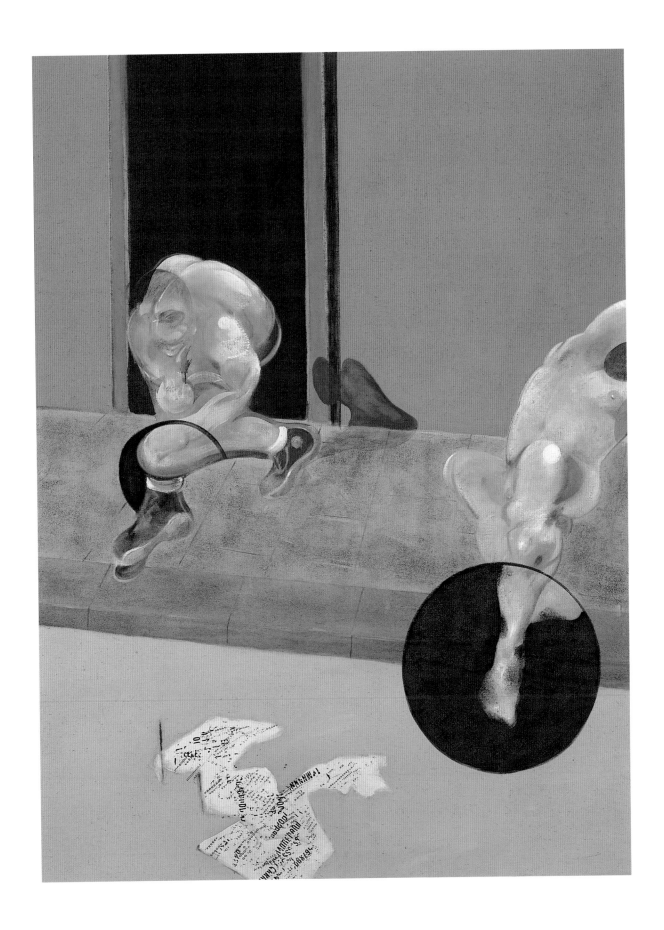

56. THREE STUDIES FOR A PORTRAIT OF PETER BEARD, 1975

OIL ON CANVAS, TRIPTYCH, EACH PANEL 14 × 12 INCHES (35.5 × 30.5 CM)
LIT: LEIRIS 1988, PL. 98; PEPPIATT 1996, PP. 263, 271–72
EXH: TATE 1985 (91)
COLLECTION JUAN ABELLÓ

One of two sets of three studies of the head and shoulders of Peter Beard, a handsome American photographer and author, whom Bacon had first met some ten years earlier, painted in 1975. He painted a third small triptych of Peter Beard, shown against a pale green background, in 1980.[1] Here, he uses a dark ground after the manner of the Old Masters, and imparts a somber gravity to the sitter's head, which is viewed sequentially: first shown turned slightly to the spectator's right, then seen centrally head-on, and in the right-hand panel, turned half-left. Splashes of white paint appear in all three, and give the appearance of fortuitous highlights, as if the head were caught in the glare of a photographic flashbulb. These "random" patches of paint appear again in *Triptych* 1976 (no. 57).

1. Exhibited at Marlborough Fine Art, London, *Francis Bacon 1909–1992: Small Portrait Studies,* 21 Oct.–3 Dec. 1993 (29). A small *Etude d'un Portrait*, titled, signed, and dated 1978, a head and shoulders study of Peter Beard, also exists.

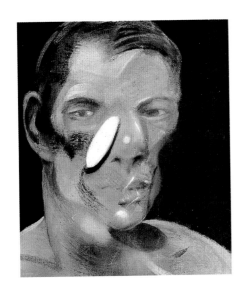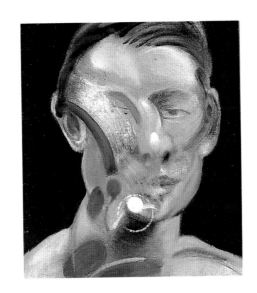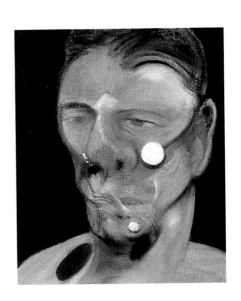

57. TRIPTYCH, 1976
TITLED, SIGNED, AND DATED ON THE BACK
OIL AND PASTEL ON CANVAS, TRIPTYCH, EACH PANEL 78 × 58 INCHES (198 × 147.5 CM)
EXH: *DOCUMENTA VI*, KASSEL 1976; TATE 1985 (98); LUGANO 1993 (47); *BACON-FREUD: EXPRESSIONS*, FONDATION MAEGHT, SAINT-PAUL, 4 JULY–15 OCT. 1995 (22);
PARIS + MUNICH 1996–7 (71)
PRIVATE COLLECTION

One of Bacon's grandest and most enigmatic triptychs, this work contains many motifs familiar from earlier works, but which are here combined in a new and startling fashion. The left- and right-hand panels present menacing inset head-and-shoulder images of seemingly impassive men like those seen on huge advertising billboards, who might be politicians or pop stars. The central panel is filled with whirling vulturelike birds, who feast on a riven corpse, in a modern version of the Prometheus myth.[1] Of the predatory beasts in the foreground, a similar one has appeared before, in *Seated Figure, 1974.*

The elongated head in the left hand panel has been based on a photograph of Sir Austen Chamberlain's head, seen in a distorting mirror, first published in Amédée Ozenfant's *Foundations of Modern Art* (1931).[2] Here, the monocle worn by Chamberlain has become a large white ellipse, grotesquely parodying its prototype and being parodied, in turn, by splotches of white paint thrown at the canvas lower down. The black-clad figure bleeds from the billboard to become a seminude body seated on an office stool; the arms of this figure reach down to unzip a black carry-all, its right foot planted on sheets of newspaper, and an amorphous flesh-colored blob. In both side panels the posterlike images are supported on two converging rails, which can be read either as the legs of an easel or the dolly used for TV cameras.[3]

Clipping of Sir Austen Chamberlain as seen in a distorting mirror from Foundations of Modern Art, *by Amédée Ozenfant, 1931*

In the right-hand panel, the sinister figure presides over two nude figures struggling with each other, one with teeth bared in a silent scream; they, too, lie on a pinkish blob of fluid and newspapers. Is the observer an Orwellian "Big Brother" figure, or an echo of Il Duce?[4] The central panel, with its ravening birds and nameless monsters, evokes sacrifice and propitiation: a tilted chalice, from which blood spills, surely confirms this. The Greek tragedies of Aeschylus, especially the *Oresteia*, deeply moved Bacon and fired his imagination: "The reek of blood smiles out at me, spilt blood calling out for more blood."[5]

1. Michel Leiris 1988, p. 18, noticed this allusion.
2. First published in French 1928; English, German, and American editions 1931. Dover Publications Inc., New York, produced an augmented edition 1952, where the photograph of Chamberlain is reproduced on p. 59. This photograph, torn from the book, was found among Bacon's studio effects.
3. Cf. Valérie Breuvart in Paris + Munich 1996–7, p. 198, who noted the TV camera allusion.
4. Peppiatt 1996, p. 72, refers to Bacon's fascination with the images in Ozenfant's book; and pp. 277, 339 n. 13 records that this figure may have been based on photographs that Bacon had of the photographer Peter Beard, with his head shaven.
5. W. Bedell Stanford, *Aeschylus in His Style: A Study in Language and Personality,* Dublin 1942. Cited by Russell 1971–93, p. 24; Dawn Ades, Tate 1985, pp. 17–21 discusses Bacon's keen interest in and appreciation of Aeschylus's tragedies; Peppiatt, Lugano 1993, p. 110.

(Illustrated pp. 184–186)

58. THREE STUDIES FOR A PORTRAIT, 1977
Oil on canvas, triptych, each panel 14 × 11¾ inches (35.5 × 30 cm)
Exh: Lugano 1993 (50)
Private Collection — Courtesy Fine Arts & Projects, Mendrisio

Bacon rarely painted portraits on commission; the triple study of Mick Jagger (see below, no. 62) was an exception, as is this portrait, which he agreed to do although he did not know the sitter particularly well. First exhibited publicly at Lugano in 1993, this work shows his ability to capture a good likeness, in spite of his reputation as a destroyer of the human face.

59. TRIPTYCH, 1977
OIL ON CANVAS, TRIPTYCH, EACH PANEL 14 × 11⅞ INCHES (35.5 × 30.2 CM)
EXH: LUGANO 1993 (51)
PRIVATE COLLECTION

This unusually explicit autobiographical picture was first publicly exhibited at Lugano in 1993. Michael Peppiatt and Jill Lloyd described the three panels as follows: on the right, a self-portrait; in the center, Bacon's bed with its Moroccan cover and a bedside table with an anglepoise lamp, the table strewn with books and papers; on the left, a glimpse into "the colored chaos of his [Bacon's] South Kensington studio — well known enough from photographs, but never previously painted by the artist."[1]

1. Lugano 1993, sv. 51.

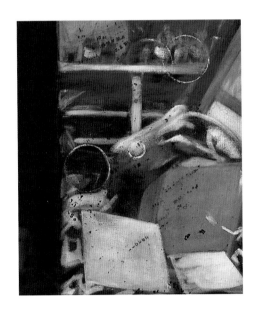 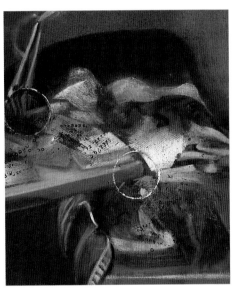

60. FIGURE IN MOVEMENT, 1978

OIL AND PASTEL ON CANVAS, 78 × 58 INCHES (198 × 147.5 CM)
EXH: TATE 1985 (105); LONDON 1998 (20)
COURTESY OF IVOR BRAKA LTD., LONDON

An athlete appears here to be performing a somersault over a bar, his action reflected in the suspended black inset which doubles as a mirror. His blond round head is a little reminiscent of Bacon's own head as depicted by the artist in several self-portraits, but it seems much more likely to be that of George Dyer, if one compares it with the figure in *Three Studies of the Male Back,* 1970 (Kunsthaus, Zurich), where Dyer is seen from a similar angle, but upright. If this identification is correct, then once again the painting is an elegy with a violent twist, for although the athlete does not vomit his life away (as Dyer had done), he seems doomed to crash to the ground.[1]

Bacon has fused images of wrestlers and athletes, photographed in action by Muybridge, with his stored-up visual memories of people he knew well, to produce an extraordinarily disquieting pictorial metaphor. He abhorred "illustration," and told his friend Michel Leiris that his conception of reality was "an attempt to capture the appearance together with the cluster of sensations that the appearance arouses in me."[2] He observed that "it may be that realism, in its most profound expression, is always subjective"; that there are, in fact, "inner realities."[3] Sylvester remarked to the artist about this picture that it was a "whittling down" to get at the essence, to which Bacon assented: "It was an attempt to make a figure in movement as concentrated as I could do it so long as one can work, one may be able to get nearer to a kind of essence of these things."[4]

1. Dyer, full of drink and sleeping pills, died hemorrhaging, as he sat on a lavatory in a Paris hotel after failing to vomit up the lethal mixture.
2. See Leiris 1988, p. 13, who quotes a letter from the artist to him.
3. Ibid.
4. Bacon-Sylvester, *Interview* 7 (1979), p. 168.

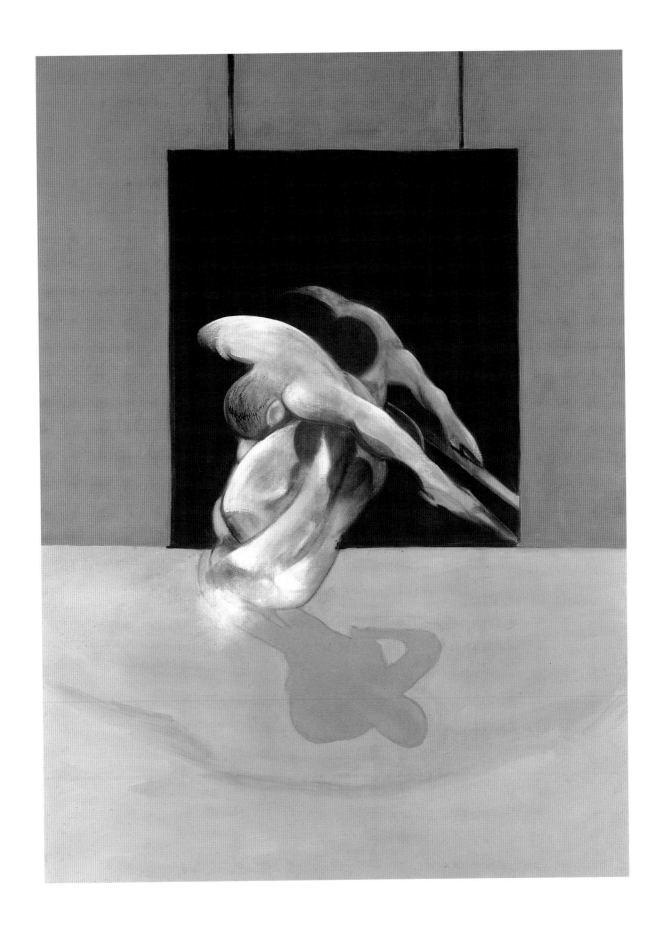

61. TRIPTYCH INSPIRED BY THE *ORESTEIA* OF AESCHYLUS, 1981

TITLED, SIGNED, AND DATED ON THE BACK
OIL ON CANVAS, TRIPTYCH, EACH PANEL 78 × 58 INCHES (198 × 147.5 CM)
LIT: RUSSELL 1971–93, P. 161; DAWN ADES IN TATE 1985, PP. 16–21; PEPPIATT
1996, P. 269
EXH: *FRANCIS BACON: RECENT PAINTINGS,* MARLBOROUGH GALLERY, NEW YORK,
5 MAY–5 JUNE 1984 (9); TATE 1985 (110); *FRANCIS BACON,* CENTRAL HOUSE OF
ARTISTS, NEW TRETYAKOV GALLERY, MOSCOW, 23 SEPT.–6 NOV. 1988 (15);
HIRSHHORN 1989–90 (49); VENICE 1993 (26); PARIS + MUNICH 1996–7 (74)
ASTRUP FEARNLEY COLLECTION, MUSEET FOR MODERNE KUNST, OSLO

The left panel of this triptych had originally formed the center panel of a triptych comprising *Two Seated Figures* on the left and *Seated Figure* on the right, both dating from 1979, which Bacon quickly dismembered.[1]

The *Triptych Inspired by the* Oresteia *of Aeschylus* is a direct descendant of *Three Studies for Figures at the Base of a Crucifixion* of 1944, in that both works encapsulated the tragedy of human life. Neither is a direct paraphrase of either the Crucifixion or specific scenes from Aeschylus's *Oresteia;* what Bacon attempts is to convey his sense of the inevitable, preordained doom of human existence, as in Greek tragedy and Christ's Crucifixion. He refers to the figures in the 1944 *Three Studies for Figures at the Base of a Crucifixion* as Eumenides — the Greek Furies — and he was already intrigued by the *Oresteia* of Aeschylus. In this tragedy, Orestes kills his mother, Clytemnestra, in revenge for her murder of his father, Agamemnon, a crime for which Orestes is pursued by the Erinyes (a nastier species of the Furies) in punishment of an "incestuous murder."[2]

The image of an eviscerated corpse, displayed on a dais in the central panel, dominates the triptych, and the dark red stage set recalls the crimson tapestries laid before Agamemnon by Clytemnestra and her women in welcome, before he is murdered, and described by Aeschylus in bloody metaphor:

> Let the red stream flow and bear him home
> To the home he never hoped to see — Justice lead him in . . .[3]

The same gory allusion is sustained in the left panel, where a rivulet of blood seeps from under the open door: both Agamemnon and Clytemnestra, in keeping with the canons of Greek tragedy, are murdered off-stage; their bodies are revealed only at the end of the trilogy. The hideous winged figure, which also appears in *Triptych,* 1976 (see above), alludes to an avenging Fury; while in the right-hand panel one may perhaps interpret the mutilated, fleeing figure as the dying Orestes himself, his blood seeping across the floor.

1. Hervé Vanel in Paris + Munich 1996–7, sv. 74, n. 1, who records Valerie Beston's recollections of the two paintings, shown at the Marlborough Gallery, New York, 1980 (7 and 8).
2. Dawn Ades, Tate 1985, pp. 16–21, gives a succinct analysis of Bacon's use of Greek tragedy, especially Aeschylus's *Oresteia*, and places it within the wider context of the rediscovery of Aeschylus by the Romantics, and by early twentieth-century poets such as T. S. Eliot. See also the entry for *Triptych,* 1976 (no. 57), where specific reference is made to the importance of W. B. Stanford's study of Aeschylus, published 1942, which greatly influenced Bacon's own understanding of the Greek tragedian, whose "rough, bold poetics" he preferred to the more polished style of Euripides.
3. Cited by Ades, op. cit., p. 20. She uses R. Fagles's translation of Aeschylus's *Oresteia* (1976).

(Illustrated on pp. 187–189)

62. THREE STUDIES FOR A PORTRAIT (MICK JAGGER), 1982

OIL AND PASTEL ON CANVAS, TRIPTYCH, EACH PANEL 14 × 12 INCHES (35.5 × 30.5 CM)
LIT: PEPPIATT 1996, P. 209
EXH: *BRITAIN SALUTES NEW YORK*, MARLBOROUGH GALLERY, NEW YORK, 9
APRIL–3 MAY 1983 (6, AS "STUDIES FOR PORTRAIT"); TOKYO 1983 (45); TATE 1985
(117)
PAUL JACQUES SCHUPF

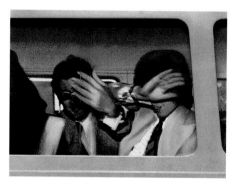

Richard Hamilton
Swingeing London, *1967*
*Acrylic, collage, and aluminum
relief, on a silkscreen of acrylic on
canvas*
Tate Gallery, London

One of the few commissioned portraits executed by the artist, the sitter achieved fame (and notoriety) in the 1960s as the lead singer in the pop group The Rolling Stones. In February 1967, the Sussex police raided the home of Keith Richards, also of The Rolling Stones, and charged him with allowing his house to be used for the smoking of cannabis resin; Jagger and Robert Fraser, the art dealer, were charged with being in unlawful possession of different drugs. After court proceedings, both were sentenced to imprisonment (Fraser for six months), but Jagger's sentence was commuted on appeal to a twelve-month conditional discharge. The artist Richard Hamilton, whose dealer was Robert Fraser, published an acrylic, collage, and aluminum relief, on a silkscreen of acrylic on canvas, *Swingeing* [sic] *London* 1968–69 (Tate Gallery), based on a press photograph showing Fraser and Jagger handcuffed together, and seen through the window of a police van.[1]

This portrait follows Bacon's usual practice of using photographs of the subject as an aide-mémoire, and shows just the head of Mick Jagger against an orange background.[2] He appears in three poses; in the central panel his mouth is open as if caught in the act of singing. In all three, the facial features have been softened by parallel strokes of pastel across the eyes, cheeks, mouth, and neck, which both focus our attention on these areas and suggest the transitory effects of strobe lighting.

1. Richard Morphet in *The Tate Gallery 1968–70* (1970), pp. 84–85, sv. T. 1144.
2. *Francis Bacon in Conversation with Michel Archimbaud* (1993), pp. 15–16, 48, where Bacon uses the phrase "aide-mémoire" to describe his use of photographs. He also told Michel Archimbaud that he did not know Jagger.

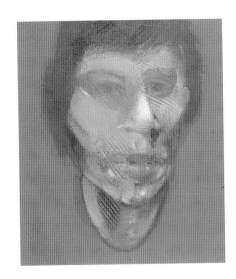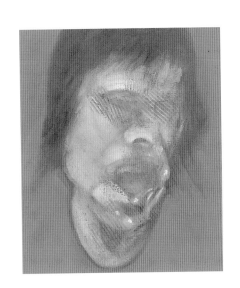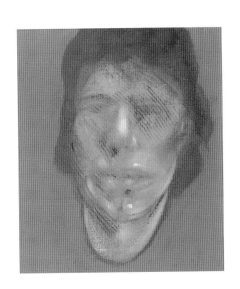

63. A PIECE OF WASTE LAND, 1982

TITLED, SIGNED, AND DATED ON THE BACK
OIL ON CANVAS, 78 × 58 INCHES (198 × 147.5 CM)
EXH: *FRANCIS BACON: RECENT PAINTINGS,* MARLBOROUGH GALLERY, NEW YORK,
5 MAY–5 JUNE 1984 (4); TATE 1985 (115); VENICE 1993 (28); PARIS + MUNICH
1996–7 (77)
PRIVATE COLLECTION

Although he painted few "pure" landscapes, that is, landscapes devoid of human or animal presence, those that were so composed always carried an emotional charge, however subtly conveyed. *A Piece of Waste Land* can either be read as a view of the Earth, seen from a spaceship, or as a close-up of a patch of derelict land with a hint of human debris in the fragment of torn newsprint, towards which our attention is drawn by one of two red arrows. The Baconian ambivalence is deliberate; the title, with its echo of T. S. Eliot's poem *The Waste Land,* might suggest an apocalyptic scene of global destruction, or it might have a more personal meaning of despair, of *nada* (nothing), a Spanish word Bacon was fond of using toward the end of his life to express the hopelessness of the human lot in general, and of his own sense of its futility.[1]

As in much of Bacon's late work, he keeps the forms at their simplest, with a few telling variations in color and texture.

1. Peppiatt 1996, p. 304.

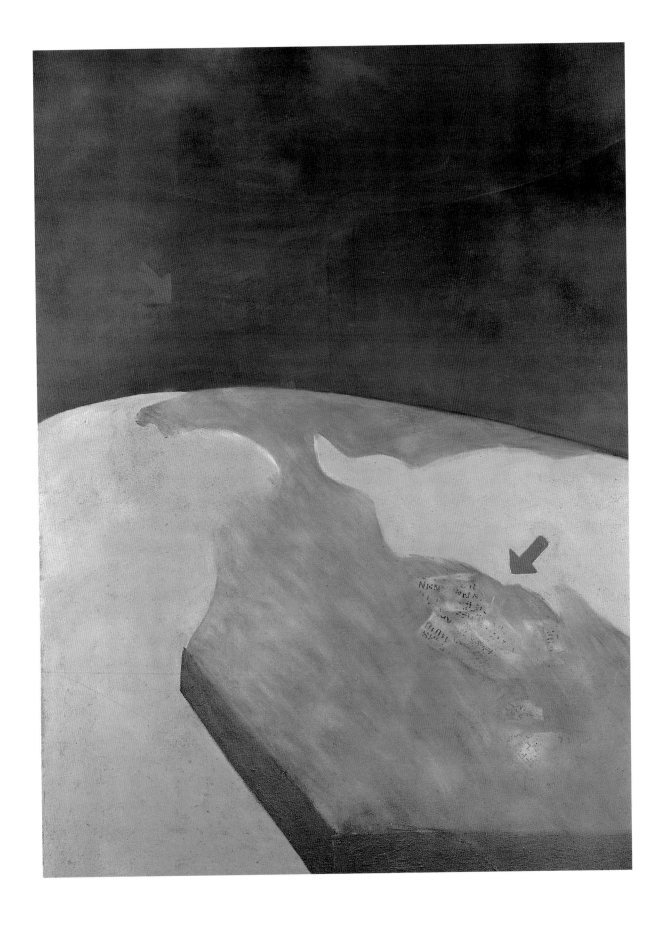

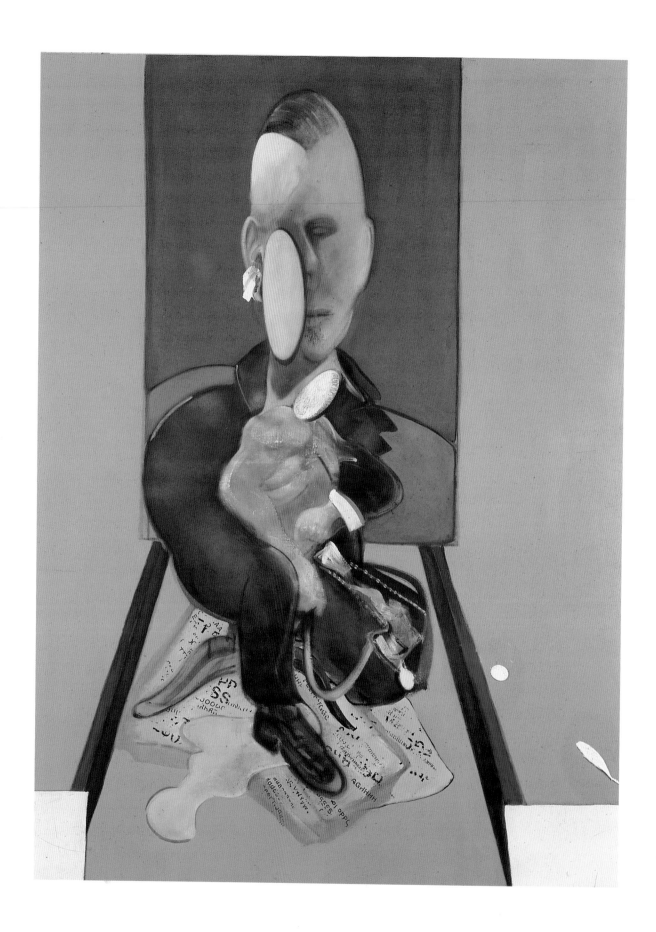

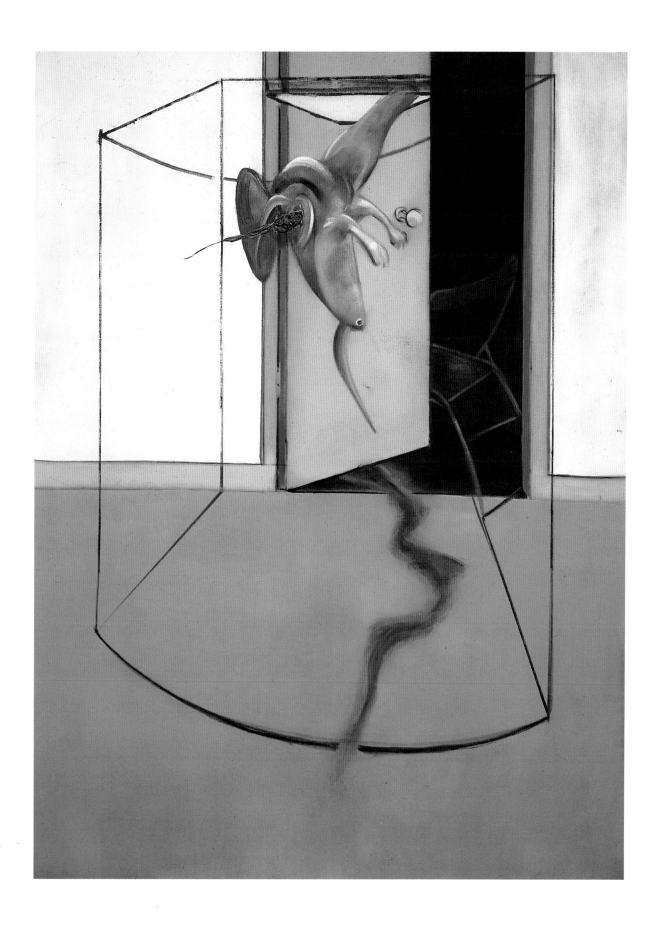

187

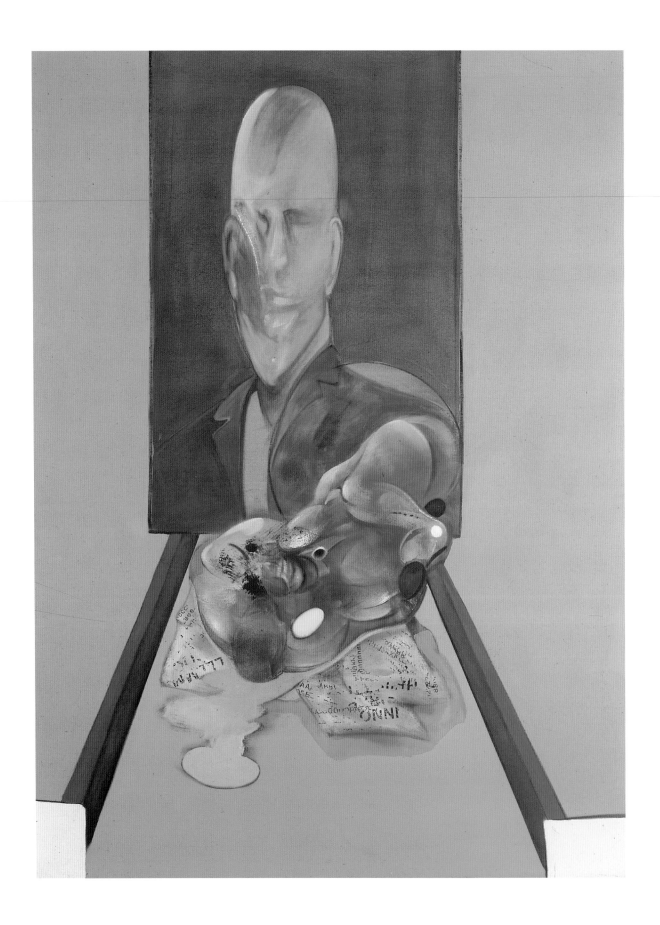

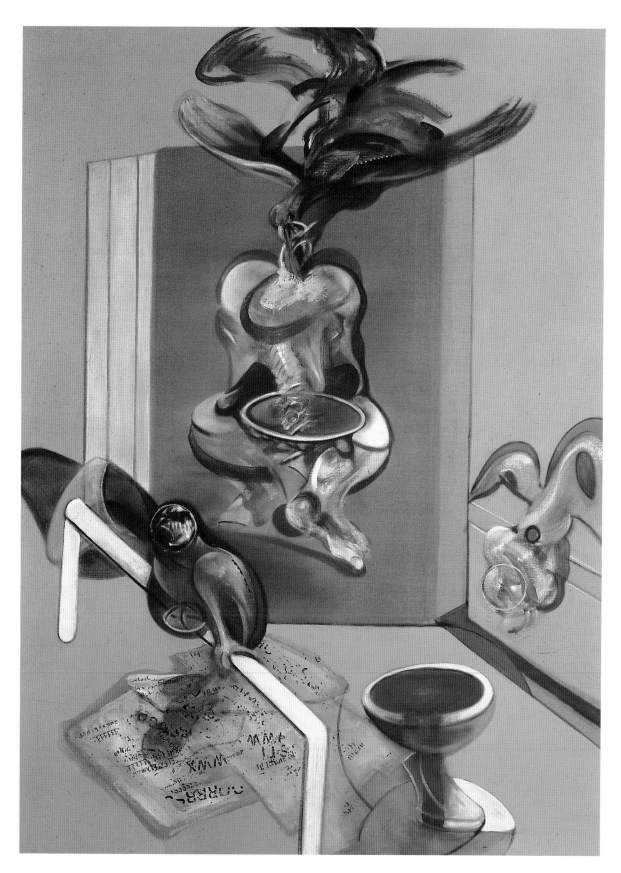

57. TRIPTYCH, 1976

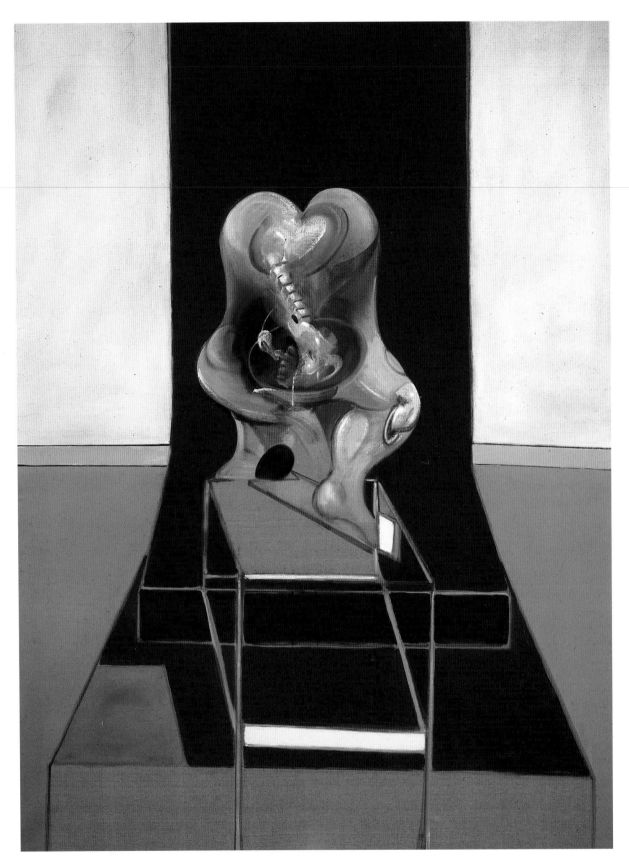

61. TRIPTYCH INSPIRED BY THE *ORESTEIA* OF AESCHYLUS, 1981

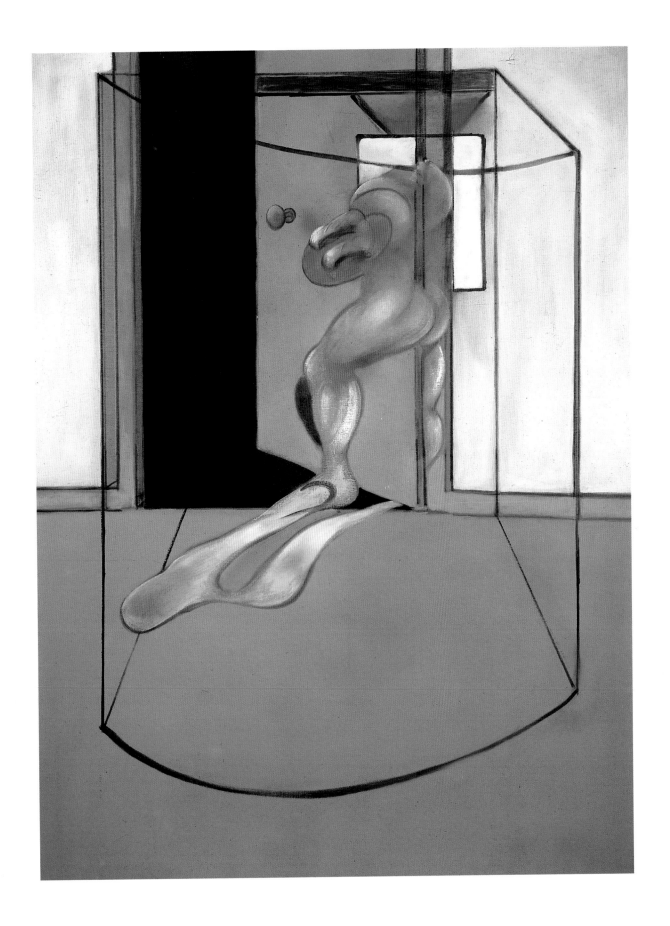

64. STUDY FROM THE HUMAN BODY — FIGURE IN MOVEMENT, 1982
TITLED, SIGNED, AND DATED ON BACK.
OIL ON CANVAS, 78 × 58 INCHES (198 × 147.5 CM)
EXH: TOKYO 1983 (44); *FRANCIS BACON: RECENT PAINTINGS,* MARLBOROUGH GALLERY, NEW YORK, 5 MAY–5 JUNE 1984 (2); TATE 1985 (118); LUGANO 1993 (55).
MARLBOROUGH INTERNATIONAL FINE ART

This composition anticipates a later work, *Diptych: Study from the Human Body,* 1982–84; *Study of the Human Body, From a Drawing by Ingres,* 1982 (see below, no. 65). The sculptural quality of Bacon's later work has been noted; but here he combines this quality with the depiction of a figure — a cricketer — in a sharp, twisting movement. He has reverted to an all-over orange background, one of his favorite colors, but the orange has been punctuated by a blue panel, which suggests an open window. Bacon has also used an aerosol spray in some areas of the body, which softens the forms.

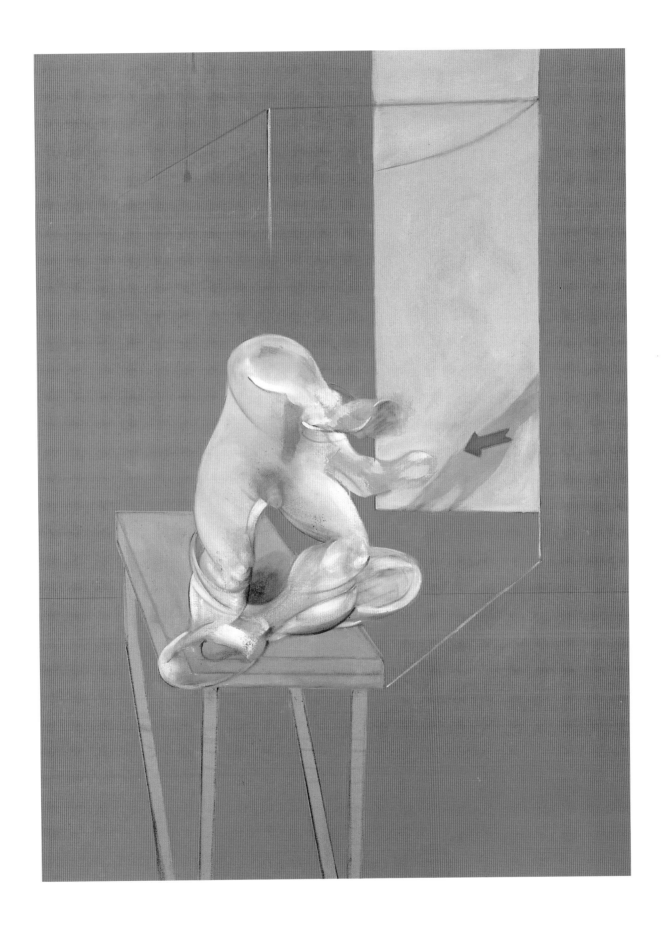

65. DIPTYCH: STUDY FROM THE HUMAN BODY, 1982–84; STUDY OF THE HUMAN BODY, FROM A DRAWING BY INGRES, 1982

OIL AND TRANSFER TYPE ON LINEN, DIPTYCH, PANEL A: 78⅛ × 58¼ INCHES (198.5 × 148 CM); PANEL B: 78⅛ × 58⅛ INCHES (195.5 × 147.6 CM)

EXH: *FRANCIS BACON: RECENT PAINTINGS,* MARLBOROUGH GALLERY, NEW YORK, 5 MAY–5 JUNE 1984(11); TATE 1985 (124); HIRSHHORN 1989–90 (53)

HIRSHHORN MUSEUM AND SCULPTURE GARDEN, SMITHSONIAN INSTITUTION, WASHINGTON, DC. GIFT OF MARLBOROUGH INTERNATIONAL FINE ART AND GIFT OF THE JOSEPH H. HIRSHHORN FOUNDATION, BY EXCHANGE, 1989

Jean-Auguste-Dominique Ingres, Drawing for Bain Turc
Musée Ingres, Montauban

Bacon admired Ingres, although he is reported to have thought Ingres had "a certain meanness of spirit or defensive tightness" that put him slightly below the very top rank.[1] In this diptych, he combines elements from sporting photographs of the cricketer David Gower, such as the batsmen's pads, with motifs from Ingres's drawing for the right-hand figure in the *Bain Turc* of 1859–63 (Louvre, Paris).[2] "Well, I have often seen cricket. And when I did this image I suddenly said, well, I don't know why, but I think it's going to strengthen it very much and make it look very much more real if it has cricket pads on it. I can't tell you why."[3] Lawrence Gowing observed, "Classic lucidity has enabled the painter to fantasize metamorphoses of the female nudes in *The Turkish Bath* of Ingres so that a whole world of linear harmony and smoothly modeled roundness suddenly opens to him."[4]

We have already noted the increasingly sculptural quality of Bacon's late work, of a paring down to essentials. In the left panel, he focuses with brutal clarity on the male genitalia; in both, red arrows point up the message.[5] The rounded male breast is wittily parodied by the upturned breasts of the female torso. Both torsos are presented on pedestals like pieces of sculpture, and against a hot orange-red background, which intensifies the erotic charge.

1. Russell 1971–93, p. 50.
2. Bacon-Sylvester, *Interview* 8 (1982–84), p. 180. Sylvester noticed photographs of Gower in Bacon's studio.
3. Ibid.
4. Hirshhorn 1989–90, p. 24. The drawing is in the Musée Ingres, Montauban.
5. Peppiatt 1996, p. 230, observes that Bacon's use of arrows was derived from golfing manuals, where arrows indicated the direction of the drive.

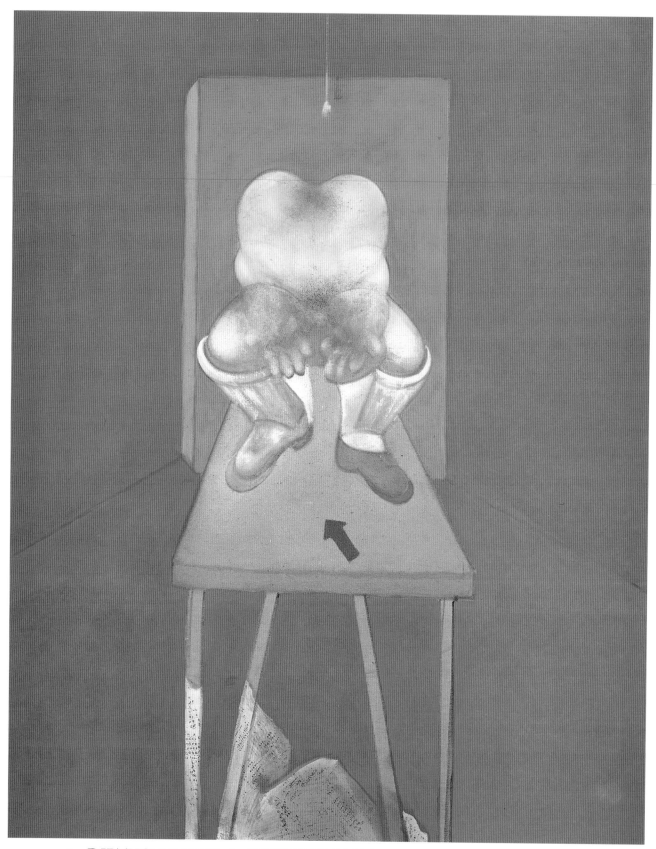

65. DIPTYCH PANEL A: STUDY FROM THE HUMAN BODY, 1982–84

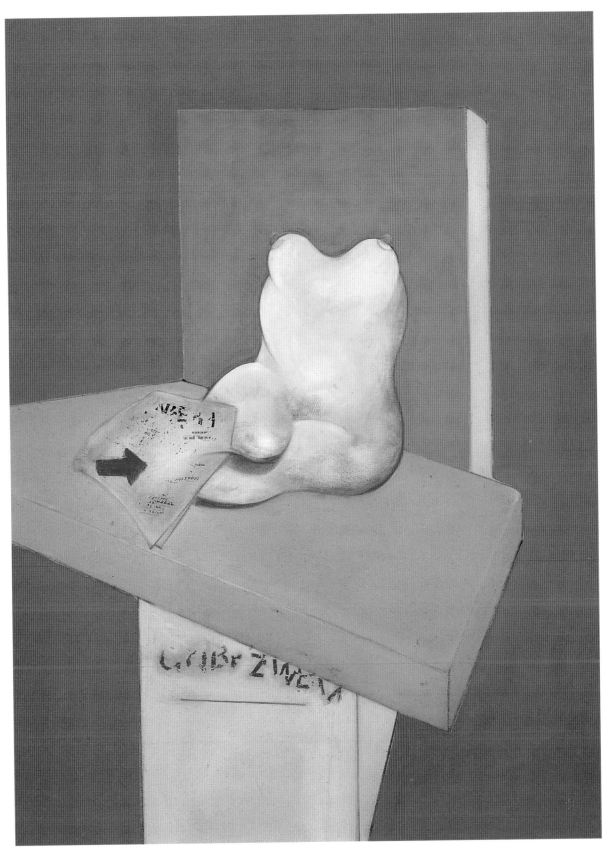

65. DIPTYCH PANEL B: STUDY OF THE HUMAN BODY,
FROM A DRAWING BY INGRES, 1982

66. OEDIPUS AND THE SPHINX AFTER INGRES, 1983

OIL ON CANVAS, 78 × 58 INCHES (198 × 147.5 CM)
EXH: *FRANCIS BACON: RECENT PAINTINGS,* MARLBOROUGH GALLERY, NEW YORK,
5 MAY–5 JUNE 1984 (6); TATE 1985 (120); LONDON 1998 (21)
COURTESY OF IVOR BRAKA LTD., LONDON

Jean-Auguste-Dominique Ingres,
Oedipus and the Sphinx
Oil on canvas, 6⅞ × 5⅜"
National Gallery, London

Inspired by Ingres's *Oedipus and the Sphinx* of c. 1826–27 in the National Gallery, London, Bacon has freely adapted elements of the story of Oedipus, son of Laius, king of Thebes and his wife Jocasta.[1] Oedipus (literally "swell-foot") had a spike driven through his foot as a child and was left to die, but was found and brought up by a shepherd. He thus lived to fulfil the prophecy that he would kill his father by chance, and marry his mother. He went to Delphi to ask who his parents were; on the way to Thebes he killed an old man (unknown to him, his own father). He rescued Thebes from the Sphinx, a monster who destroyed those who could not solve a riddle she asked, either by guessing the riddle or by overcoming her. The tragedy is recounted by both Aeschylus and Sophocles (*Oedipus Tyrannus*). Oedipus, on learning of his terrible fate, blinded himself and went into exile. Jocasta hanged herself.

In this painting, Oedipus, his foot anachronistically still bleeding and bandaged, is consulting the Sphinx; through the open door an avenging Fury whirls in the air, blood dripping from its jaws. The sickly pinks and browns heighten the atmosphere of impending doom. The composition is starkly simple, and forms are broadly brushed in, but the bloodied foot holds our fascinated gaze.

1. A larger, earlier version of Ingres's painting (1808) is in the Louvre, Paris.

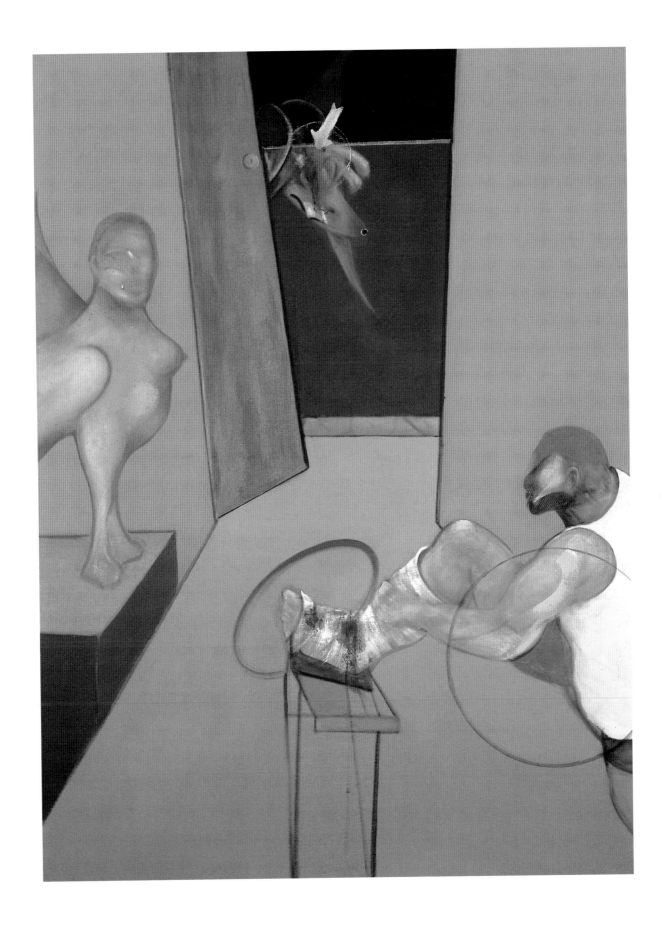

67. THREE STUDIES FOR A PORTRAIT OF JOHN EDWARDS, 1984

OIL ON CANVAS, TRIPTYCH, EACH PANEL 78 × 58 INCHES (198 × 147.5 CM)
LIT: DAVIES + YARD 1986, P. 88; PEPPIATT 1996, PP. 286, 307
EXH: TATE 1985 (125); LUGANO 1993 (56)
PRIVATE COLLECTION

Like the *Triptych — Study for a Self-Portrait,* 1985–86 (see below, no. 68), this large triple portrait of his friend John Edwards, whom he had met some ten years earlier, has a grand simplicity and serenity. The format is a familiar one of two profile portraits balancing a full-face center panel, with a classical sense of symmetry and cohesion. Only in the right panel, where John Edwards's head is sharply twisted, do we see a trace of the old Baconian *Angst*. Bacon makes extensive use of airbrushing to obtain an overall matt finish, with subtle gradations of color and tone. The red lining to Edwards's shirt collar provides, in an otherwise muted color scheme, a linking motif for all three panels.

(Illustrated on pp. 206–208)

68. TRIPTYCH — STUDY FOR A SELF-PORTRAIT, 1985–86

TITLED, SIGNED, AND DATED ON BACK
OIL ON CANVAS, TRIPTYCH, EACH PANEL 78 × 58 INCHES (198 × 147.5 CM)
EXH: *PAINTINGS AND SCULPTURE BY 19TH AND 20TH CENTURY MASTERS*,
MARLBOROUGH FINE ART, LONDON, 31 JULY–29 AUG. 1986 (NO CAT.); *FRANCIS
BACON: PAINTINGS OF THE EIGHTIES*, MARLBOROUGH GALLERY, NEW YORK,
7 MAY–31 JULY 1987 (8); *FRANCIS BACON*, CENTRAL HOUSE OF ARTISTS, NEW
TRETYAKOV GALLERY MOSCOW, 23 SEPT.–6 NOV. 1988 (18); HIRSHHORN 1989–90
(54); GALERIA MARLBOROUGH, MADRID, 1992 (4); VENICE 1993 (29); *BACON-FREUD:
EXPRESSIONS*, FONDATION MAEGHT, SAINT-PAUL, 4 JULY–15 OCT. 1995 (27); PARIS +
MUNICH 1996–7 (82); LONDON 1998 (23)
MARLBOROUGH INTERNATIONAL FINE ART

At the major retrospective in Paris in 1996–97 this painting hung in the last gallery of
the Centre Pompidou, almost as if it were the artist's farewell to the public. There is a
simple grandeur and an elegiac mood in this most beautiful work. Bacon uses a very
smooth brushstroke and has airbrushed some areas of the face, arms, and hands, which
when viewed under glass, as he always insisted his work should be, imparts to the whole
a soft overall density akin to Color Field painting.

In each of the panels Bacon repeats, with variations, the familiar ill-at-ease cross-
legged pose; in the two outside panels, he clasps his knees; in the central one, he achieves
an ungainly equilibrium, his hands melting into the canvas. Each panel has its own char-
acter and yet each gains by being juxtaposed with the other two. He used passport-size
photographs of himself taken in automatic booths over a period of many years. It was a
form of self-exploration, yet he hated his face, and in two of the heads in this triptych,
he seems content to destroy part of it, while at the same time calling attention to his
right cheek by inserting a small red arrow in two of them. This formal device helps to
establish a unity.

He told David Sylvester: "I go on painting it [his face] only because I haven't got
any other people to do. . . . One of the nicest things that Cocteau said was: 'Each day in
the mirror I watch death at work.' This is what one does oneself."[1]

1. Bacon-Sylvester, *Interview* 5 (1957). p. 133.

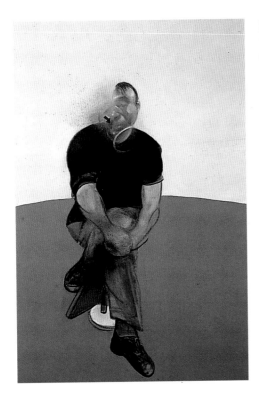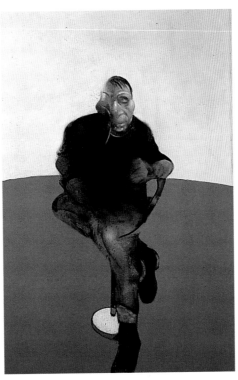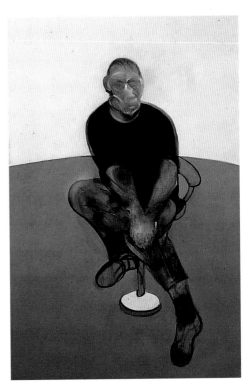

69. BLOOD ON THE FLOOR — PAINTING, 1986
OIL ON CANVAS, 78 × 58 INCHES (198 × 147.5 CM)
EXH: *FRANCIS BACON. PAINTINGS OF THE EIGHTIES*, MARLBOROUGH FINE ART,
LONDON, 7 MAY–31 JULY 1987 (11); LUGANO 1993 (57)
PRIVATE COLLECTION, MELBOURNE, AUSTRALIA. COURTESY RICHARD NAGY,
DOVER STREET GALLERY, LONDON

This strikingly simple theme of a splash of blood on the floor, treated on a monumental scale, is characteristic of Bacon's late work, where he reduces to a minimum so as to attain maximum effect. There is an anecdote that this painting was inspired by blood left on the floor by John Edwards, after a fracas, but Bacon would have considered this an irrelevance.

Bacon has heightened the shock of blood on the sand-colored floor by juxtaposing it against a fierce orange background, where all sense of three-dimensional space is deliberately negated. Such points of reference as the hanging lightbulb and toggle, and the wall switch seemingly suspended from its conduit, only increase one's sense of disorientation.

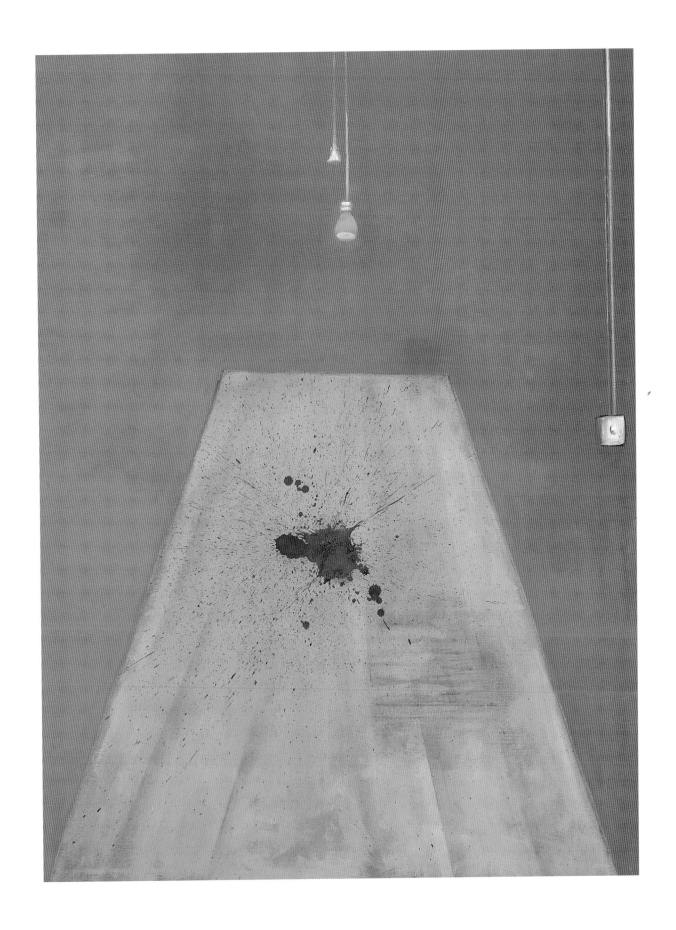

70. TRIPTYCH, 1986–87

TITLED, SIGNED, AND DATED ON BACK

OIL AND PASTEL ON CANVAS, TRIPTYCH, EACH PANEL 78 × 58 INCHES (198 × 147.5 CM)

EXH: *FRANCIS BACON. PAINTINGS OF THE EIGHTIES,* MARLBOROUGH GALLERY, NEW YORK, 7 MAY–31 JULY 1987 (12); *FRANCIS BACON,* CENTRAL HOUSE OF ARTISTS, NEW TRETYAKOV GALLERY, MOSCOW, 23 SEPT.–6 NOV. 1988 (20); LUGANO 1993 (19); *BACON-FREUD: EXPRESSIONS,* FONDATION MAEGHT, SAINT-PAUL, 4 JULY–15 OCT. 1995 (28); PARIS + MUNICH 1996–7 (84)

MARLBOROUGH INTERNATIONAL FINE ART

Bacon takes the use of stark black panels a stage further, having first used the device in *Triptych August 1972* (Tate Gallery) and, in a modified form, in *Triptych, 1976* (see above, no. 57). The funereal note is deliberately struck. On the left, President Woodrow Wilson is shown emerging in somber mood from the Quai d'Orsay after having just signed the ill-fated Treaty of Versailles in 1919; on the right stands the lectern used by Leon Trotsky in his heavily fortified house in a suburb of Mexico City, where he was betrayed and hacked to death in 1937, his blood staining the white sheet draped over it. The Wilson episode is based on an old press-cutting photo, the Trotsky on a photo of his studio (see pp. 36–7). In the center, somewhat incongruously, a male nude clad in batsman's cricket pads sits on a skewed podium, his features resembling those of John Edwards, Bacon's last friend, to whom he bequeathed his estate in 1992. The seemingly disparate mixture of public and private events, of prominent statesmen and the obscure citizen, defies easy explanation. Perhaps Bacon is merely restating the obvious — that we are all mortal.

In his last published interview with David Sylvester, Bacon responded to the question of how to interpret his works by saying he wanted them to have titles as anonymous as possible; "I mean people can interpret things as they want. I don't even interpret very much what I do. By saying that, I don't think that I'm inspired, but I work, and what I do I may like the look of, but I don't try to interpret it."[1] This triptych contains the, by now, familiar ingredients of images transposed from photographs and transformed into a highly personal language. Although Bacon professed not to interpret these "very much," he did allow for others to attach meanings to them, but in his lifetime he rigorously enforced a ban on catalogue notes for individual pictures.

1. Bacon-Sylvester, *Interview 9* (1984–86), p. 198.

(Illustrated on pp. 209–211)

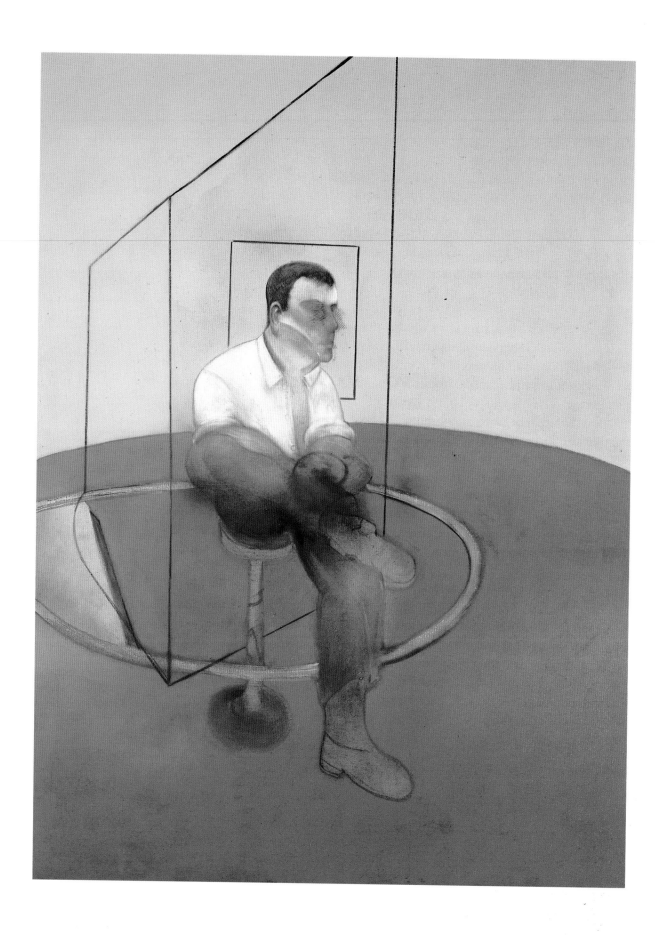

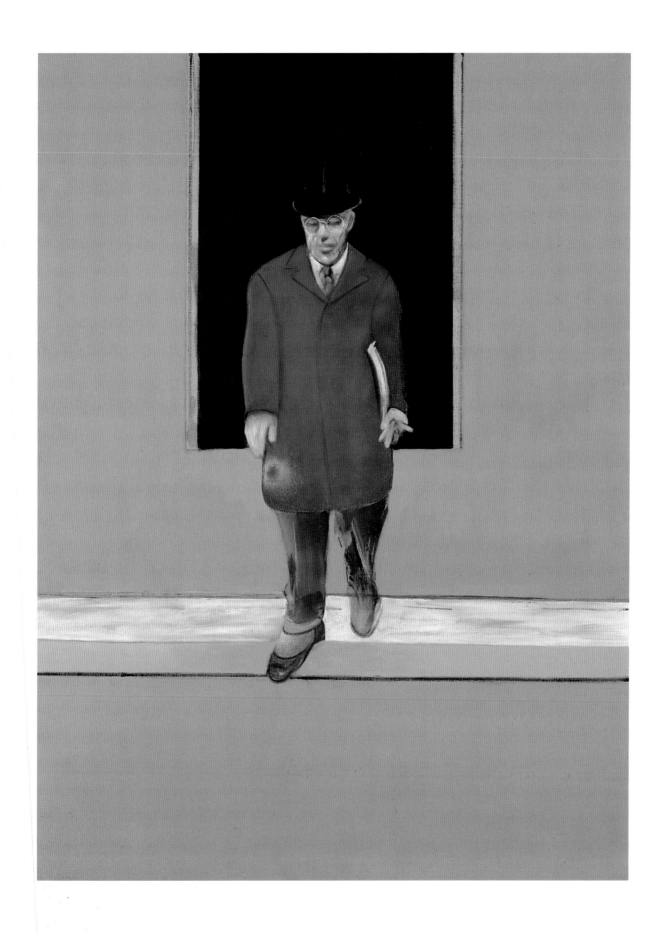

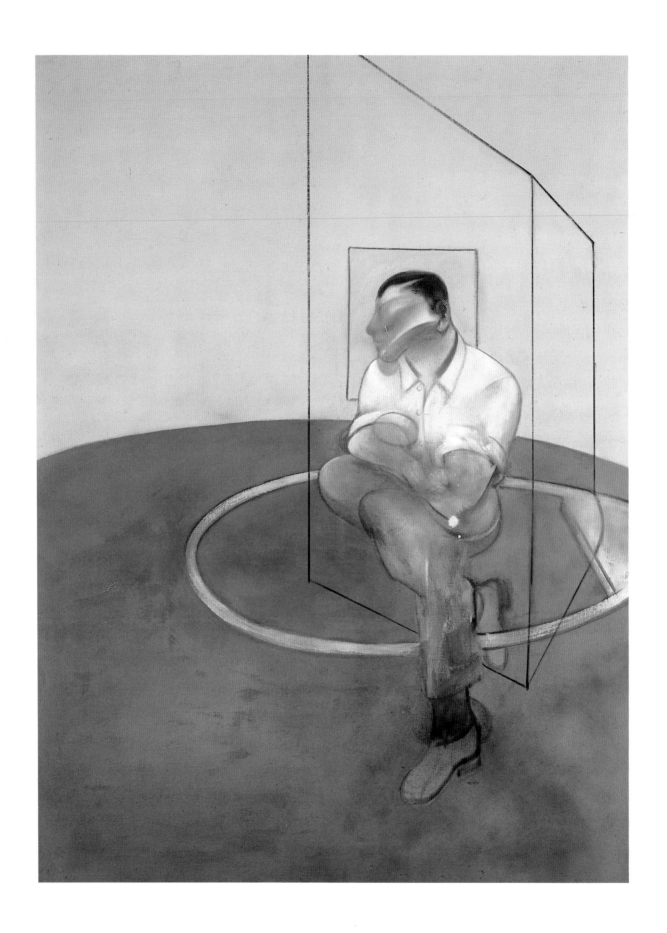

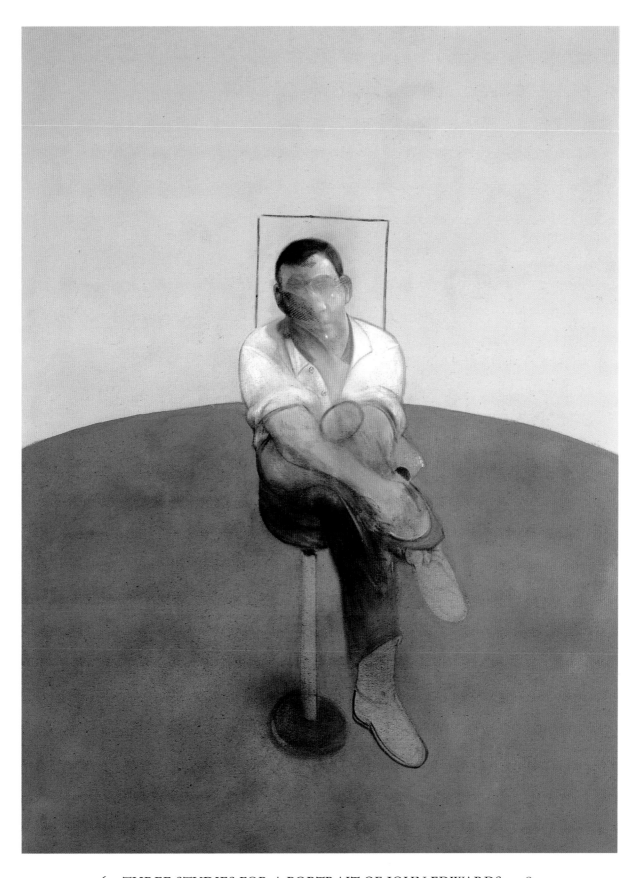

67. THREE STUDIES FOR A PORTRAIT OF JOHN EDWARDS, 1984

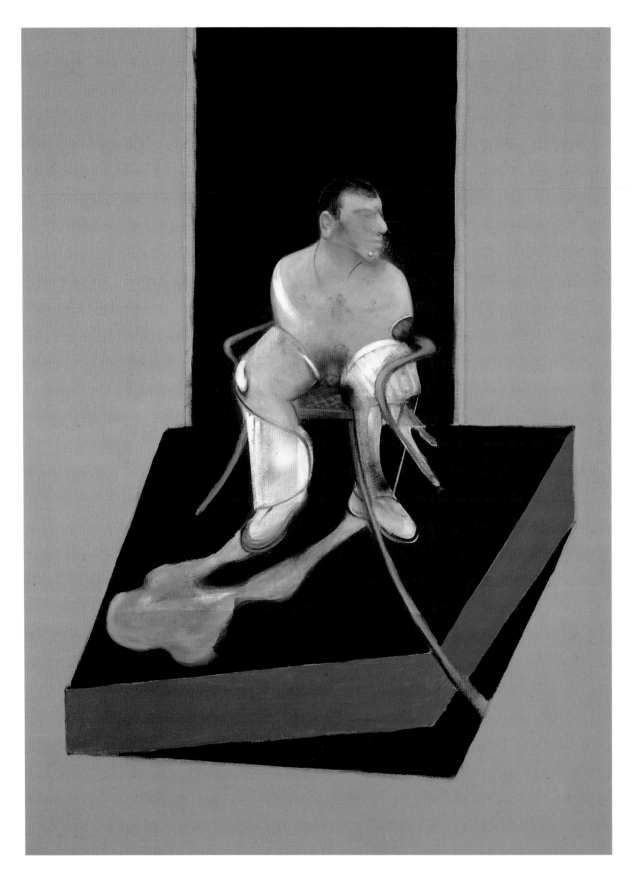

70. TRIPTYCH, 1986–87

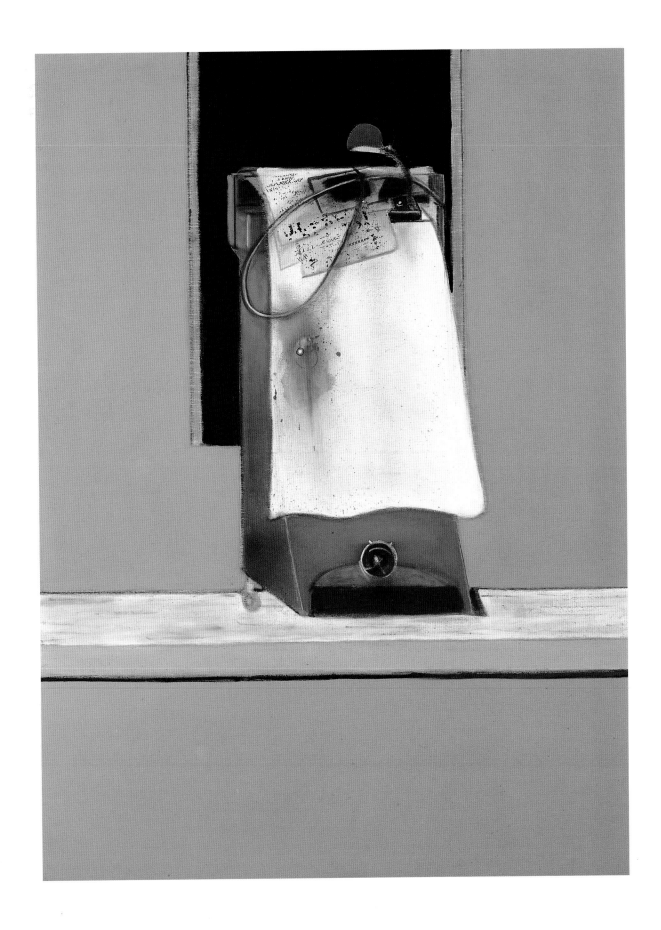

211

71. TRIPTYCH, 1987

OIL ON CANVAS, TRIPTYCH, EACH PANEL 78¼ × X 58¼ INCHES (198 × 147.5 CM)
EXH: *FRANCIS BACON: PEINTURES RÉCENTES,* GALERIE LELONG, PARIS, 30 SEPT.–
14 NOV. 1987 (10); LUGANO 1993 (58, RIGHT-HAND PANEL ONLY: *PAINTING {BULL}*)
FRANCIS BACON ESTATE

Bacon combines in this triptych iconography used in earlier pictures: on the left, part of a wounded male body rests on a table, with an arrow and a toggle light-switch and its cast shadow; in the center, the lower section of a striding male figure mounting a step, seen from the level of the genitals, with a white sticking-plaster above one knee. But perhaps the most interesting element is the head of a bull in the right-hand panel. Bacon painted three bullfighting scenes in 1969 and only returned to the subject of the corrida in 1986–87. In this treatment, as in all his later work, everything is highly stylized and pared down to essentials.

Although not an aficionado, Bacon admired the courage of man and beast in this ancient ritualized contest, but his sympathies lay more with the bull, and he concentrates on him in this panel. He saw the studio as an arena in which the struggle to realize a painting is played out.[1] There are inexplicable elements in these compositions, where all three images appear to be projected onto screens or reflected in mirrors, and set in spaces bounded by interlocking curves. Above the bull hovers a strange avian shape akin to the creatures he invented as Furies, but which does not fit this context. A precisely delineated hole also defies exact classification: is it an eye, an orifice, or a neatly drilled bullet hole?[2]

A similar hole, less precisely defined and more like a gory wound, appears on the thigh of the body in the left panel; a bleeding wound also disfigures the left groin of the central figure. It is as if Bacon were reflecting on the dangers faced by both the bullfighter and the bull in the corrida.

1. This point was made by Jill Lloyd and Michael Peppiatt in Lugano 1993, sv. 58.
2. Ibid.

(Illustrated on pp. 228–230)

72. JET OF WATER, 1988

TITLED, SIGNED, AND DATED ON THE BACK
OIL ON CANVAS, 78 × 58 INCHES (198 × 147.5 CM)
EXH: *FRANCIS BACON,* CENTRAL HOUSE OF ARTISTS, NEW TRETYAKOV GALLERY,
MOSCOW, 23 SEPT.–6 NOV. 1988 (22); HIRSHHORN 1989–90 (57); VENICE 1993 (31);
PARIS + MUNICH 1996–7 (86)
MARLBOROUGH INTERNATIONAL FINE ART

A reworking of a theme first explored in 1979, *Jet of Water* shows Bacon attempting a
form of "action painting" in that the thick white paint of the jet has been thrown across
the canvas, partly obliterating areas already painted, and then spread by brush. Instances
of the artist using this random projection of paint on canvas appear in his work of the
1970s, and it is an extension of his belief that so much in his art comes about by chance,
or at best a calculated gamble. Bacon's own love of gambling at Monte Carlo and else-
where was a feature of his life.

In the earlier version, the setting appears to be a shower/bathroom, but in this pic-
ture, the scene perhaps more resembles a street pavement and fire hydrant, with the jet
of water falling upon, and obscuring, a glass case housing an unidentifiable machine
object. It has even been suggested that the jet has sexual connotations, that it is an ejac-
ulation of sperm. Bacon himself agreed with Sylvester that in the first version he had
originally tried to do a seascape that didn't look like a seascape and it ended up not as a
wave breaking on the shore, but as a jet of water. The transformation happened thus: ". . .
I collected an enormous amount of paint, and I didn't really mix them; I put them all
into a pot, and I had painted the background in, and I just threw the paint onto the can-
vas, as you can see; I threw on what I hoped to be a wave, and it didn't make a wave. But
there were lots of things about it that I liked, . . . so I turned it into a jet of water."[1]

Peppiatt has seen this work as an apocalyptic allegory of man's destruction, a grim
industrial wasteland with water escaping in futile energy: "Mankind has been swept from
the stage."[2] He recalls that Bacon was very pleased with the picture and unusually boast-
ful about it.

1. Bacon-Sylvester, *Interview* 7 (1979), pp. 162–64.
2. Peppiatt 1996, pp. 303–4.

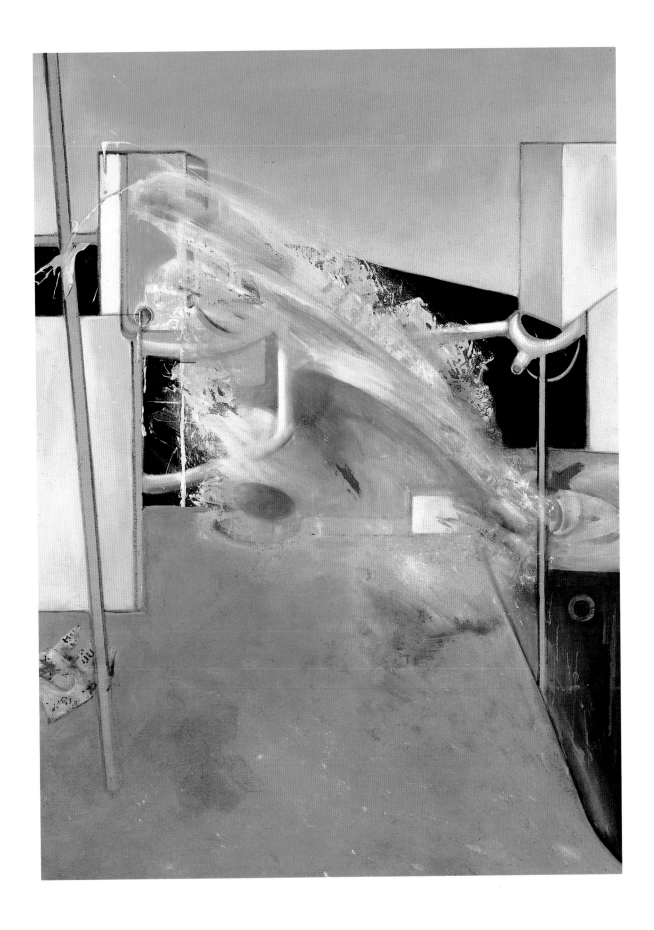

216

73. SECOND VERSION OF "TRIPTYCH 1944," 1988
TITLED, SIGNED, AND DATED ON THE BACK
ACRYLIC AND OIL ON CANVAS, TRIPTYCH, EACH PANEL 78 × 58 INCHES (198 × 147.5 CM)
EXH: GALERIE LELONG, PARIS, 20–21 MAY 1989 (1); HIRSHHORN 1989–90 (59);
VENICE 1993 (32); PARIS + MUNICH 1996–7 (87)
TATE GALLERY, LONDON. PRESENTED BY THE ARTIST, 1991

The 1944 triptych *Three Studies for Figures at the Base of a Crucifixion,* given to the Tate by
Eric Hall in 1953, caused a sensation when it was first exhibited in London at the Lefevre
Gallery in 1945. The raw horror of the monstrous creatures shocked and baffled critics,
yet some grasped that Bacon had caught the mood of the times as World War II moved
towards its end, bringing with it revelations of unspeakable cruelties and suffering. In
this second version, Bacon has substituted a blood-red background for the orange-red of
the earlier work. He has mixed acrylic with oil paint, which has produced correspond-
ingly smoother forms and a suaver finish. It could be said that this is a more theatrical
presentation; or it may be that we have become so familiar with the Baconian nightmare
that it no longer shocks us so profoundly. But it could equally well be argued that this
more svelte presentation, so elegant and seemingly banal, is just as effective in its longer-
term impact as the earlier work. It is also over twice the size of the 1944 triptych, and
this greater scale gives it a majestic quality which is highly effective.

Bacon painted several second versions of his major paintings, such as *Painting,* 1946
(Museum of Modern Art, New York), executed in 1971, when the first version had
become too fragile to withstand transportation to exhibitions and ostensibly as a replace-
ment for it.[1] His reasons for painting others are less easily explicable, but he told Richard
Cork that ". . . I have always wanted to make a large version of the first [*Three Studies . . .
Crucifixion* 1944]. I thought that it could come off, but I think that the first is better. I
would have had to use the orange again so as to give a shock, that which red dissolves.
But the tedium of doing it perhaps dissuaded me, because mixing that orange with pas-
tel and then crushing it was an enormous job."[2] Bacon has made great use of the airbrush,
especially on the figures, and this imparts a refinement to the modeling of the forms that
differs considerably from the comparatively crudely painted surfaces of the earlier pic-
ture.

1. Paris + Munich 1996–7, sv. 87. In fact, as Hervé Vanel points out, both versions were shown in the Paris
retrospective of 1971.
2. Cork, "Le portrait moderne en Grande Bretagne: innovation et tradition," *Artstudio* Paris, 21, Summer
1991, pp. 50–57. Cited by Hervé Vanel, loc. cit.

(Illustrated on pp. 231–233)

74. MAN AT WASHBASIN, 1989–90
TITLED, SIGNED, AND DATED ON BACK
OIL ON CANVAS, 78 × 58 INCHES (198 × 147.5 CM)
EXH: *FRANCIS BACON: PAINTINGS*, MARLBOROUGH GALLERY, NEW YORK. 23 MAY–
29 JUNE 1990 (14); PARIS + MUNICH 1996–7 (88)
MARLBOROUGH INTERNATIONAL FINE ART

Francis Bacon, Study for a
Human Body — Man Turning
on the Light, *1973–74*
Royal College of Art Collection,
London

The pose for this figure is taken, once again, from Muybridge plate 344, "Striking a Blow with Right Hand," from the second volume of his collection of photographs, *The Human Figure in Motion.*[1] A boxer is leading with his right hand, body bent low, his back turned to us and revealing a strongly developed musculature. Bacon has adapted this pose from the sixth of a series of twelve photographs on the plate, and makes his figure bend the right arm back to his face as if he were either brushing his teeth, or washing, or drinking. He has also exaggerated the spread of the legs, adding testicles, and a bluish-gray stocking, top turned back, adorns his left leg; his left ankle seems to be partly inserted into the top of a pair of denim shorts, but this bright blue patch might also be read either as a bath mat or simply a blue patch. He has made the muscles more massive but less clearly defined than in the photograph; and, as if to defy the illusion of the volume of the body, he has scored a blue razor-like slash diagonally down from the left shoulder and across the back so as to form a cross with the main diagonal thrust of the boxer's pose.

The boxer's flesh is softly air-brushed in, with pinks, darker reds, and blues, and appears to bear sores and bruises. A slash of the buff-gray background color has been dragged across the junction of calf with thigh at the back of the right knee so as to connect the figure with its nondescript surroundings. A washbasin is summarily outlined in white, with the wastepipe disappearing into nowhere. There are perhaps echoes of Degas's *Woman at Her Toilet* (National Gallery, London), but although both artists have introduced deformities of the upper spine and shoulders, Bacon's are the more severe and willful. As Fabrice Hergott has observed, the boxer's general pose was first used by Bacon in *Study for a Human Body (Man Turning on the Light)* of 1973–4 (Royal College of Art, London), but in this picture the right arm is extended and the hand raised upwards to clutch at an electric light toggle.

1. Fabrice Hergott, Paris + Munich 1996–7, sv. 88, has made the identification, and I am indebted to him for his perceptive comments on this painting.

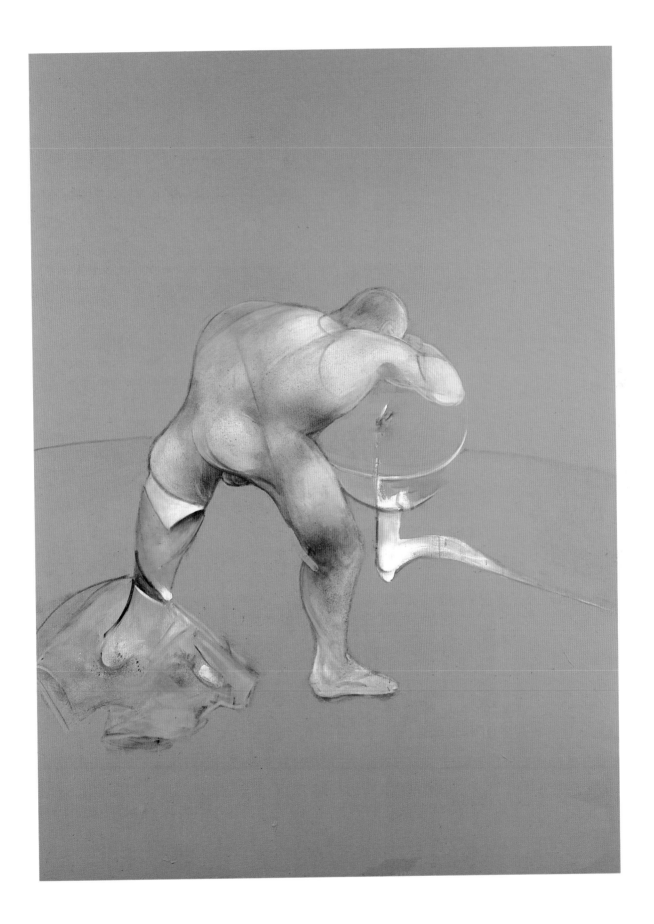

Chronology

BY DENNIS FARR

1909 Born in Dublin, 28 October, of English parents, Edward Anthony Mortimer Bacon and Christina Winifred Loxley Bacon (née Firth). Collateral descendant of the statesman and philosopher, Sir Francis Bacon (1561–1626), Viscount St. Albans). He was the second of five children. His father, a former army officer, trains racehorses. Francis suffers from asthma; receives no conventional schooling.

1914 On outbreak of World War I, Bacon family moves to London; father works with Territorial Forces.

1918–26 Bacon family moves between England and Ireland. Francis attends Dean Close School, Cheltenham from spring 1924 to April 1926, but withdrawn after asthma attacks worsen.

1926 Leaves home for London, after final quarrel with his father; mother makes him a small allowance.

1927–28 Travels to Berlin, stays two months, thence to Paris, where he sees Picasso exhibition at Paul Rosenberg's in summer 1927, which greatly impresses him. Begins drawing and painting in watercolors. Secures occasional commissions for interior decoration. Learns French.

1929 Returns to London. Exhibits in his studio (a converted garage), 17 Queensberry Mews, South Kensington, furniture and rugs made from his designs. Begins painting in oils.

1930 Becomes friends with Australian artist, Roy de Maistre (1894–1968), who helps secure furniture commissions for him. Meets Graham Sutherland (1903–80). Organizes in November, a studio exhibition of his work with de Maistre and Jean Shepeard (1904–89).

1931–32 Moves to Fulham Road; turns increasingly to oil painting. Precarious living from odd jobs. De Maistre gives him informal tuition in oil painting.

1933–36 Occupies studio in 71 Royal Hospital Road, Chelsea. Paints first of several *Crucifixions* shown in a mixed exhibition organized by the Mayor Gallery.

1934 Organizes his first one-man show in February at Transition Gallery, in basement of Sunderland House, Curzon Street, Mayfair, by arrangement with designer, Arundell Clarke, one of Bacon's admirers. Exhibition a failure.

1936 Work submitted to the International Surrealist Exhibition, New Burlington Galleries, London, is rejected as "insufficiently surreal."

1937 Represented by three works in "Young British Painters" exhibition held January at Agnew's, Old Bond Street, London, organized by his friend and patron, Eric Hall; among other exhibitors were de Maistre, Sutherland, Victor Pasmore, Ivon Hitchens, John Piper, and Ceri Richards.

1940 Death of Bacon's father 1 June, Bradford Peverell, near Dorchester.

1941–44 Destroys nearly all his early work. Unfit for military service, he volunteers for the Civil Defence (Air Raid Precautions). End 1942 rents studio at 7 Cromwell Place, South Kensington, once occupied by Sir John Millais, President of the Royal Academy. Meets the painter Lucian Freud 1943.

1944–5 Resumes painting, executes triptych *Three Studies for Figures at the Base of a Crucifixion.*

1945–6 Exhibits in group shows at Lefevre and Redfern Galleries, London.

1946–50 Lives mainly in Monte Carlo. Friendship with Graham Sutherland.

1948 Alfred Barr buys *Painting 1946* for Museum of Modern Art, New York.

1949 One-man show at Hanover Gallery, London, who become his dealer for next ten years.

1950 Teaches briefly at Royal College of Art. Meets art critic David Sylvester. Travels to South Africa to see his mother, returns via Cairo.

1951–55 Changes studio several times.

1952 Second visit to South Africa. Exhibits landscapes inspired by Africa and the South of France. Meets Peter Lacy.

1953 First one-man show in USA at Durlacher Brothers, New York. Helen Lessore organises a one-man show at the Beaux Arts Gallery, London.

1954 Visits Italy, but does not see the Velázquez *Pope Innocent X* at the Palazzo Doria Pamphili, Rome. Twelve paintings shown at Venice *Biennale.*

1955 January: first retrospective exhibition at Institute of Contemporary Arts, London. Paints portraits of collectors Robert and Lisa Sainsbury, who become his patrons.

1956 Visits Tangier to see his friend Peter Lacy.

1957 First exhibition in Paris at Galerie Rive Droite. Exhibits Van Gogh series at Hanover Gallery.

1958 First one-man exhibition in Italy: at Galleria dell'Ariete, Milan, and Galleria dell' Obelisco, Rome. Signs contract with Marlborough Fine Art, London.

1959 Exhibits at *Documenta II*, Kassel; Vth *Bienal*, São Paulo, and at Museum of Modern Art, New York.

1960 First exhibition at Marlborough Fine Art.

1961 Settles in studio at 7 Reece Mews, S. Kensington, where he remains until his death.

1962 Paints first large triptych, *Three Studies for a Crucifixion*, acquired by Solomon R. Guggenheim Museum in New York. Major retrospective at the Tate Gallery, versions of this exhibition toured to Mannheim, Turin, Zürich, and Amsterdam.

1963 Friendship with George Dyer.

1963–64 Retrospective exhibition at Solomon R. Guggenheim Museum, New York, and at Art Institute of Chicago.

1964	Room devoted to his paintings at *Documenta III*, Kassel.
1965	Paints *Crucifixion* triptych, bought by Staatsgalerie der moderner Kunst, Munich. July: meets Michel Leiris, who champions his work in France.
1967	Wins Carnegie Award in Painting at Pittsburgh International Exhibition, and awarded Rubens Prize by the city of Siegen.
1968	Visits USA for the first time in connection with first Marlborough Gallery, New York, exhibition. Visits his sick mother in South Africa.
1971–72	Major retrospective exhibition at Grand Palais, Paris, and Kunsthalle, Düsseldorf. Death of George Dyer (October 1971).
1972–73	Paints series of three large triptychs inspired by death of George Dyer.
1974	Meets John Edwards. Undergoes gall bladder operation.
1975	Retrospective exhibition at the Metropolitan Museum of Art, New York, of works 1968–74, selected by Henry Geldzahler.
1976	First group of interviews with David Sylvester published.
1977	Recent works shown at Galerie Claude Bernard, Paris; exhibitions in Mexico (1977) and Caracas (1978).
1983	First exhibition in Japan at National Museum of Modern Art, Tokyo, and at Kyoto and Nagoya.
1985	Second major retrospective exhibition at Tate Gallery, London; toured to Stuttgart and Berlin (1986).
1988	Exhibition at Central House of Artists, New Tretyakov Gallery, Moscow, the first by a living modern artist to be held there.
1989	Operation to remove cancerous kidney.
1989–90	Retrospective exhibition at the Hirshhorn Museum and Sculpture Garden, Washington, DC; shown also at Los Angeles County Museum of Art, and Museum of Modern Art, New York.
1990	Visits Colmar to see Grünewald's Isenheim altarpiece; and Madrid to see Velázquez exhibition at the Prado.
1992	28 April, dies in a Madrid hospital of a heart attack following hospitalization six days earlier for pneumonia aggravated by acute asthma.
1993	Retrospective exhibitions at Lugano and Venice.
1996–97	Major retrospective exhibition at Centre Georges Pompidou, Paris, and Haus der Kunst, Munich.

Notes

ESSAY 1:

"FRANCIS BACON"
by Sally Yard

1. Francis Bacon, interview by Hugh Davies, 17 March 1973, London. I am grateful to Hugh Davies not only for the extensive and remarkable material revealed in his interviews with Francis Bacon, but also for sharing his understanding of Bacon's work with me.

2. David Sylvester, *Interviews with Francis Bacon, 1962–1979* (London: Thames and Hudson, 1980), 28.

3. Francis Bacon, interview by Hugh Davies, 13 August 1973, London.

4. Francis Bacon, interview by Miriam Gross, "Bringing Home Bacon," *Observer,* 30 November 1980, 29.

5. See John Russell, *Francis Bacon* (London: Thames and Hudson, 1971), 13; Michael Peppiatt, *Francis Bacon: Anatomy of an Enigma* (New York: Farrar, Straus and Giroux, 1997), 21; and Francis Bacon, interview by Hugh Davies, 3 April 1973, London.

6. Russell, 15–17; Peppiatt, 16, 21; and Francis Bacon, interview by Hugh Davies, 29 May 1973, London. See Peppiatt, 16–17 for a discussion of the disciplinary strategies of Francis's father.

7. Francis Bacon, interview by Davies, 29 May 1973.

8. Ibid.; and Russell, 15–17.

9. See Peppiatt, 48, 73–75.

10. "The 1930 Look in British Decoration," *The Studio* (August 1930): 140–41.

11. Peppiatt's research has made clear Jessie Lightfoot's importance for Bacon. See pp. 56–57, 135.

12. Ibid., 65.

13. See Ibid., 67–68.

14. Sir Roland Penrose, interview by Hugh Davies, 29 March 1973, London. See Hugh M. Davies, *Francis Bacon: The Early and Middle Years, 1928–1958* (New York: Garland, 1978), 32.

15. Peppiatt, 75.

16. See Ibid., 76.

17. Ronald Alley and John Rothenstein, *Francis Bacon* (London: Thames and Hudson, 1964), 35, cite a letter written by Bacon in 1959, in which he explains that these are "sketches for the Eumenides . . . which I intend to use as the base of a large Crucifixion which I may still do." See also Peppiatt, 108.

18. Sylvester, 76.

19. Alley and Rothenstein, 17. On a visit to Bacon's studio in 1950, Sam Hunter assembled newspaper clippings, magazine illustrations, reproductions from art books, and other visual sources that were scattered around the space and photographed them for inclusion in his crucial article "Francis Bacon: The Anatomy of Horror," *Magazine of Art* 95 (January 1952): 11–15.

20. Sylvester, 22.

21. Bacon repeated this explanation to a number of writers. John Russell (pp. 48, 57) explains that the work began with an image of a chimpanzee in long grass, which gave way to the image of the bird.

22. "Compost" is Bacon's word, mentioned in Michael Peppiatt's essay "Francis Bacon at Work" included in this book.

23. Francis Bacon, in Peppiatt, 121–22.

24. Peppiatt, 123.

25. Bacon had seen the Eisenstein film several times.

26. Lawrence Gowing, *Francis Bacon: Paintings 1945–1982,* exhibition catalogue (Tokyo, 1983), 105, quoted in Peppiatt, 130–31.

27. "Survivors," *Time* 54 (21 November 1949): 44.

28. Sylvester, 134.

29. See Peppiatt's more full description, 156–58.

30. Russell, 129.

31. Alley and Rothenstein, 72.

32. Peppiatt writes perceptively of the relationship of Hall and Bacon. See esp. p. 134.

33. See Peppiatt, 171–72, 175, 192.

34. Francis Bacon, interview by David Sylvester, in *Francis Bacon: Fragments of a Portrait,* a film for BBC Television, London, 1966; published as "From Interviews with Francis Bacon," in *Francis Bacon: Recent Paintings,* exhibition catalogue (London: Marlborough Fine Art Ltd., 1967), 34.

35. See Hugh M. Davies, "Bacon's 'Black' Triptychs," *Art in America* 63 (March–April 1975): 62–68.

36. Francis Bacon, in Peppiatt, 300.

37. Francis Bacon, interview by Davies, 13 August 1973.

38. Paired with a passage from Saint John of the Cross, Orestes's harried lament from the *Choephoroi* had served as an epigraph to Eliot's "Sweeney Agonistes." See T. S. Eliot, *The Family Reunion* (New York: Harcourt, Brace & World, 1939), 24. Bacon spoke of his interest in *The Family Reunion* in an interview with Hugh Davies, 12 April 1973, London.

39. Francis Bacon, interview by Hugh Davies, 7 September 1983, London.

40. Peppiatt, 316.

41. Russell, 58.

42. Ibid., 46, 11.

43. C. G. Jung, *The Archetypes and the Collective Unconscious,* second edition, trans. R. F. C. Hull (Princeton: Princeton University Press, 1969), 82.

44. Aeschylus, "The Eumenides," *Oresteia,* trans. Richmond Lattimore (Chicago: University of Chicago Press, 1953), 139.

45. T. S. Eliot, "Sweeney Agonistes" (1932), in *Collected Poems 1909–1935* (New York: Harcourt, Brace and Company, 1936), 150.

46. Sylvester, 86.

47. Francis Bacon, interview by Davies, 7 September 1983.

48. Sylvester, 152.

ESSAY 2:
"FRANCIS BACON IN CONTEXT"
by Dennis Farr

1. Peppiatt 1996, pp. 140–41, quotes Bacon as saying, many times, that there was *"nothing* to explain" about his work. I am indebted to Peppiatt for much of the biographical detail in this study.

2. There is a story that, on being asked by a researcher toward the end of his life if he would bequeath his source material to an archive, Bacon swept up all the photographs and press-cuttings that littered his studio floor, bundled them into two plastic sacks, and made a bonfire of them. This is as much to do with the tactlessness of the enquirer as with Bacon's secretiveness; Michael Peppiatt has confirmed to me that Bacon made periodic "spring-cleans" of the accumulated "rubbish" on his studio floor (see also Peppiatt 1996, pp. 295–96).

3. Bacon-Sylvester, *Interview 1* (1962), pp. 20–21.

4. Bacon-Sylvester, *Interview 3* (1971–73), pp. 71–72, and 81 for example, contains some autobiographical information.

5. The year had been variously given as 1909, 1910, and 1912. The correct date and place of birth were published in the 1962 Tate exhibition catalogue.

6. Peppiatt 1996, p. 17.

7. Peppiatt 1996, pp. 26–32, refers to this "uncle" simply as Harcourt-Smith. It seems probable that he was Sir Cecil Harcourt-Smith (1859–1944), Director of the Victoria and Albert Museum from 1909 until his retirement in 1924, a noted linguist, and of handsome ambassadorial bearing. Harcourt-Smith married Alice Edith Watson in 1892 and they had two sons; Bacon's great-aunt Eliza was born a Watson, and one of Bacon's cousins was Diana Watson. Alternatively, it may have been Harcourt-Smith's elder son, Simon, Bacon's senior by at least ten years, who wrote on art.

8. Martin Battersby, *The Decorative Twenties* (1971), pp. 56–63. Bacon may just possibly have read Sir Lawrence Weaver's article on the Leipzig Deutscher Werkbund's 1926 Fair in *The Studio Year-book of Decorative Art* of 1927.

9. "The 1930 Look in British Decoration," *The Studio,* C (August 1930), pp. 140–41. The rugs illustrated in R+A, between pp. 2–21, also have affinities with the work of Edward McKnight Kauffer and Marion Dorn, but are perhaps more restrained. Bacon was probably well aware of publications such as *Art et Décoration,* and he no doubt visited the Salon des Décorateurs in Paris.

10. Bacon-Sylvester *Interview 1* (1962), p. 35.

11. Francis Watson in *Art Lies Bleeding* (1939), gives a chilling account of the difficulties faced by all but the most successful artists in the late 1930s.

12. Peppiatt 1996, pp. 67–68 quotes *The Times* review of 16 February 1934.

13. R+A, nos. A1–A4.

14. R+A, no. A4, formerly known as *Figure Getting out of a Car.*

15. Russell 1971–93, pp. 10–11. He had expressed similar sentiments in his article "Francis Bacon, Peer of the Macabre" in *Art in America,* No. 5, October 1963, pp. 100–103.

16. Peppiatt 1996, p. 332 n. 17.

ESSAY 3:

"FRANCIS BACON AT WORK"
by Michael Peppiatt

1. As an adolescent, Bacon had been found trying on his mother's underwear by his irascible, military father. Having been ordered to leave the family home in Ireland, the young man made his way to London, and thence to Berlin and Paris.

2. During his stay in Paris in 1927–28, Bacon picked up some elements of furniture design and interior decoration. When he returned to London, he made several pieces of furniture out of glass and tubular steel and designed a number of rugs.

3. Bacon liked to preserve the "accidents" that happened in his apartment as well as in his painting. The smash occurred when someone had thrown a heavy glass ash tray at him and hit the mirror instead.

4. Saint-Simon, Racine, and Baudelaire were also among Bacon's favorite authors; he read and spoke French fluently. Very few novels appealed to him, but he greatly appreciated Djuna Barnes's *Nightwood*.

5. Bacon's attitude towards drawing was ambivalent. On the one hand, he lacked confidence about his own ability to draw; on the other, he tended to see drawing as a minor activity compared to painting. Michael Ayrton once argued in an essay that Bacon could not draw. Later the two artists bumped into each other. "Is drawing what you do?" Bacon asked him in feigned interest, adding: "I wouldn't want to do that."

6. *New American Painting*, the show that gave most people outside the United States their first full introduction to Abstract Expressionism, ended its European tour at the Tate Gallery in London in 1959.

7. I am grateful to the Trustees of the Francis Bacon Estate for their permission to publish these new documents.

8. After I had published the photograph of the male patient arched in convulsions in my biography of Francis Bacon, I received a letter from a professor of cell biology and anatomy informing me that the patient in question was in fact dying of opisthotonos tetanus, a disease of which Bacon was unusually conscious since it had killed his eldest brother, Harley. This information not only sets the record straight but demonstrates admirably how Bacon's imagination moved in unforeseeable ways, finding associations in certain images that will no doubt elude his interpreters for ever.

226

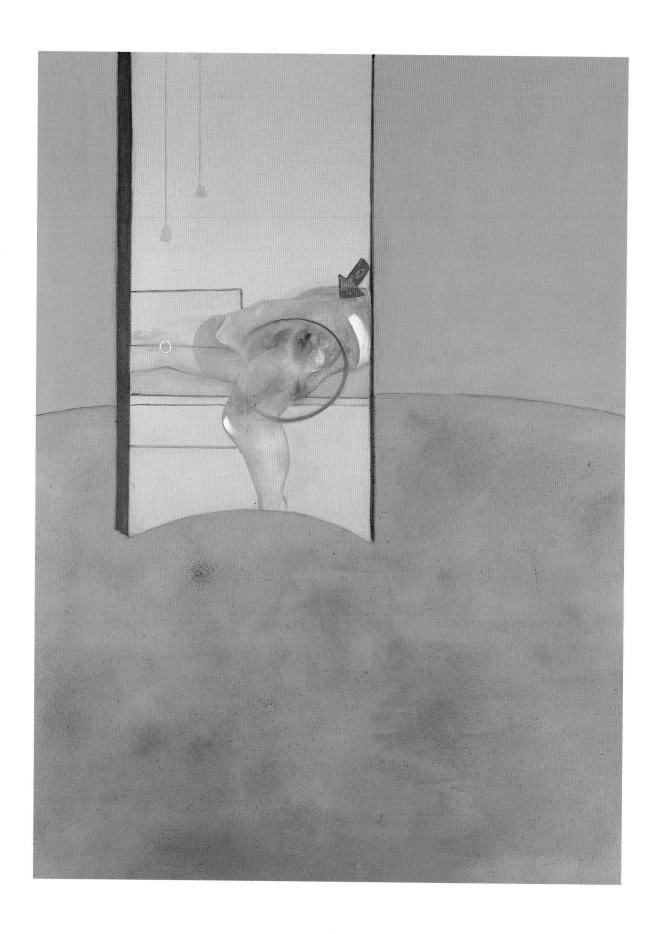

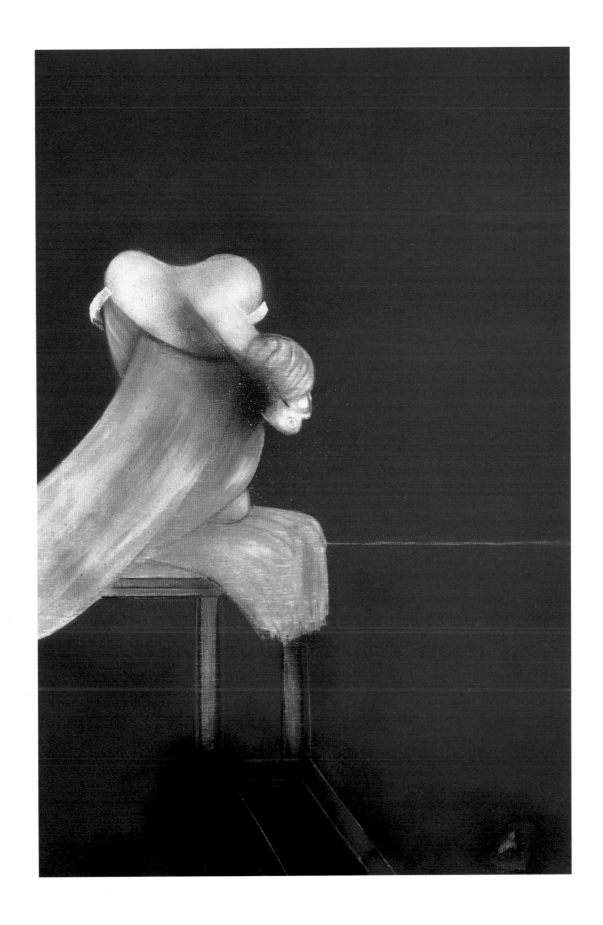

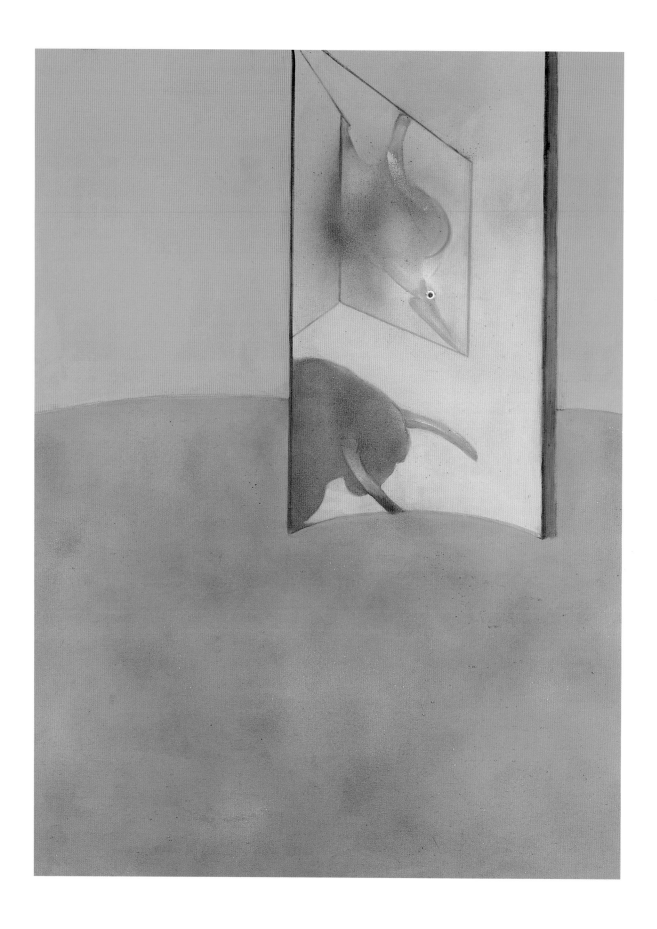

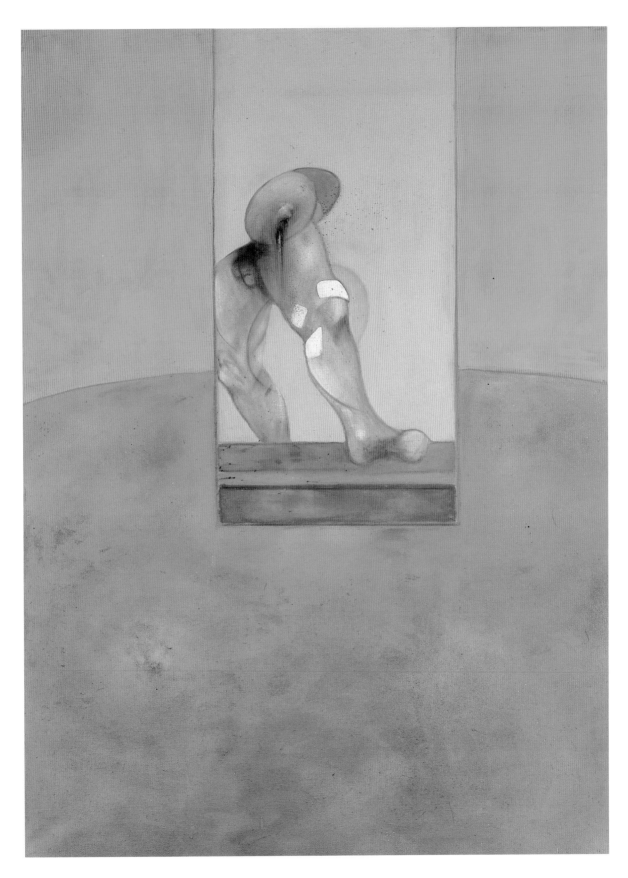

71. TRIPTYCH, 1987

73. SECOND VERSION OF "TRIPTYCH 1944," 1988

233

Abbreviations

BACON-SYLVESTER Sylvester, David. *Interviews with Francis Bacon.* (London, 1975; enlarged and reprinted 1995). Nine interviews spanning the years 1962 to 1984 – 86).

DAVIES + YARD Davies, Hugh, and Sally Yard. *Bacon* (New York and London, 1986).

LEIRIS 1988 Leiris, Michael. *Francis Bacon.* (London, 1988).

PEPPIATT 1996 Peppiatt, Michael. Francis Bacon: *Anatomy of an Enigma.* London, 1996; New York, 1997.

R + A Rothenstein, John, and Ronald Alley. *Francis Bacon.* Introductory essay by Rothenstein, catalogue raisonné by Alley. London and New York, 1964.

RUSSELL 1971 – 93 Russell, John. *Francis Bacon.* London, 1971, revised and updated 1973.

TATE 1962 London, Tate Gallery, *Francis Bacon,* 24 May – 1 July 1962. Introduction by Sir John Rothenstein, catalogue by Ronald Alley

PARIS 1971 – 72 Paris, Galleries nationales du Grand Palais. *Francis Bacon,* 26 Oct. 1971 – 10 Jan. 1972. Introduction "Francis Bacon aujourd'hui" by Michel Leiris. Exhibition toured to Düsseldorf, Kunsthalle, 7 March – 7 May 1972.

NEW YORK 1975 New York, The Metropolitan Museum of Art, *Francis Bacon: Recent Paintings,* 20 March – 19 June 1975. Introduction by Henry Geldzahler, with a contribution from Peter Beard.

MEXICO 1977 Mexico City, Museo de arte moderno, *Francis Bacon: oleos de 1970 a 1977,* Oct. – Dec. 1977.

CARACAS 1978 Caracas, Museo de arte contemporaneo, Feb. 1978. A continuation of Mexico 1977.

TOKYO 1983 Tokyo, The National Museum of Modern art, *Francis Bacon: Paintings 1945 – 1982,* 30 June – 14 Aug., 1983. Essay "Francis Bacon" by Sir Lawrence Gowing. Toured to the National Museum of Modern Art, Kyoto, 13 Sept. – 10 Oct., and Nagoya, Aichi Prefectural Art Gallery, 12 – 28 Nov. 1983.

TATE 1985 London, Tate Gallery, *Francis Bacon,* 22 May – 18 Aug. 1985. Essays by Dawn Ades, Andrew Forge, and Andrew Durham; select bibliography by Krzysztof Cieszkowski. Toured to: Stuttgart, Staatsgalerie, 17 Oct. 1985 – 5 Jan. 1986, and Nationalgalerie, Berlin, 7 Feb. – 31 March 1986.

HIRSHHORN 1989 – 90 Washington, DC, Hirshhorn Museum and Sculpture Garden, Smithsonian Institution, *Francis Bacon,* 12 Oct. 1989 – 7 Jan. 1990. Organized by James Demetrion, with essays by Lawrence Gowing and Sam Hunter. Toured to: Los Angeles County Museum of Art, 11 Feb. – 29 April 1990; and the Museum of Modern Art, New York, 24 May – 28 Aug. 1990.

BEYELER 1992 Galerie Beyeler, *Homage to Francis Bacon,* with works by Picasso, Giacometti, González, Miró, Dubuffet, Tapiés, and Rothko, June – Sept. 1992

LUGANO 1993 Lugano, Museo d'Arte Moderna di Lugano, *Francis Bacon,* 7 March – 30 May 1993. Essays by Ronald Alley, Hugh M. Davies, Michael Peppiatt, and Rudy Chiappini. Catalogue By Jill Lloyd and Michael Peppiatt.

VENICE 1993 Venice, Museo Correr, *Figurabile Francis Bacon,* 13 June – 10 Oct. 1993. Essays by David Sylvester, David Mellor, Gilles Deleuze Lorenza Trucchi, and Daniela Palazzoli.

PARIS + MUNICH 1996 – 7 Paris, Centre Georges Pompidou, *Francis Bacon,* 27 June – 14 Oct. 1996. Essays by David Sylvester, Jean Louis Schefer, Jean-Claude Lebensztejn, Fabrice Hergott, Hervé Vanel, and Yves Kobry; plus an anthology, chronology, bibliography, and a list of exhibitions. Toured to Munich, Haus der Kunst, 4 Nov. – 31 Jan. 1997.

LONDON 1998 London, Hayward Gallery, *Francis Bacon: The Human Body,* 5 Feb. – 5 April 1998. Curated by David Sylvester, with introductory notes by him; plus biographical note and select bibliography.

© Dennis Farr

Selected Bibliography

An extensive bibliography of material on Francis Bacon as of 1996 is included in the exhibition catalogue of the Centre Georges Pompidou exhibition. A bibliography by Anna Brooks covering the years 1984–1989 will be found in the catalogue of the Hirshhorn Museum, Washington, D.C., exhibition: *Francis Bacon* (Lawrence Gowing and Sam Hunter). A further bibliography as of 1984 by Krzysztof Cieszkowski is in the catalog of the Tate Gallery exhibition, *Francis Bacon* (Dawn Ades and Andrew Forge). The bibliography below includes important material since 1996, along with certain books and articles that can be considered essential.

Ades, Dawn, and Andrew Forge. (1985). *Francis Bacon.* Exhibition catalogue (London: Tate Gallery, Thames and Hudson, and New York: Abrams).

Alley, Ronald. (1993). "Francis Bacon's Place in Twentieth-Century Art," Chiappini, *Francis Bacon,* 15–30.

Archimbaud, Michel. (1992). *Francis Bacon: entretiens avec Michel Archimbaud* (Paris: J.-C. Lattes).

Chiappini, Rudy. (1993). *Francis Bacon* Exhibition catalogue (Lugano: Museo d'Arte Moderna della Città di Lugano and Milan: Electa).

del Conde, Teresa. (1997). *Tres maestros* (Mexico: Universidad Nacional Automnoma de Mexico).

Dagen, Philippe. (1996). *Francis Bacon* (Paris: Cercle d'Art).

Davies, Hugh. (1978). *Francis Bacon: The Early and Middle Years, 1928–1958.* Ph.D. Dissertation, Princeton University, 1975 (New York: Garland Publishing).

Davies, Hugh, and Sally Yard. (1986). *Bacon* (New York: Abbeville).

Deleuze, Gilles. (1983). "Francis Bacon: The Logic of Sensation," *Flash Art* 112: May, 8–16.

Deleuze, Gilles. (1981). *Francis Bacon: Logique de la sensation* (Paris: Éditions de la Différence).

Domino, Christophe. (1997). *Francis Bacon* (New York: Harry N. Abrams, Inc.).

Farson, Dan. (1993). *The Gilded Gutter Life of Francis Bacon* (New York: Pantheon Books).

Fusini, Nadia. (1994). *B & B* (Milan: Garantzi).

Gayford, Martin. (1996). "The Brutality of Facts," *Modern Painters* 9: Autumn, 43–49.

Gowing, Lawrence, and Sam Hunter. (1989). *Francis Bacon.* Exhibition catalogue (Washington, D.C., Hirschhorn Museum and Thames and Hudson).

Hergott, Fabrice. (1996). *Francis Bacon.* Exhibition catalogue (Paris: Centre Georges Pompidou, Éditions du Centre Pompidou).

Hughes, Robert. (1985). "Singing within the Bloody Wood," *Time,* July 1, 54–55.

Lessøe, Rolf. (1986). "Francis Bacon 'Man and Child' — selfprojektion of katharsis," *Tidsbilleder* (Copenhagen) 5: 8–18. Reprinted: Kjeld Kjeldsen and Charlotte Sabroe, editors. (1988). *The Evolution of a Collection* (Humlebaek: Louisiana Museum), 35–39.

Leiris, Michael. (1988). *Francis Bacon: Full Face and in Profile* (rev. ed., New York: Rizzoli).

Peppiatt, Michael. (1997). *Francis Bacon: Anatomy of an Enigma* (New York: Farrar, Straus and Giroux).

Peppiatt, Michael. (1987). "Francis Bacon: Reality Conveyed by a Lie," *Art International* I:Autumn, 36–37.

Peppiatt, Michael. (1987). "Six New Masters," *Connoisseur* 217: September, 79–85.

Peppiatt, Michael. (1985). "Sono come un tritatutto," *Arte* 153: June, 36–43.

Polac, Michel. (1996). "Bacon: 'Don't make me say it . . . ,'" *Cimase* 43: Sept./Oct., 109–112.

Rothenstein, John and Ronald Alley. (1964). *Francis Bacon.* Introductory essay by Rothenstein, catalogue raisonné by Alley (New York: Viking Press).

Russell, John. (1993). *Francis Bacon* (New York: Thames and Hudson, rev. ed.).

Saraben, Jacques. (1996). "To make a Sahara of the mouth": interview with the artist, 1978. *Art Press* #215: July/August, 20–26.

Schmied, Wieland. (1996). *Francis Bacon* (New York: Prestel).

Sylvester, David. *Interviews with Francis Bacon.* (1975; enlarged and reprinted 1995). (London: Thames & Hudson, and New York: Pantheon Books).

Tourigny, Maurice. (1990). "Francis Bacon: le hasard et l'odeur de la mort," *Vie des Arts* 35:139 June, 16–19.

Photo Credits

Index

EDITOR: ELAINE M. STAINTON
DESIGNER: RAYMOND P. HOOPER

Library of Congress Cataloging-in-Publication Data

Farr, Dennis, 1929–
Francis Bacon : a retrospective / guest curator, Dennis Farr ;
with essays by Dennis Farr, Michael Peppiatt, Sally Yard.
p. cm.
Catalog of an exhibition held at the Yale Center for British Art
and others, Jan. 25–Oct. 15, 1999.
Includes bibliographical references and index.
ISBN 0–8109–4011–6 (hardcover).—ISBN 1–882507–07–X (paperback)
1. Bacon, Francis, 1909– —Exhibitions. I. Bacon, Francis,
1909– . II. Peppiatt, Michael. III. Yard, Sally. IV. Trust for
Museum Exhibitions. V. Yale Center for British Art. VI. Title.
ND497.B16A4 1999
759.2—dc21 98–30699

Endpapers:
Two views of Francis Bacon's studio, 1992
Photos: Courtesy Marlborough Fine Art

Printed and bound in Japan

Harry N. Abrams, Inc.
100 Fifth Avenue
New York, N.Y. 10011
www.abramsbooks.com